The Art of
Basic Drawing

Discover simple step-by-step techniques for drawing
a wide variety of subjects in pencil

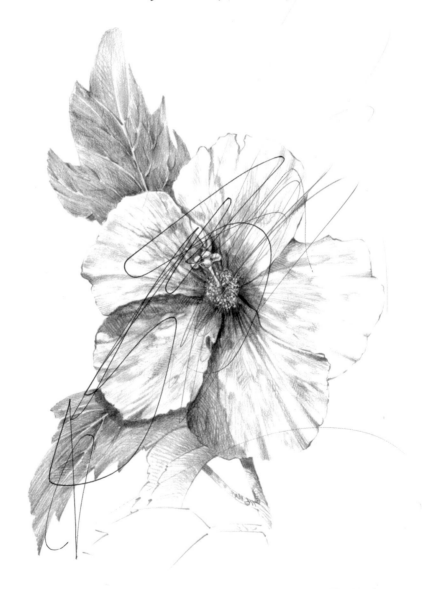

By William F. Powell, Michael Butkus, Mia Tavonatti, Michele Maltseff, & Walter T. Foster

WALTER FOSTER PUBLISHING, INC.
3 Wrigley, Suite A
Irvine, CA 92618
www.walterfoster.com

This library edition published in 2012 by Walter Foster Publishing, Inc.
Distributed by Black Rabbit Books.
P.O. Box 3263 Mankato, Minnesota 56002

Printed in Mankato, Minnesota, USA by CG Book Printers, a division of Corporate Graphics.

First Library Edition

Library of Congress Cataloging-in-Publication Data

The art of basic drawing : discover simple step-by-step techniques for drawing a wide variety of subjects in pencil / with William F. Powell ... [et al.]. -- 1st library ed.
 p. cm. -- (Collector's series ; cs06L)
 ISBN 978-1-936309-46-7 (hardcover)
 1. Drawing--Technique. I. Powell, William F. II. Title: Discover simple step-by-step techniques for drawing a wide variety of subjects in pencil.
 NC730.A689 2011
 741.2--dc22

 2010052981

042011
17320

9 8 7 6 5 4 3 2 1

The Art of
Basic Drawing

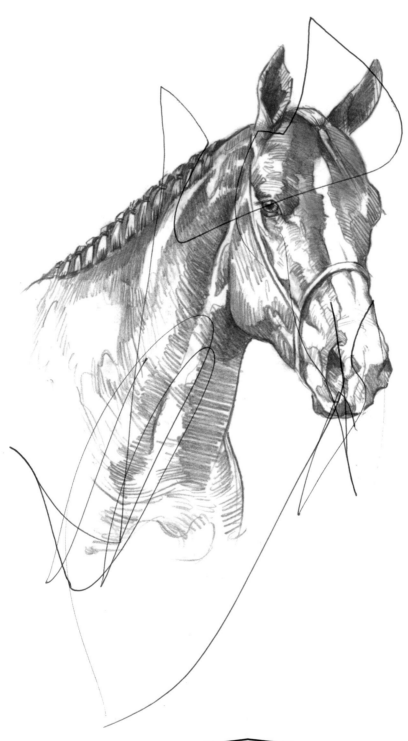

CONTENTS

INTRODUCTION TO BASIC DRAWING5
Tools and Materials 6
Perspective 8
Warming Up 10
Starting with Sketches 12
Learning to See 14
Beginning with Basic Shapes 16
Developing Form 18

INTRODUCTION TO STILL LIFES20
Fruit and Nuts 22
Strawberries 24
Pineapple 25
Pinecone 26
Candlelight 28
Floral Arrangement 29
Liquid and Glass 30
Rose with Waterdrops 31
Simple Flowers 32
Floral Bouquet 33
Tulips 34
Carnation 35
Peony 36
Dogwood 36
Regal Lily 37
Primrose 38
Hibiscus 39
Hybrid Tea Rose 40
Floribunda Rose 41
Chrysanthemums 42
Bearded Iris 44
Still Life Composition 46
Reflections and Lace 48
Bottle and Bread 50

INTRODUCTION TO ANIMALS52
Drawing Animals 54
Doberman Pinscher 56
Great Dane 57
Siberian Husky Puppy 58
English Bulldog 60
Miniature Schnauzer 61
Shar-Pei Puppy 62
Old English Sheepdog 63
Chow Chow 64
Bouvier des Flandres 65
Ragdoll Kittens 66
Persian Cat 68
Tabby Cat 70
Common Cat Behaviors 72

Horse Portrait 76
Horse Head in Profile 78
Advanced Horse Heads 79
Pony 80
Clydesdale 82
Circus Horse 83
Drawing at the Zoo 84
Flamingo 86
Elephant 87
Kangaroo 88
Toucan 89
Tortoise 90
Rattlesnake 91
Giant Panda 92
Giraffe 93

INTRODUCTION TO LANDSCAPES94
Landscape Composition 96
Perspective Tips 97
Clouds 98
Rocks 100
Tree Shapes 102
Structures 106
Mountains 108
Deserts 110
Creek with Rocks 112
Sycamore Lane 114
Half Dome, Yosemite 116

INTRODUCTION TO PEOPLE118
Beginning Portraiture 120
Adult Head Proportions 122
Head Positions 123
Eyes 124
Noses and Ears 125
Woman in Profile 126
Woman Front View 127
Young Man in Profile 128
Older Man in Profile 129
Girl in Profile 130
Boy in Profile 131
The Body 132
Hands and Feet 133
Figures in Action 134
Portraying Children 138
Composing Figures 140
People in Perspective 141

INDEX .142

INTRODUCTION TO BASIC DRAWING

Although the age-old art of pencil drawing is the basic foundation of all the visual arts, its elemental beauty allows it to stand on its own. And pencil art is amazingly versatile—it can range from simple, unshaded contour line drawings to complex, fully rendered compositions with a complete range of tonal values. The projects in this book are taken from some of the most popular drawing books in Walter Foster's How to Draw and Paint Series. And because all the successful artists featured in this book have developed their own special approach to drawing, there are countless lessons to be learned from their individual and distinct perspectives. You'll find all the inspiration you need as you follow a diverse presentation of subject matter and instruction. So grab a pencil and start making your mark!

TOOLS AND MATERIALS

Drawing is not only fun, it is also an important art form in itself. Even when you write or print your name, you are actually drawing! If you organize the lines, you can make shapes; and when you carry that a bit further and add dark and light shading, your drawings begin to take on a three-dimensional form and look more realistic. One of the great things about drawing is that you can do it anywhere, and the materials are very inexpensive. You do get what you pay for, though, so purchase the best you can afford at the time, and upgrade your supplies whenever possible. Although anything that will make a mark can be used for some type of drawing, you'll want to make certain your magnificent efforts will last and not fade over time. Here are some of the materials that will get you off to a good start.

Sketch Pads Conveniently bound drawing pads come in a wide variety of sizes, textures, weights, and bindings. They are particularly handy for making quick sketches and when drawing outdoors. You can use a large sketchbook in the studio for laying out a painting, or take a small one with you for recording quick impressions when you travel. Smooth- to medium-grain paper texture (which is called the "tooth") is often an ideal choice.

Work Station It is a good idea to set up a work area that has good lighting and enough room for you to work and lay out your tools. Of course, an entire room with track lighting, easel, and drawing table is ideal. But all you really need is a place by a window for natural lighting. When drawing at night, you can use a soft white light bulb and a cool white fluorescent light so that you have both warm (yellowish) and cool (bluish) light.

Drawing Papers For finished works of art, using single sheets of drawing paper is best. They are available in a range of surface textures: smooth grain (plate and hot pressed), medium grain (cold pressed), and rough to very rough. The cold-pressed surface is the most versatile. It is of medium texture but it's not totally smooth, so it makes a good surface for a variety of different drawing techniques.

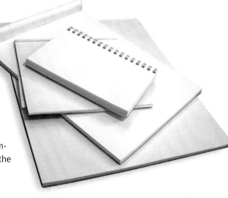

Artist's Erasers A kneaded eraser is a must. It can be formed into small wedges and points to remove marks in very tiny areas. Vinyl erasers are good for larger areas; they remove pencil marks completely. Neither eraser will damage the paper surface unless scrubbed too hard.

Charcoal Papers Charcoal paper and tablets are also available in a variety of textures. Some of the surface finishes are quite pronounced, and you can use them to enhance the texture in your drawings. These papers also come in a variety of colors, which can add depth and visual interest to your drawings.

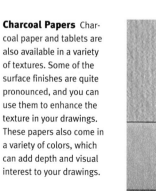

Tortillons These paper "stumps" can be used to blend and soften small areas where your finger or a cloth is too large. You can also use the sides to quickly blend large areas. Once the tortillons become dirty, simply rub them on a cloth, and they're ready to go again.

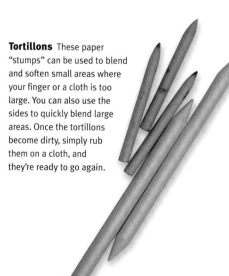

Utility Knives Utility knives (also called "craft" knives) are great for cleanly cutting drawing papers and mat board. You can also use them for sharpening pencils. (See the box on page 7.) Blades come in a variety of shapes and sizes and are easily interchanged. But be careful; the blades are as sharp as scalpels!

GATHERING THE BASICS

You don't need a lot of supplies to start; you can begin enjoying drawing with just a #2 or an HB pencil, a sharpener, a vinyl eraser, and any piece of paper. You can always add more pencils, charcoal, tortillons, and such later. When shopping for pencils, notice that they are labeled with letters and numbers; these indicate the degree of lead softness. Pencils with B leads are softer than ones with H leads, and so they make darker strokes. An HB is in between, which makes it very versatile and a good beginner's tool. The chart at right shows a variety of drawing tools and the kind of strokes that are achieved with each one. As you expand your pencil supply, practice shaping different points and creating different effects with each by varying the pressure you put on the pencil. The more comfortable you are with your tools, the better your drawings will be!

ADDING ON

Unless you already have a drawing table, you will probably want to purchase a drawing board. It doesn't have to be expensive; just get one large enough to accommodate individual sheets of drawing paper. Consider getting one with a cut-out handle, especially if you want to draw outdoors, so you can easily carry it with you.

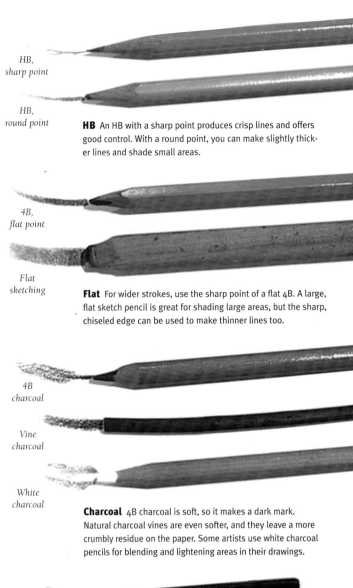

HB, sharp point

HB, round point

HB An HB with a sharp point produces crisp lines and offers good control. With a round point, you can make slightly thicker lines and shade small areas.

4B, flat point

Flat sketching

Flat For wider strokes, use the sharp point of a flat 4B. A large, flat sketch pencil is great for shading large areas, but the sharp, chiseled edge can be used to make thinner lines too.

4B charcoal

Vine charcoal

White charcoal

Charcoal 4B charcoal is soft, so it makes a dark mark. Natural charcoal vines are even softer, and they leave a more crumbly residue on the paper. Some artists use white charcoal pencils for blending and lightening areas in their drawings.

Conté crayon

Conté pencil

Conté Crayon or Pencil Conté crayon is made from very fine Kaolin clay. Once it came only in black, white, red, and sanguine sticks, but now it's also available in a wide range of colored pencils. Because it's water soluble, it can be blended with a wet brush or cloth.

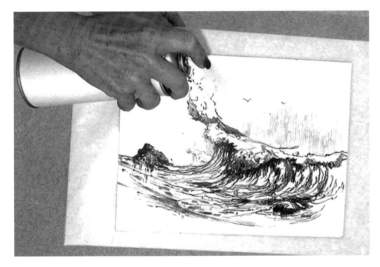

Spray Fix A fixative "sets" a drawing and protects it from smearing. Some artists avoid using fixative on pencil drawings because it tends to deepen the light shadings and eliminate some delicate values. However, fixative works well for charcoal drawings. Fixative is available in spray cans or in bottles, but you need a mouth atomizer to use bottled fixative. Spray cans are more convenient, and they give a finer spray and more even coverage.

SHARPENING YOUR DRAWING IMPLEMENTS

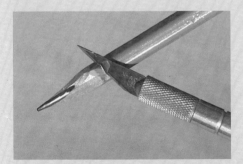

A Utility Knife can be used to form different points (chiseled, blunt, or flat) than are possible with an ordinary pencil sharpener. Hold the knife at a slight angle to the pencil shaft, and always sharpen away from you, taking off only a little wood and graphite at a time.

A Sandpaper Block will quickly hone the lead into any shape you wish. It will also sand down some of the wood. The finer the grit of the paper, the more controllable the resulting point. Roll the pencil in your fingers when sharpening to keep the shape even.

Rough Paper is wonderful for smoothing the pencil point after tapering it with sandpaper. This is also a great way to create a very fine point for small details. Again, it is important to gently roll the pencil while honing to sharpen the lead evenly.

PERSPECTIVE

Drawing is actually quite simple; just sketch the shapes and masses you see. Sketch loosely and freely—if you discover something wrong with the shapes, you can refer to the rules of perspective below to make corrections. Your drawings don't need to be tight and precise as far as geometric perspective goes, but they should be within the boundaries of these rules for a realistic portrayal of the subject.

Practice is the only way to improve your drawing skills and to polish your hand-eye relationships. It's a good idea to sketch everything you see and keep all your drawings in a sketchbook so you can track the improvement. (See page 12 for more on sketching and keeping a sketchbook.) Following are a few exercises to introduce the basic elements of drawing in perspective. Begin with the one-point exercise.

ONE-POINT PERSPECTIVE

In *one-point perspective,* the face of a box is the closest part to the viewer, and it is parallel to the horizon line (eye level). The bottom, top, and sides of the face are parallel to the picture plane.

1. Draw a horizontal line and label it "eye level" or "horizon line." Draw a box below this line.

2. Now draw a light guideline from the top right corner to a spot on the horizon line. Place a dot there and label it VP (vanishing point). All side lines will go to the same VP.

3. Next, draw a line from the other corner as shown; then draw a horizontal line to establish the back of the box.

4. Finally darken all lines as shown, and you will have drawn a perfect box in one-point perspective. This box may become a book, a chest, a building, etc.

TWO-POINT PERSPECTIVE

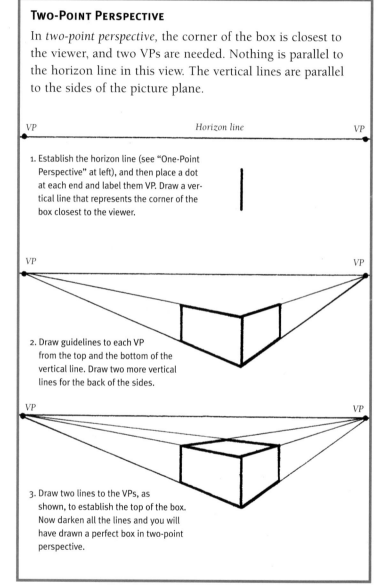

In *two-point perspective,* the corner of the box is closest to the viewer, and two VPs are needed. Nothing is parallel to the horizon line in this view. The vertical lines are parallel to the sides of the picture plane.

1. Establish the horizon line (see "One-Point Perspective" at left), and then place a dot at each end and label them VP. Draw a vertical line that represents the corner of the box closest to the viewer.

2. Draw guidelines to each VP from the top and the bottom of the vertical line. Draw two more vertical lines for the back of the sides.

3. Draw two lines to the VPs, as shown, to establish the top of the box. Now darken all the lines and you will have drawn a perfect box in two-point perspective.

FINDING THE PROPER PEAK AND ANGLE OF A ROOF

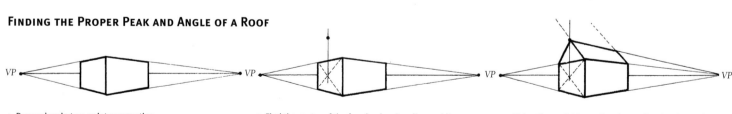

1. Draw a box in two-point perspective.

2. Find the center of the face by drawing diagonal lines from corner to corner; then draw a vertical line upward through the center. Make a dot for the roof height.

3. Using the vanishing point, draw a line for the angle of the roof ridge; then draw the back of the roof. The angled roof lines will meet at a third VP somewhere in the sky.

BASIC FORMS

There are four basic forms you should know: the cube, the cone, the cylinder, and the sphere. Each of these forms can be an excellent guide for beginning a complex drawing or painting. Below are some examples of these forms in simple use.

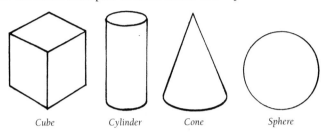

Cube *Cylinder* *Cone* *Sphere*

CREATING DEPTH WITH SHADING

To create the illusion of depth when the shapes are viewed straight on, shading must be added. Shading creates different values and gives the illusion of depth and form. The examples below show a cone, a cylinder, and a sphere in both the line stage and with shading for depth.

Line

Shaded

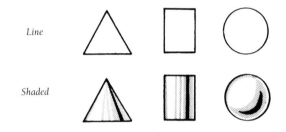

FORESHORTENING

As defined in Webster's dictionary, to *foreshorten* is "to represent the lines (of an object) as shorter than they actually are in order to give the illusion of proper relative size, in accordance with the principles of perspective." Here are a few examples of foreshortening to practice.

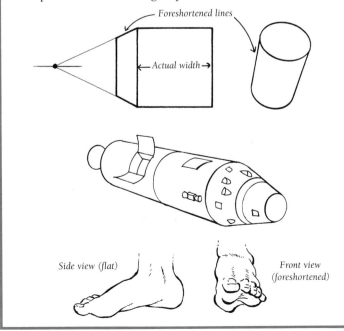

Foreshortened lines

←*Actual width*→

Side view (flat) *Front view (foreshortened)*

ELLIPSES

An *ellipse* is a circle viewed at an angle. Looking across the face of a circle, it is foreshortened, and we see an ellipse. The axis of the ellipse is constant, and it is represented as a straight centerline through the longest part of the ellipse. The height is constant to the height of the circle. Here is the sequence we might see in a spinning coin.

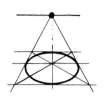

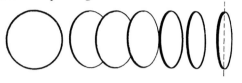

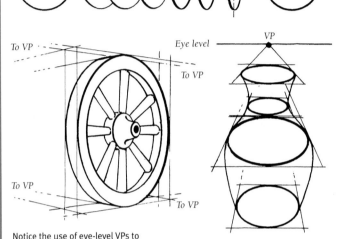

To VP *Eye level* *VP*

To VP

To VP

To VP

Notice the use of eye-level VPs to establish planes for the ellipses.

CAST SHADOWS

When there is only one light source (such as the sun), all shadows in the picture are cast by that single source. All shadows read from the same vanishing point. This point is placed directly under the light source, whether on the horizon line or more forward in the picture. The shadows follow the plane on which the object is sitting. Shadows also follow the contour of the plane on which they are cast.

Light rays travel in straight lines. When they strike an object, the object blocks the rays from continuing and creates a shadow relating to the shape of the blocking object. Here is a simple example of the way to plot the correct shape and length of a shadow for the shape and the height of the light.

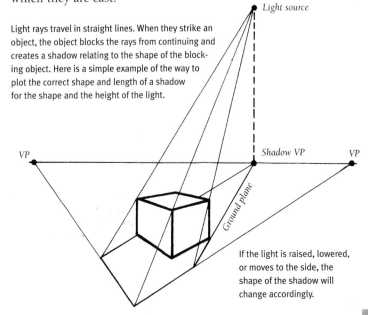

Light source

VP *Shadow VP* *VP*

Ground plane

If the light is raised, lowered, or moves to the side, the shape of the shadow will change accordingly.

WARMING UP

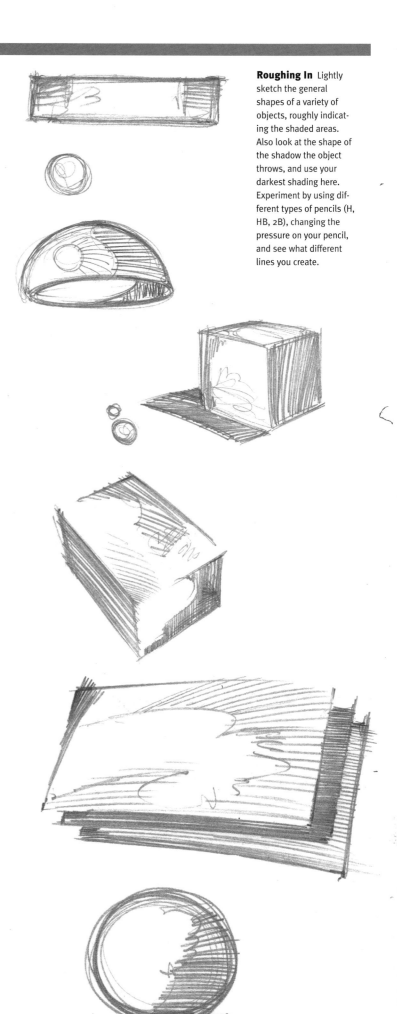

Drawing is about observation. If you can look at your subject and really *see* what is in front of you, you're halfway there already—the rest is technique and practice. Warm up by sketching a few basic three-dimensional forms—spheres, cylinders, cones, and cubes. (See page 16 for more on basic shapes and their corresponding forms.) Gather some objects from around your home to use as references, or study the examples here. And by the way, feel free to put a translucent piece of paper over these drawings and trace them. It's not cheating—it's good practice.

STARTING OUT LOOSELY

Begin by holding the pencil loosely in the underhand position. (See page 16.) Then, using your whole arm, not just your wrist, make a series of loose circular strokes, just to get the feel of the pencil and to free your arm. (If you use only your wrist and hand, your sketches may appear stiff or forced.) Practice drawing freely by moving your shoulder and arm to make loose, random strokes on a piece of scrap paper. Keep your grip relaxed so your hand does not get tired or cramped, and make your lines bold and smooth. Now start doodling—scribble a bunch of loose shapes without worrying about drawing perfect lines. You can always refine them later.

Roughing In Lightly sketch the general shapes of a variety of objects, roughly indicating the shaded areas. Also look at the shape of the shadow the object throws, and use your darkest shading here. Experiment by using different types of pencils (H, HB, 2B), changing the pressure on your pencil, and see what different lines you create.

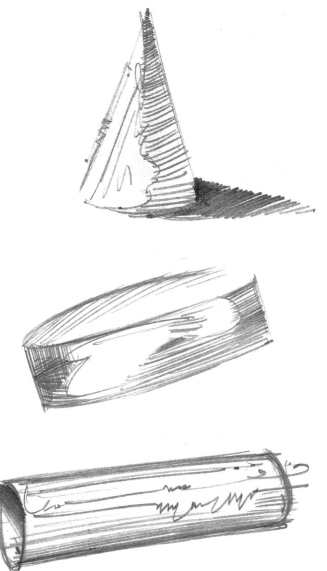

BLOCKING IN A SIMPLE COMPOSITION

Now loosely sketch an assortment of shapes in a simple still life. (See Chapter 2 for a more in-depth coverage of drawing still lifes.) Collect objects that have a variety of sizes and shapes—large and small, tall and short, spherical and rectangular—and put them together in an interesting arrangement. Then start blocking in the shapes using a sharp HB pencil. Remember to use your whole arm and to work quickly so you don't start tightening up and getting caught up in details. The more you practice drawing this way, the more quickly your eye will learn to see what's really there.

Measuring Up Before you start sketching the individual shapes, make sure you establish the correct proportions. When drawing freely like this, it's easy to lose sight of the various size relationships. Draw a few guidelines to mark the height of each object, and keep your sketches within those lines.

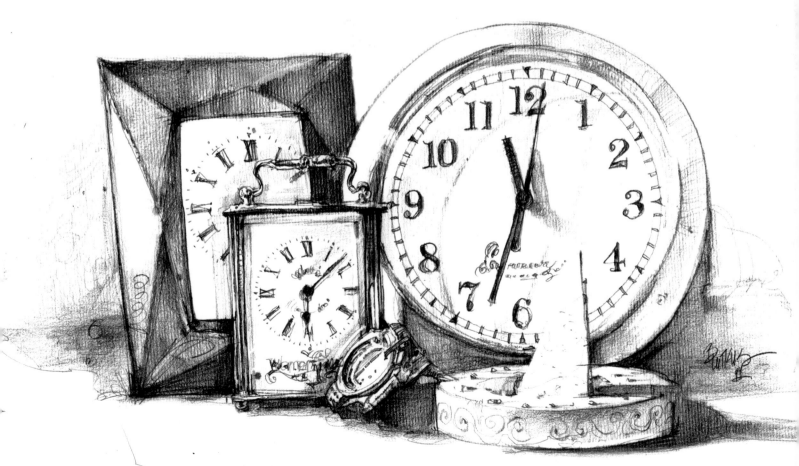

Time's Up You can create this piece by lightly roughing out the objects using rectangles and circles. Then refine the shapes and gently erase the initial guidelines.

STARTING WITH SKETCHES

Sketching is a wonderful method of quickly capturing an impression of a subject. Depending on the pencil lead and technique used, you can swiftly record a variety of shapes, textures, moods, and actions. For example, dark, bold strokes, can indicate strength and solidity; lighter, more feathered strokes can convey a sense of delicacy; and long, sweeping strokes can suggest movement. (See the examples below for a few common sketching techniques.) Some artists often make careful sketches to use as reference for more polished drawings later on, but loose sketches are also a valuable method of practice and a means of artistic expression, as the examples on these pages show. You might want to experiment with different strokes and sketching styles. With each new exercise, your hand will become quicker and more skilled.

Recording Your Impressions
Here are examples of a few pages that might be found in an artist's sketchbook. Along with sketching interesting things you see, make notes about the mood, colors, light, time of day—anything that might be helpful when you refer back to them. It's a good idea to carry a pad and pencil with you at all times, because you never know when you will come across an interesting subject you'd like to sketch.

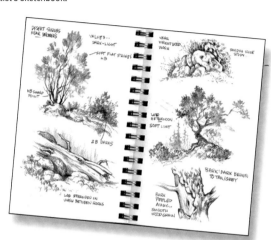

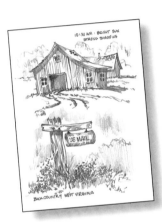

Using Circular Strokes Loose, circular strokes are great for quickly recording simple subjects or for working out a still life arrangement, as shown in this example. Just draw the basic shapes of the objects and indicate the shadows cast by the objects; don't pay attention to rendering details at this point. Notice how much looser these lines are compared to the examples from the sketchbook at right.

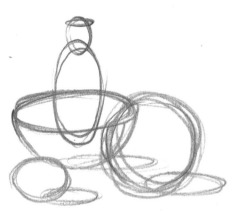

Scribbling Free, scribbled lines can also be used to capture the general shapes of objects such as clouds, treetops, or rocks. Use a soft B lead pencil with a broad tip to sketch the outlines of the clouds; then roughly scribble in a suggestion of shadows, hardly ever lifting your pencil from the drawing paper. Note how this technique effectively conveys the puffy, airy quality of the clouds.

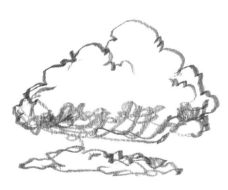

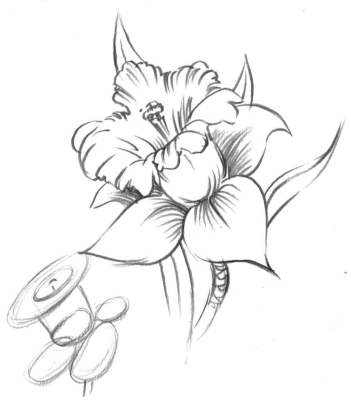

Using Wide, Bold Strokes This method is used for creating rough textures and deep shadows, making it ideal for subjects such as foliage and hair and fur textures. For this example, use the side of a 2B pencil, varying the pressure on the lead and changing the pencil angle to produce different values (lights and darks) and line widths. This creates the realistic form and rough texture of a sturdy shrub.

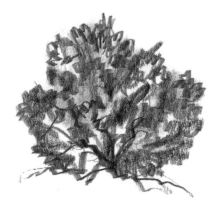

Sketching for Reference Material Here is an example of using a rough sketch as a source of reference for a more detailed drawing. Use loose, circular strokes to record an impression of the flower's general shape, keeping your lines light and soft to reflect the delicate nature of the subject. Then use the sketch as a guide for the more fully rendered flower above.

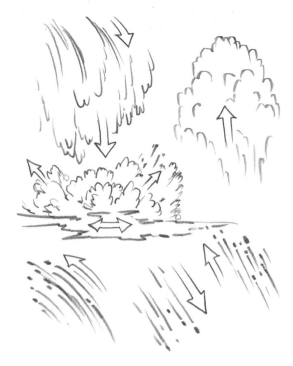

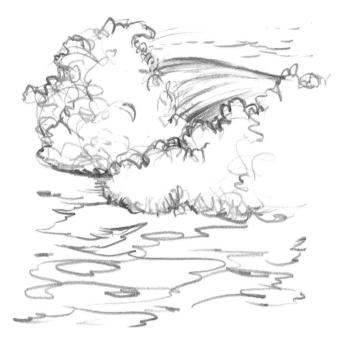

Conveying Movement To show movement in a drawing, you need to fool the viewer's eye and make it appear as if the object is moving up, down, or sideways. In the examples above, the arrows indicate the direction of movement—but your pencil strokes should actually be made in the opposite direction. Press down at the beginning of each stroke to get a strong line, lifting your pencil at the end to taper it off. Note how these lines convey the upward and downward direction of water and the rising and billowing movement of smoke.

Rendering Wave Action Quickly sketch a wave, using long, flowing strokes to indicate the arcing movement of the crest, and make tightly scribbled lines for the more random motions of the water as it breaks and foams. As in the examples at left, your strokes should taper off in the direction opposite the movement of the wave. Also sketch in a few meandering lines in the foreground to depict the slower movement of the pooled water as it flows and recedes.

FOCUSING ON THE NEGATIVE SPACE

Sometimes it's easier to draw the area *around* an object instead of drawing the object itself. The area around and between objects is called the "negative space." (The actual objects are the "positive space.") If an object appears to be too complex or if you are having trouble "seeing" it, try focusing on the negative space instead. At first it will take some effort, but if you squint your eyes, you'll be able to blur the details so you see only the negative and positive spaces. You'll find that when you draw the negative shapes around an object, you're also creating the edges of the object at the same time. The examples below are simple demonstrations of how to draw negative space. Select some objects in your home and place them in a group, or go outside and look at a clump of trees or a group of buildings. Try sketching the negative space, and notice how the objects seem to emerge almost magically from the shadows!

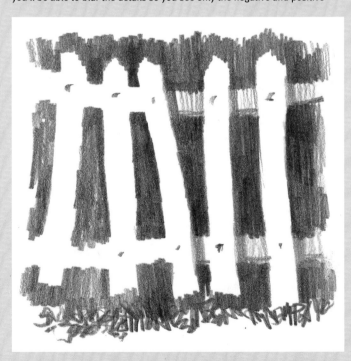

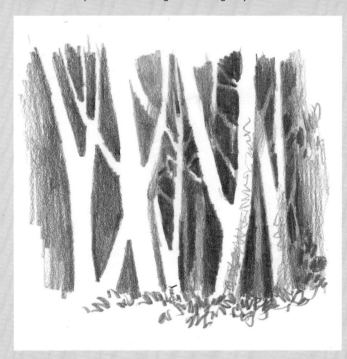

Filling In Create the white picket fence by filling in the negative spaces around the slats. Don't draw the slats—instead draw the shapes surrounding them and then fill in the shapes with the side of a soft lead pencil. Once you establish the shape of the fence, refine the sketch a bit by adding some light shading on the railings.

Silhouetting This stand of trees is a little more complicated than the fence, but having sketched the negative spaces simplified it immensely. The negative shapes between the tree trunks and among the branches are varied and irregular, which adds a great deal of interest to the drawing.

LEARNING TO SEE

Many beginners draw without really looking carefully at their subject; instead of drawing what they *actually* see, they draw what they *think* they see. Try drawing something you know well, such as your hand, without looking at it. Chances are your finished drawing won't look as realistic as you expected. That's because you drew what you *think* your hand looks like. Instead, you need to forget about all your preconceptions and learn to draw only what you really see in front of you (or in a photo). Two great exercises for training your eye to see are contour drawing and gesture drawing.

PENCILING THE CONTOURS

In *contour drawing*, pick a starting point on your subject and then draw only the contours—or outlines—of the shapes you see. Because you're not looking at your paper, you're training your hand to draw the lines exactly as your eye sees them. Try doing some contour drawings of your own; you might be surprised at how well you're able to capture the subjects.

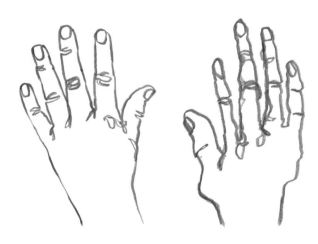

Drawing "Blind" The contour drawing above can be made while occasionally looking down at the paper while you draw your hand. The drawing on the right is an example of a blind contour drawing, where you can draw without looking at your paper even once. It will be a little distorted, but it's clearly your hand. Blind contour drawing is one of the best ways of making sure you're truly drawing only what you see.

Drawing with a Continuous Line
When drawing a sketch like the one of this man pushing a wheelbarrow, glance only occasionally at your paper to check that you are on track, but concentrate on really looking at the subject and tracing the outlines you see. Instead of lifting your pencil between shapes, keep the line unbroken by freely looping back and crossing over your lines. Notice how this simple technique effectively captures the subject.

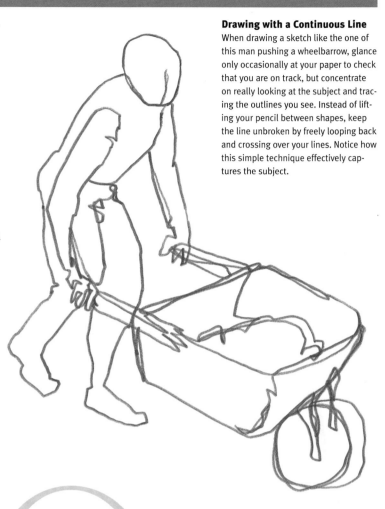

To test your observation skills, study an object very closely for a few minutes, and then close your eyes and try drawing it from memory, letting your hand follow the mental image.

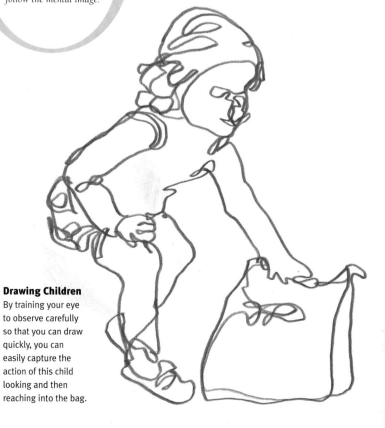

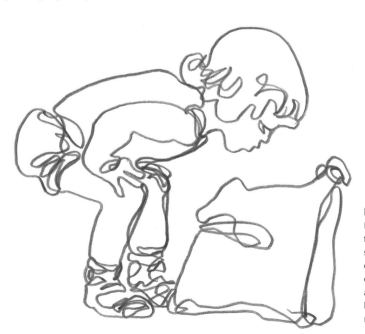

Drawing Children
By training your eye to observe carefully so that you can draw quickly, you can easily capture the action of this child looking and then reaching into the bag.

DRAWING GESTURE AND ACTION

Another way to train your eye to see the essential elements of a subject—and train your hand to record them rapidly—is through *gesture drawing*. Instead of rendering the contours, gesture drawings establish the *movement* of a figure. First determine the main thrust of the movement, from the head, down the spine, and through the legs; this is the *line of action*, or *action line*. Then briefly sketch the general shapes of the figure around this line. These quick sketches are great for practicing drawing figures in action and sharpening your powers of observation. (See pages 134–137 for more on drawing people in action.)

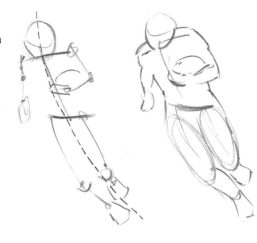

Starting with an Action Line Once you've established the line of action, try building a "skeleton" stick drawing around it. Pay particular attention to the angles of the shoulders, spine, and pelvis. Then sketch in the placement of the arms, knees, and feet and roughly fill out the basic shapes of the figure.

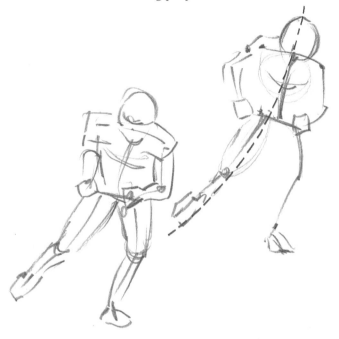

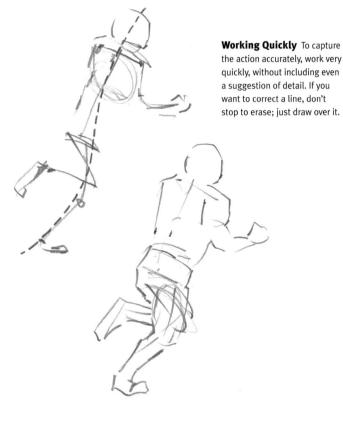

Working Quickly To capture the action accurately, work very quickly, without including even a suggestion of detail. If you want to correct a line, don't stop to erase; just draw over it.

Studying Repeated Action Group sports provide a great opportunity for practicing gesture drawings and learning to see the essentials. Because the players keep repeating the same action, you can observe each movement closely and keep it in your memory long enough to sketch it correctly.

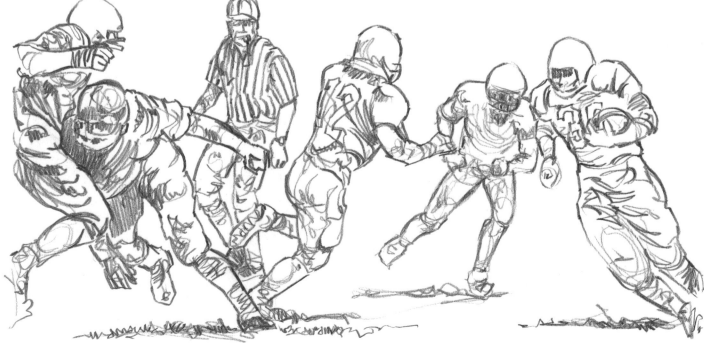

Drawing a Group in Motion Once you compile a series of gesture drawings, you can combine them into a scene of people in action, like the one above.

15

BEGINNING WITH BASIC SHAPES

Anyone can draw just about anything by simply breaking down the subject into the few basic shapes: circles, rectangles, squares, and triangles. By drawing an outline around the basic shapes of your subject, you've drawn its shape. But your subject also has depth and dimension, or *form*. As you learned on pages 9–10, the corresponding forms of the basic shapes are spheres, cylinders, cubes, and cones. For example, a ball and a grapefruit are spheres, a jar and a tree trunk are cylinders, a box and a building are cubes, and a pine tree and a funnel are cones. That's all there is to the first step of every drawing: sketching the shapes and developing the forms. After that, it's essentially just connecting and refining the lines and adding details.

Creating Forms Here are diagrams showing how to draw the forms of the four basic shapes. The ellipses show the backs of the circle, cylinder, and cone, and the cube is drawn by connecting two squares with parallel lines. (How to shade these forms is shown on page 10.)

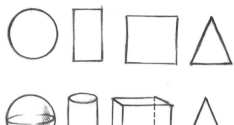

Sphere *Cylinder* *Cube* *Cone*

Combining Shapes Here is an example of beginning a drawing with basic shapes. Start by drawing each line of action (see page 15); then build up the shapes of the dog and the chick with simple ovals, circles, rectangles, and triangles.

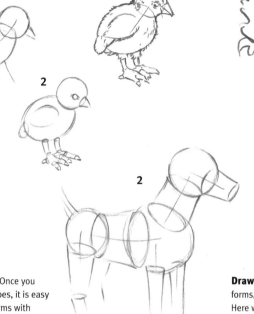

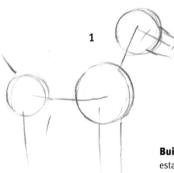

Building Form Once you establish the shapes, it is easy to build up the forms with cylinders, spheres, and cones. Notice that the subjects are now beginning to show some depth and dimension.

Drawing Through *Drawing through* means drawing the complete forms, including the lines that will eventually be hidden from sight. Here when the forms were drawn, the back side of the dog and chick were indicated. Even though you can't see that side in the finished drawing, the subject should appear three-dimensional. To finish the drawing, simply refine the outlines and add a little fluffy texture to the downy chick.

HOLDING YOUR DRAWING PENCIL

Basic Underhand The basic underhand position allows your arm and wrist to move freely, which results in fresh and lively sketches. Drawing in this position makes it easy to use both the point and the side of the lead by simply changing your hand and arm angle.

Underhand Variation Holding the pencil at its end lets you make very light strokes, both long and short. It also gives you a delicate control of lights, darks, and textures. Place a protective "slip sheet" under your hand when you use this position so you don't smudge your drawing.

Writing The writing position is the most common one, and it gives you the most control for fine detail and precise lines. Be careful not to press too hard on the point, or you'll make indentations in the paper. And remember not to grip the pencil too tightly, as your hand may get cramped.

SEEING THE SHAPES AND FORMS

Now train your eye and hand by practicing drawing objects around you. Set up a simple still life—like the one on page 11 or the arrangement below—and look for the basic shapes in each object. Try drawing from photographs, or copy the drawings on this page. Don't be afraid to tackle a complex subject; once you've reduced it to simple shapes, you can draw anything!

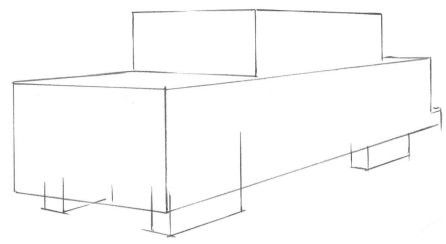

STEP ONE Begin with squares and a circle, and then add ellipses to the jug and sides to the book. Notice that the whole apple is drawn, not just the part that will be visible. That's another example of drawing through.

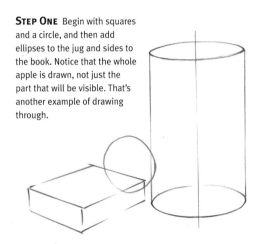

STEP ONE Even a complex form such as this '51 Ford is easy to draw if you begin with the most basic shapes you see. At this stage, ignore all the details and draw only squares and rectangles. These are only guidelines, which you can erase when your drawing is finished, so draw lightly and don't worry about making perfectly clean corners.

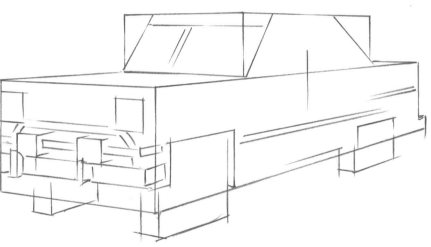

STEP TWO Next add an ellipse for the body of the jug, a cone for the neck, and a cylinder for the spout. Also pencil in a few lines on the sides of the book, parallel to the top and bottom, to begin developing its form.

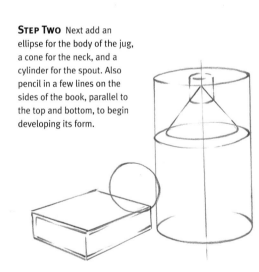

STEP TWO Using those basic shapes as a guide, start adding more squares and rectangles for the headlights, bumper, and grille. Start to develop the form of the windshield with angled lines, and then sketch in a few straight lines to place the door handle and the side detail.

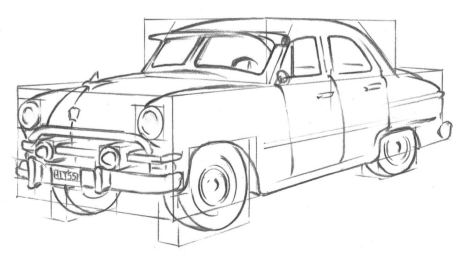

STEP THREE Finally refine the outlines of the jug and apple, and then round the book spine and the corners of the pages. Once you're happy with your drawing, erase all the initial guidelines, and your drawing is complete.

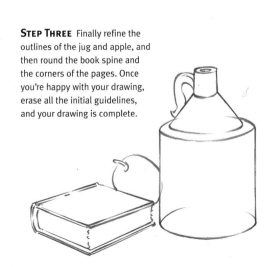

STEP THREE Once you have all the major shapes and forms established, begin rounding the lines and refining the details to conform to the car's design. Your guidelines are still in place here, but as a final step, you can clean up the drawing by erasing the extraneous lines.

DEVELOPING FORM

Values tell us even more about a form than its outline does. Values are the lights, darks, and all the shades in between that make up an object. In pencil drawing, the values range from white to grays to black, and it's the range of values in shading and highlighting that gives a three-dimensional look to a two-dimensional drawing. Focus on building dimension in your drawings by modeling forms with lights and darks.

DRAWING CAST SHADOWS

Cast shadows are important in drawing for two reasons. First, they anchor the image, so it doesn't seem to be floating in air. Second, they add visual interest and help link objects together. When drawing a cast shadow, keep in mind that its shape will depend on the light source as well as on the shape of the object casting it. For example, as shown below, a sphere casts a round or elliptical shadow on a smooth surface, depending on the angle of the light source. The length of the shadow is also affected: the lower the light source, the longer the shadow.

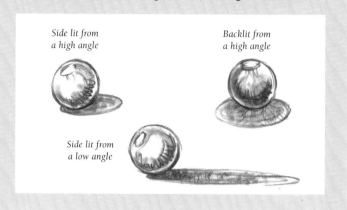

Side lit from a high angle

Backlit from a high angle

Side lit from a low angle

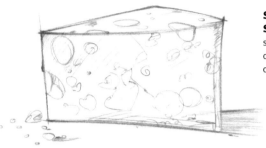

Sketching the Shapes First lightly sketch the basic shape of this angular wedge of cheese.

Laying in Values Here the light is coming from the left, so the cast shadows fall to the right. Lightly shade in the middle values on the side of the cheese, and place the darkest values in holes where the light doesn't hit.

UNDERSTANDING LIGHT AND SHADOWS

To develop a three-dimensional form, you need to know where to place the light, dark, and medium values of your subject. This will all depend on your light source. The angle, distance, and intensity of the light will affect both the shadows on an object (called "form shadows") and the shadows the object throws on other surfaces (called "cast shadows"; see the box above). You might want to practice drawing form and cast shadows on a variety of round and angular objects, lighting them with a bright, direct lamp so the highlights and shadows will be strong and well-defined.

Highlighting Either "save" the white of your paper for the brightest highlights or "retrieve" them by picking them out with an eraser or painting them on with white gouache.

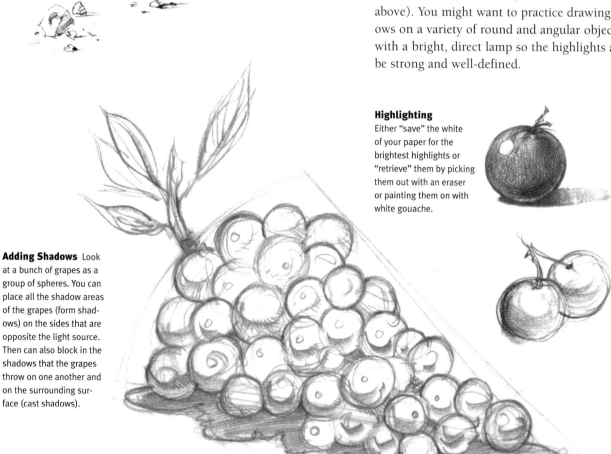

Adding Shadows Look at a bunch of grapes as a group of spheres. You can place all the shadow areas of the grapes (form shadows) on the sides that are opposite the light source. Then can also block in the shadows that the grapes throw on one another and on the surrounding surface (cast shadows).

Shading Shade in the middle value of these grapes with a couple of swift strokes using the side of a soft lead pencil. Then increase the pressure on your pencil for the darkest values, and leave the paper white for the lights.

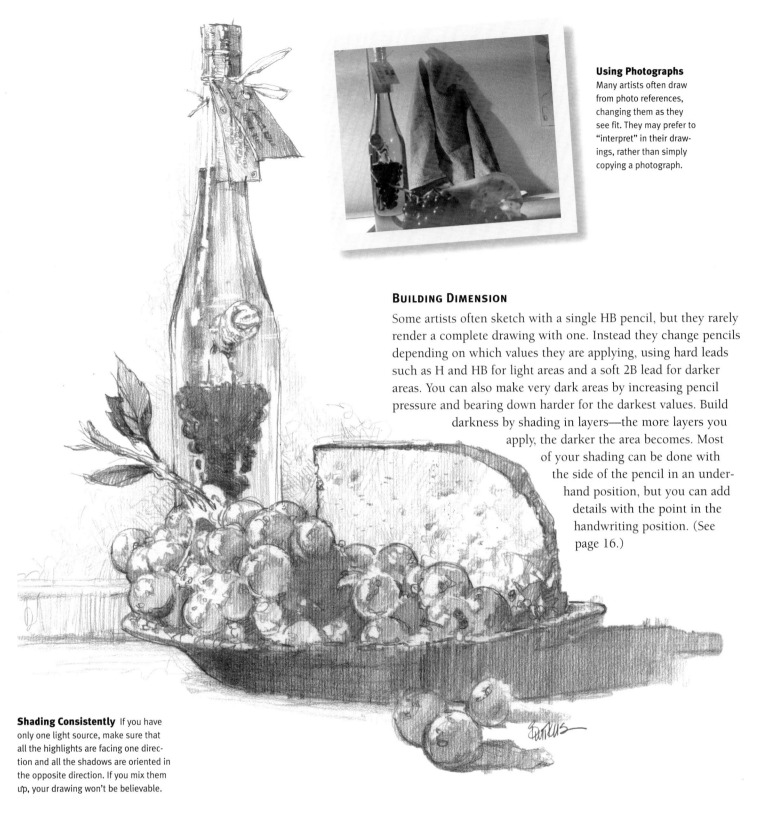

Using Photographs
Many artists often draw from photo references, changing them as they see fit. They may prefer to "interpret" in their drawings, rather than simply copying a photograph.

Building Dimension

Some artists often sketch with a single HB pencil, but they rarely render a complete drawing with one. Instead they change pencils depending on which values they are applying, using hard leads such as H and HB for light areas and a soft 2B lead for darker areas. You can also make very dark areas by increasing pencil pressure and bearing down harder for the darkest values. Build darkness by shading in layers—the more layers you apply, the darker the area becomes. Most of your shading can be done with the side of the pencil in an underhand position, but you can add details with the point in the handwriting position. (See page 16.)

Shading Consistently If you have only one light source, make sure that all the highlights are facing one direction and all the shadows are oriented in the opposite direction. If you mix them up, your drawing won't be believable.

Getting to Know Your Subject Quick, "thumbnail" sketches are invaluable for developing a drawing. You can use them to play with the positioning, format, and cropping until you find an arrangement you like. These aren't finished drawings by any means, so you can keep them rough. And don't get too attached to them—they're meant to be changed.

INTRODUCTION TO STILL LIFES

Still life drawings offer a great opportunity to learn and practice a variety of drawing skills, including developing form, applying shading, and using perspective. Still life compositions traditionally depict a carefully arranged grouping of a number of household objects, such as fruit, vegetables, glassware, or pottery—all of which offer a wide range of textures, sizes, and shapes. But you don't have to restrict yourself to traditional items; use your artistic license to get as creative as you want! The following lessons will guide you through the basics of drawing still lifes, from designing the composition to blocking in the basic shapes and adding the final details for depth and texture.

FRUIT AND NUTS BY WILLIAM F. POWELL

Study your subject closely, and lightly sketch the simple shapes. (Notice, for example, that the pear is made up of two circles—one large and one small.) Once the basic shapes are drawn, begin shading with strokes that are consistent with the subjects' rounded forms, as shown in the final drawings.

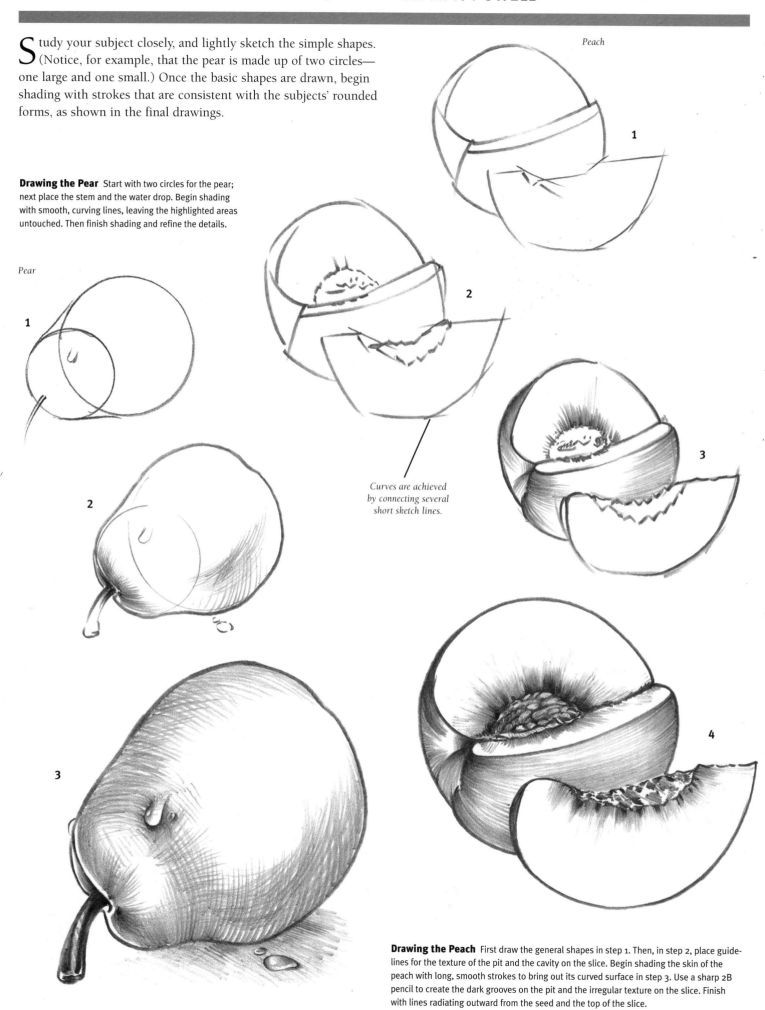

Peach

Pear

Drawing the Pear Start with two circles for the pear; next place the stem and the water drop. Begin shading with smooth, curving lines, leaving the highlighted areas untouched. Then finish shading and refine the details.

Curves are achieved by connecting several short sketch lines.

Drawing the Peach First draw the general shapes in step 1. Then, in step 2, place guidelines for the texture of the pit and the cavity on the slice. Begin shading the skin of the peach with long, smooth strokes to bring out its curved surface in step 3. Use a sharp 2B pencil to create the dark grooves on the pit and the irregular texture on the slice. Finish with lines radiating outward from the seed and the top of the slice.

Drawing the Cherry To start the cherry, lightly block in the round shape and the stem, using a combination of short sketch lines. Smooth the sketch lines into curves, and add the indentation for the stem. Then begin light shading in step 3. Continue shading until the cherry appears smooth. Use the tip of a kneaded eraser to remove any shading or smears that might have gotten into the highlights. Then fill in the darker areas using overlapping strokes, changing stroke direction slightly to give the illusion of three-dimensional form to the shiny surface.

Cherry

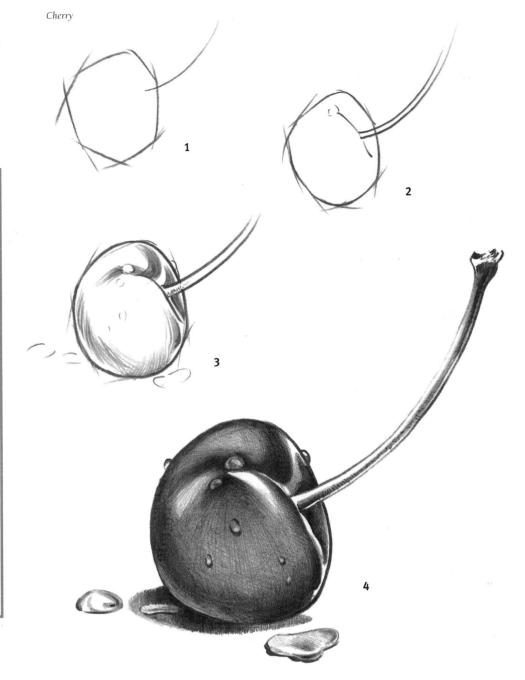

1

2

3

4

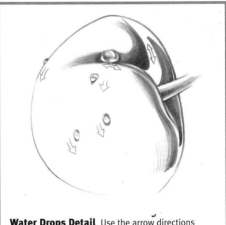

Water Drops Detail Use the arrow directions shown above as a guide for shading the cherry according to its contour. Leave light areas for the water drops, and shade inside them, keeping the values soft.

1 2

Pools of Water Detail Sketch the outline shape of the pool of water with short strokes, as you did with the cherry. Shade softly, and create highlights with a kneaded eraser.

Rendering the Chestnuts To draw these chestnuts, use a circle and two intersecting lines to make a cone shape in steps 1 and 2. Then place some guidelines for ridges in step 3. Shade the chestnuts using smooth, even strokes that run the length of the objects. These strokes bring out form and glossiness. Finally add tiny dots on the surface. Make the cast shadow the darkest part of the drawing.

Chestnuts

1 2 3 4

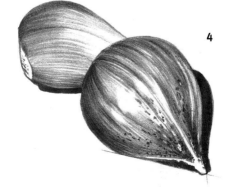

STRAWBERRIES BY WILLIAM F. POWELL

These strawberries were drawn on plate-finish Bristol board using only an HB pencil. Block in the berry's overall shape in steps 1 and 2 to the right. Then lightly shade the middle and bottom in step 3, and scatter a seed pattern over the berry's surface in step 4. Once the seeds are in, shade around them.

1

2

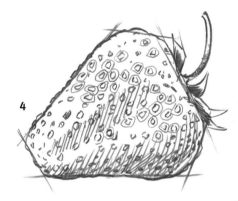

3

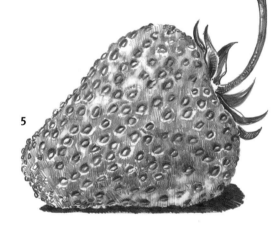

4

Drawing Guidelines Draw a grid on the strawberry; it appears to wrap around the berry, helping to establish its seed pattern and three-dimensional form.

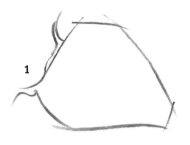

1

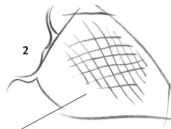

2

Sketch a grid for the surface pattern.

3

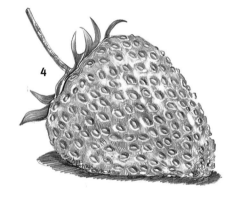

4

5

Developing Highlights and Shadows It's important to shade properly around the seeds, creating small circular areas that contain both light and dark. Also develop highlights and shadows on the overall berry to present a realistic, uneven surface.

1

2

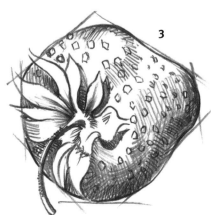

3

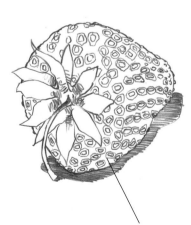

Indicate the shaded areas by lightly drawing circles around the seeds as guides.

PINEAPPLE BY WILLIAM F. POWELL

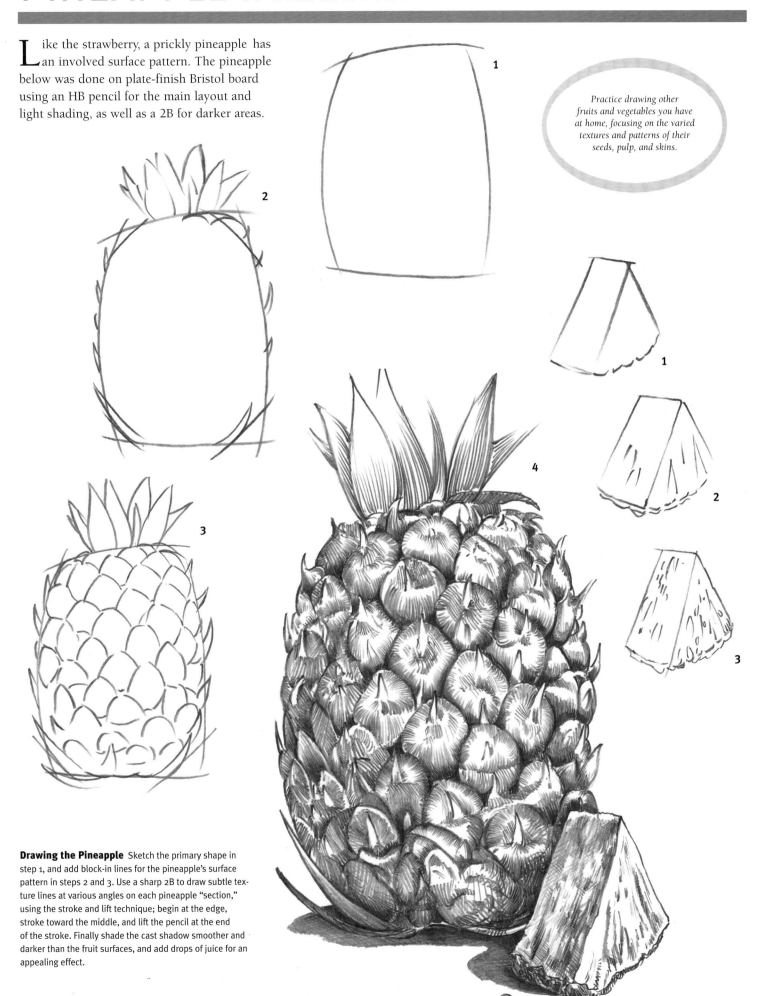

Like the strawberry, a prickly pineapple has an involved surface pattern. The pineapple below was done on plate-finish Bristol board using an HB pencil for the main layout and light shading, as well as a 2B for darker areas.

Practice drawing other fruits and vegetables you have at home, focusing on the varied textures and patterns of their seeds, pulp, and skins.

Drawing the Pineapple Sketch the primary shape in step 1, and add block-in lines for the pineapple's surface pattern in steps 2 and 3. Use a sharp 2B to draw subtle texture lines at various angles on each pineapple "section," using the stroke and lift technique; begin at the edge, stroke toward the middle, and lift the pencil at the end of the stroke. Finally shade the cast shadow smoother and darker than the fruit surfaces, and add drops of juice for an appealing effect.

PINECONE BY WILLIAM F. POWELL

Compare the highly textured surface pattern of the pinecone with the strawberry and pineapple on pages 24–25. Using an HB pencil, position the pinecone with light guidelines in step 1. Then indicate the tree trunk and pine needles in step 2, and add a grid for the pattern on the pinecone.

1

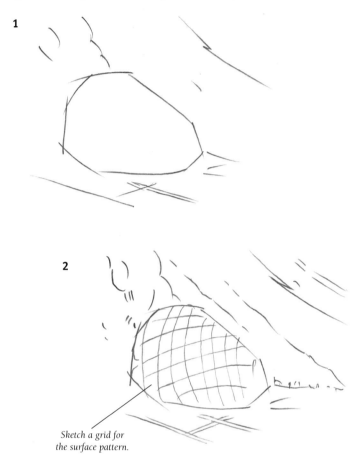

2

Sketch a grid for the surface pattern.

3

4

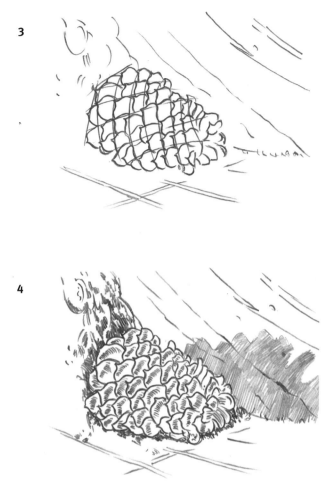

Establishing Detail Draw the shapes of the spiked scales, which change in size from one end of the cone to the other. In step 4, begin shading the cone and surrounding objects. Make the cast shadow appear to follow the curve of the tree root.

5

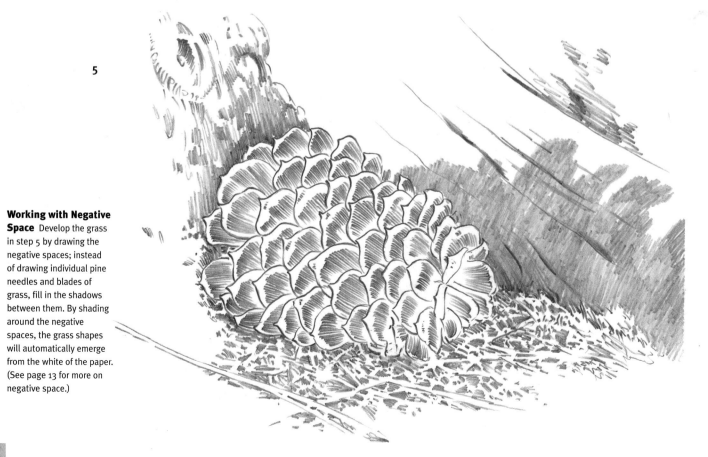

Working with Negative Space Develop the grass in step 5 by drawing the negative spaces; instead of drawing individual pine needles and blades of grass, fill in the shadows between them. By shading around the negative spaces, the grass shapes will automatically emerge from the white of the paper. (See page 13 for more on negative space.)

DEVELOPING DETAILS

Tree Texture Guidelines To render the bark and knothole of the gnarled tree trunk, first lightly draw in the texture design. Then, when you're happy with the general appearance, proceed with the shading.

Tree Texture Shading Short, rough strokes give the impression of texture, whereas long, smooth strokes provide interest and contrast. Use a combination of the two strokes to provide the bark's shading and details.

Pinecone Scale Shading Develop each pinecone scale separately, following the arrows on the diagram above for the direction of your strokes. Keep the hatched strokes smooth and close together.

6

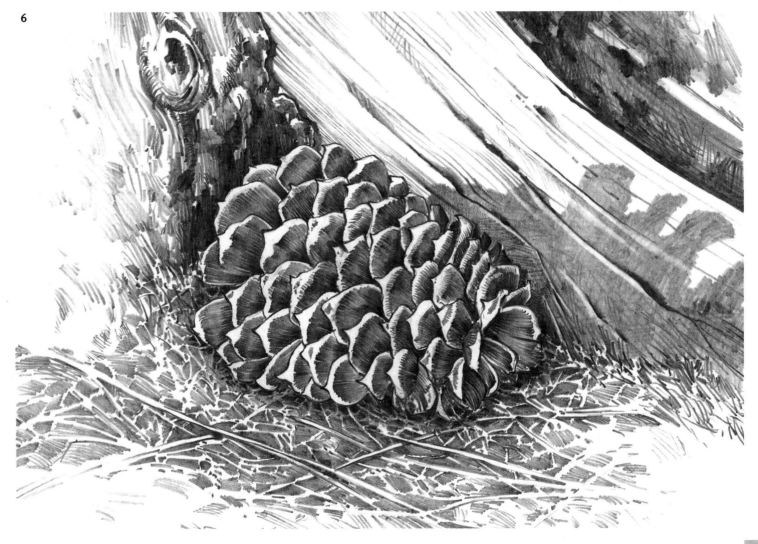

CANDLELIGHT BY WILLIAM F. POWELL

This drawing was done on plate-finish Bristol board with HB and 2B pencils. The pewter-and-glass candlestick, painting, and paintbrushes were arranged on a table; then a quick sketch was made to check the composition, as shown in step 1.

1

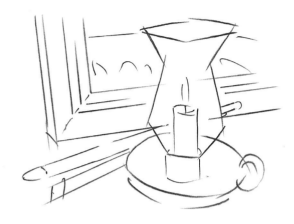

Blocking In the Composition When setting up a still life, keep rearranging the items until the composition suits you. If you're a beginner, you might want to keep the number of objects to a minimum—three to five elements is a good number to start with.

2

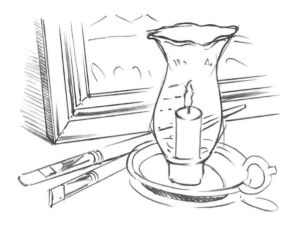

Developing Shape and Form In step 2, place all the guidelines of your subjects; then begin shading with several layers of soft, overlapping strokes in step 3. Gradually develop the dark areas rather than all at the same time.

3

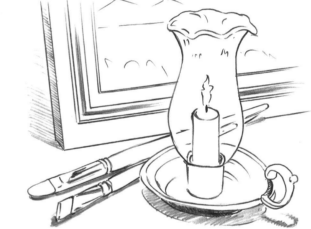

4

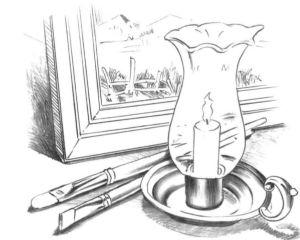

Flame Detail A candle flame isn't difficult to draw. Just make a simple outline, keep all shading soft, and make the wick the darkest part. Be sure to leave white area in the candle top to suggest a glow.

1 **2**

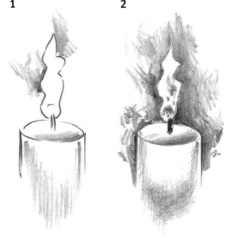

5

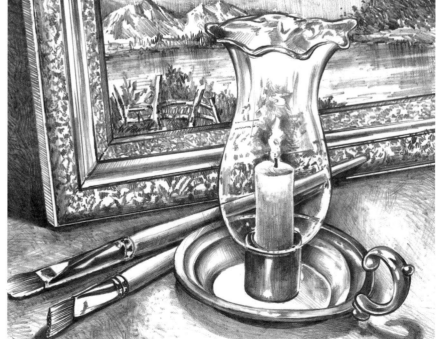

FLORAL ARRANGEMENT BY WILLIAM F. POWELL

By varying your techniques, you become a more versatile artist. Therefore this drawing was drawn more loosely than the previous one. Begin with an HB pencil, lightly drawing in the basic shapes within the floral arrangement.

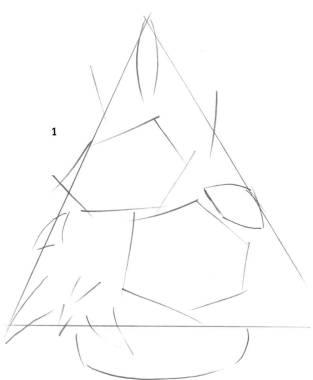

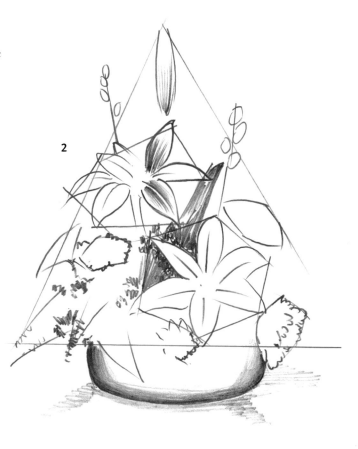

Sketching Loosely This rendering was finished using a loose, sketchy technique. Sometimes this type of final can be more pleasing than a highly detailed one.

Establishing the Shading The sketch above shows shading strokes for the flower petals and leaves. Try not to add too much detail at this stage of your drawing.

Blending the Cast Shadows As shown in the close-up above, the cast shadow needs the smoothest blending. Position the shadows using the side of an HB pencil; then blend softly with a paper stump.

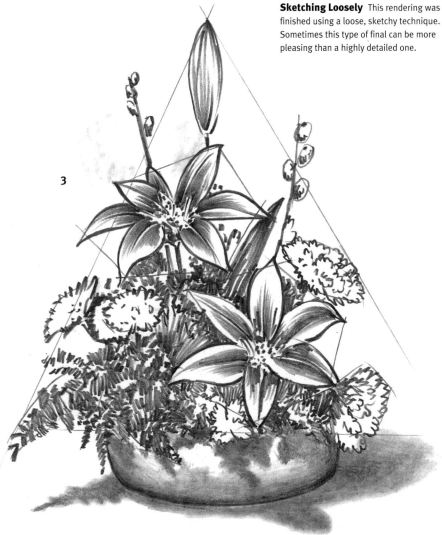

LIQUID AND GLASS BY WILLIAM F. POWELL

This drawing was done on Bristol board with a plate (smooth) finish. Use an HB pencil for most of the work and a 2B for the dark shadows. A flat sketch pencil is good for creating the background texture.

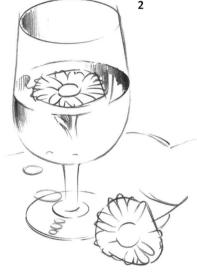

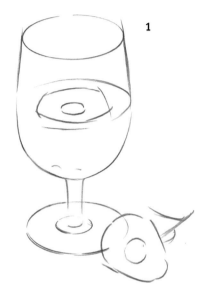

Starting Out In step 1, sketch the basic shapes of the glass, liquid, and flowers. In step 2, add more details, and begin shading the glass and liquid areas. Take your time, and try to make the edges clean.

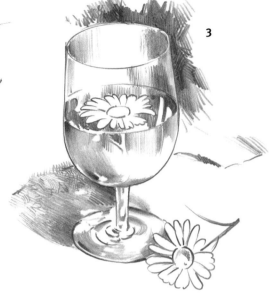

Developing the Background Use the flat lead of a sketching pencil for the background, making the background darker than the cast shadows. Note the pattern of lights and darks that can be found in the cast shadow.

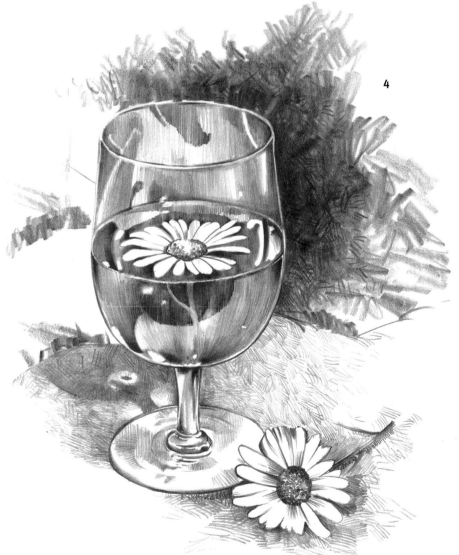

Placing Highlights Use the arrows below as a guide for shading. Remember to keep the paper clean where you want your lightest lights. These highlights help to suggest light coming through the glass stem, creating a transparent look.

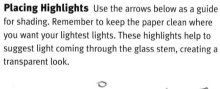

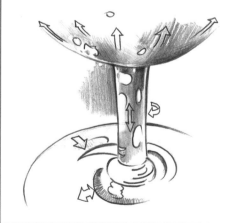

Finalizing Highlights and Shadows Use the finished drawing as your guide for completing lights and darks. If pencil smudges accidentally get in the highlights, clean them out with a kneaded eraser. Then use sharp-pointed HB and 2B pencils to add final details.

ROSE WITH WATERDROPS BY WILLIAM F. POWELL

Many beginning artists believe a rose is too difficult to draw and therefore may shy away from it. But, like any other object, a rose can be developed step by step from its most basic shapes.

4

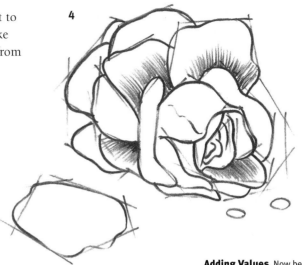

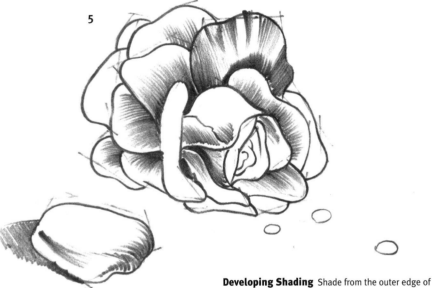

Adding Values Now begin shading. Stroke from inside each petal toward its outer edge.

1

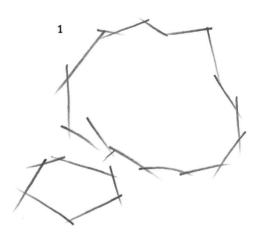

Establishing Guidelines Use an HB pencil to block in the overall shapes of the rose and petal, using a series of angular lines. Make all guidelines light so you won't have trouble removing or covering them later.

5

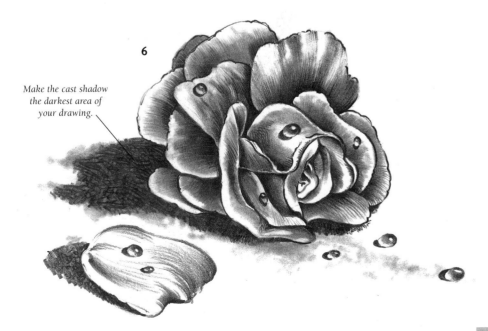

2

Following Through Continue adding guidelines for the flower's interior, following the angles of the petal edges.

Developing Shading Shade from the outer edge of each petal, meeting the strokes you drew in the opposite direction. Use what is known as a stroke and lift technique. For this technique, you should draw lines that gently fade at the end. Just press firmly, lifting the pencil as the stroke comes to an end.

3

6

Make the cast shadow the darkest area of your drawing.

SIMPLE FLOWERS BY WILLIAM F. POWELL

This morning glory and gardenia are great flowers for learning a few simple shading techniques called "hatching" and "cross-hatching." *Hatch* strokes are parallel diagonal lines; place them close together for dark shadows, and space them farther apart for lighter values. *Cross-hatch* strokes are made by first drawing hatch strokes and then overlapping them with hatch strokes that are angled in the opposite direction. Examples of both strokes are shown in the box at the bottom of the page.

Step One The gardenia is a little more complicated to draw than the morning glory, but you can still start the same way. With straight lines, block in an irregular polygon for the overall flower shape and add partial triangles for leaves. Then determine the basic shape of each petal and begin sketching in each, starting at the center of the gardenia.

Gardenia

Step One Look carefully at the overall shape of a morning glory and lightly sketch a polygon with the point of an HB pencil. From this three-quarter view, you can see the veins that radiate from the center, so sketch in five curved lines to place them. Then roughly outline the leaves and the flower base.

Morning Glory

Step Two As you draw each of the petal shapes, pay particular attention to where they overlap and to their proportions, or their size relationships—how big each is compared with the others and compared with the flower as a whole. Accurately reproducing the pattern of the petals is one of the most important elements of drawing a flower. Once all the shapes are laid in, refine their outlines.

Step Two Next draw the curved outlines of the flower and leaves, using the guidelines for placement. You can also change the pressure of the pencil on the paper to vary the line width, giving it a little personality. Then add the stamens in the center.

Step Three Again, using the side and blunt point of an HB pencil, shade the petals and the leaves, making your strokes follow the direction of the curves. Lift the pencil at the end of each petal stroke so the line tapers and lightens, and deepen the shadows with overlapping strokes in the opposite direction (called cross-hatching) with the point of a 2B pencil.

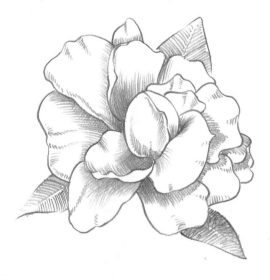

Step Three Now you are ready to add the shading. With the rounded point and side of an HB pencil, add a series of hatching strokes, following the shape, curve, and direction of the surfaces of the flower and leaves. For the areas more in shadow, make darker strokes placed closer together, using the point of a soft 2B pencil.

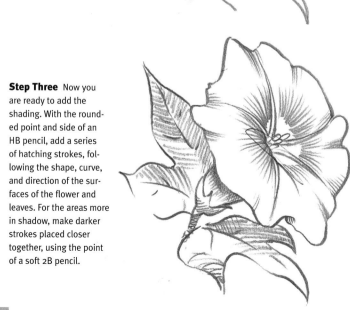

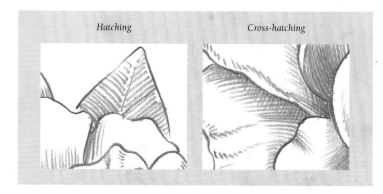

Hatching

Cross-hatching

FLORAL BOUQUET BY WILLIAM F. POWELL

I f you look carefully, you will see that although the roses resemble one another, each one has unique features, just as people do. If you make sure your drawing reflects these differences, your roses won't look like carbon copies of one another.

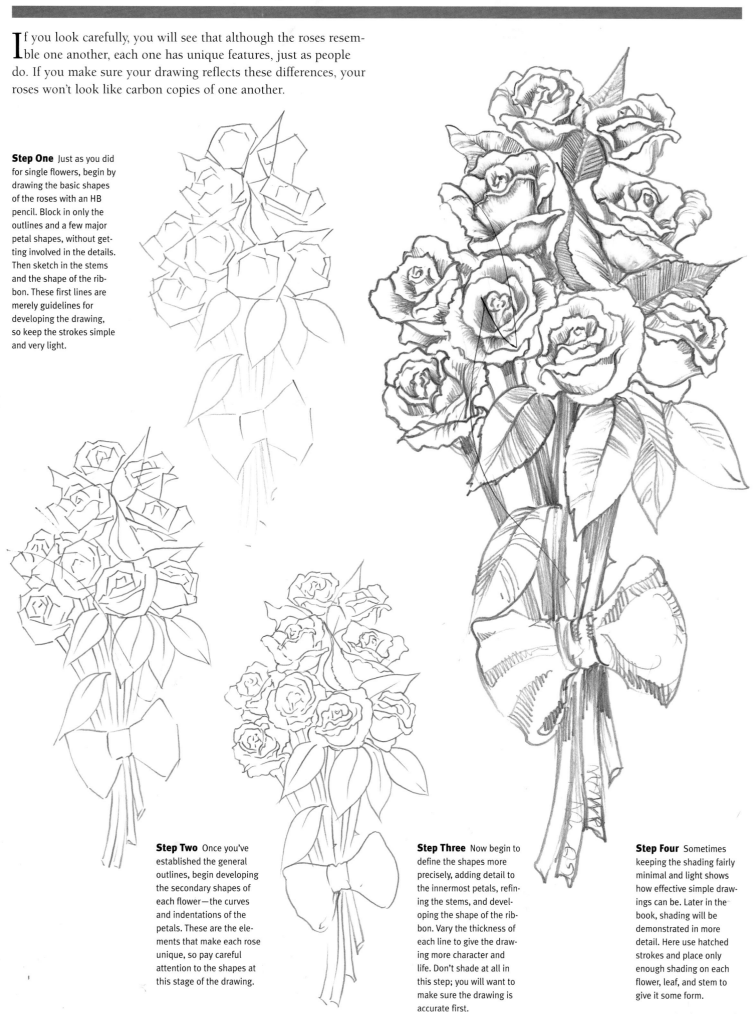

Step One Just as you did for single flowers, begin by drawing the basic shapes of the roses with an HB pencil. Block in only the outlines and a few major petal shapes, without getting involved in the details. Then sketch in the stems and the shape of the ribbon. These first lines are merely guidelines for developing the drawing, so keep the strokes simple and very light.

Step Two Once you've established the general outlines, begin developing the secondary shapes of each flower—the curves and indentations of the petals. These are the elements that make each rose unique, so pay careful attention to the shapes at this stage of the drawing.

Step Three Now begin to define the shapes more precisely, adding detail to the innermost petals, refining the stems, and developing the shape of the ribbon. Vary the thickness of each line to give the drawing more character and life. Don't shade at all in this step; you will want to make sure the drawing is accurate first.

Step Four Sometimes keeping the shading fairly minimal and light shows how effective simple drawings can be. Later in the book, shading will be demonstrated in more detail. Here use hatched strokes and place only enough shading on each flower, leaf, and stem to give it some form.

TULIPS BY WILLIAM F. POWELL

There are several classes of tulips with differently shaped flowers. The one below, known as a parrot tulip, has less of a cup than the tulip to the right and is more complex to draw. Use the layout steps shown here before drawing the details.

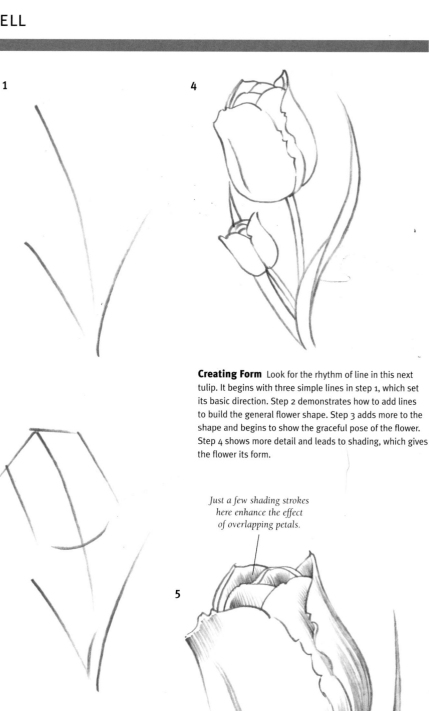

Creating Form Look for the rhythm of line in this next tulip. It begins with three simple lines in step 1, which set its basic direction. Step 2 demonstrates how to add lines to build the general flower shape. Step 3 adds more to the shape and begins to show the graceful pose of the flower. Step 4 shows more detail and leads to shading, which gives the flower its form.

Just a few shading strokes here enhance the effect of overlapping petals.

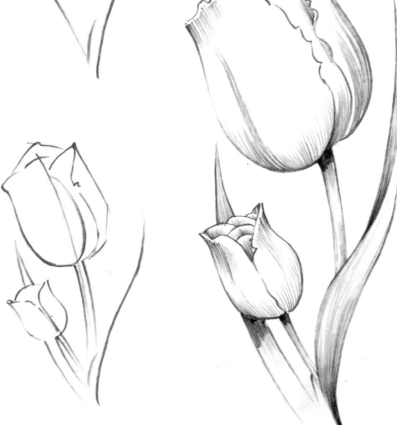

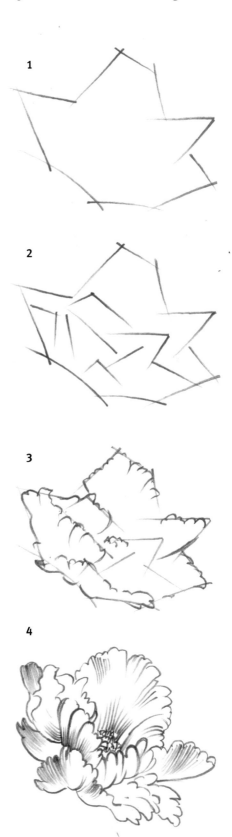

Drawing the Parrot Tulip Begin using straight lines from point to point to capture the major shape of the flower. Add petal angles in step 2. Then draw in actual petal shapes, complete with simple shading.

CARNATION BY WILLIAM F. POWELL

Carnation varieties range from deep red to bicolored to white. They are very showy and easy to grow in most gardens. They are also fun and challenging to draw because of their many overlaying petals. Shade them solid, variegated, or with a light or dark edge at the end of each petal.

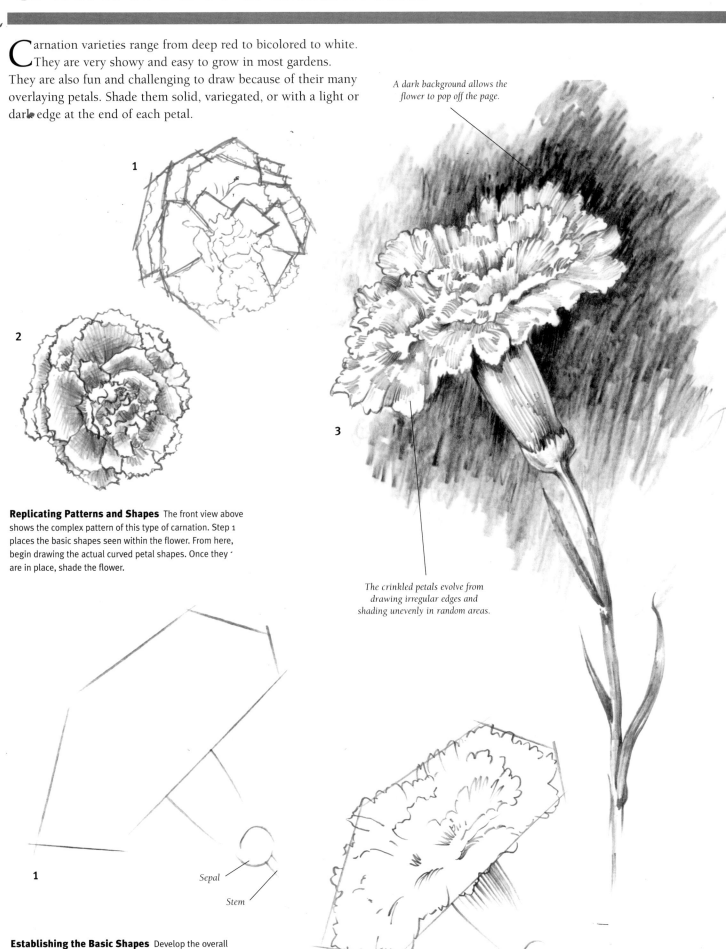

A dark background allows the flower to pop off the page.

The crinkled petals evolve from drawing irregular edges and shading unevenly in random areas.

Replicating Patterns and Shapes The front view above shows the complex pattern of this type of carnation. Step 1 places the basic shapes seen within the flower. From here, begin drawing the actual curved petal shapes. Once they are in place, shade the flower.

Sepal

Stem

Establishing the Basic Shapes Develop the overall shape of the side view, including the stem and sepal. Begin drawing the intricate flower details in step 2, keeping them light and simple.

PEONY BY WILLIAM F. POWELL

Peonies grow in single- and double-flowered varieties. They are a showy flower and make fine subjects for flower drawings.

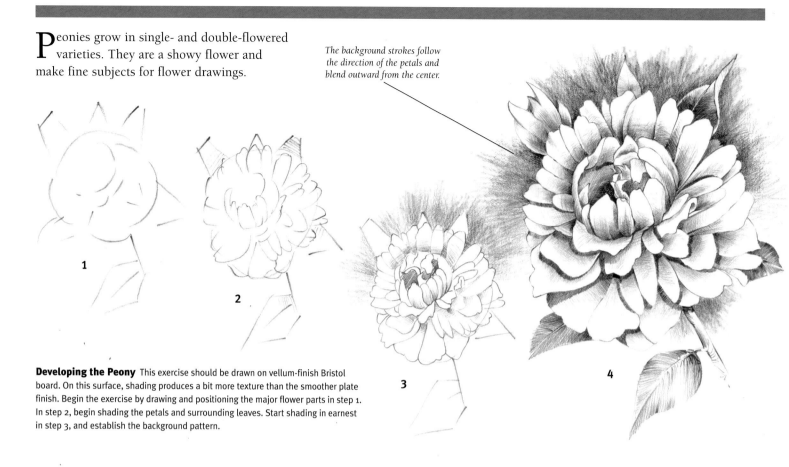

The background strokes follow the direction of the petals and blend outward from the center.

Developing the Peony This exercise should be drawn on vellum-finish Bristol board. On this surface, shading produces a bit more texture than the smoother plate finish. Begin the exercise by drawing and positioning the major flower parts in step 1. In step 2, begin shading the petals and surrounding leaves. Start shading in earnest in step 3, and establish the background pattern.

DOGWOOD BY WILLIAM F. POWELL

There are different varieties of dogwood. Below is an oriental type called the "kousa dogwood," and at the right is the American flowering dogwood. Both of their flowers vary from pure white to delicate pink. Follow the steps closely to draw them.

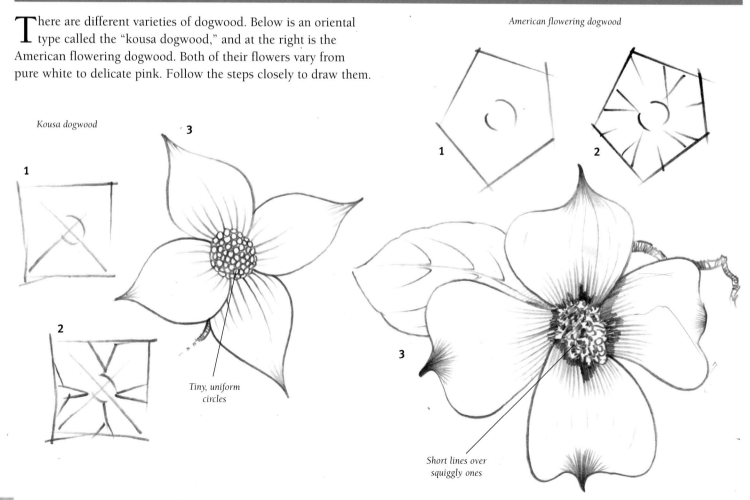

American flowering dogwood

Kousa dogwood

Tiny, uniform circles

Short lines over squiggly ones

REGAL LILY BY WILLIAM F. POWELL

Lilies are very fragrant, and the plants can grow up to 8 feet tall. Use the steps below to develop the flower, which you can attach to the main stem when drawing the entire plant, as shown at the bottom of the page.

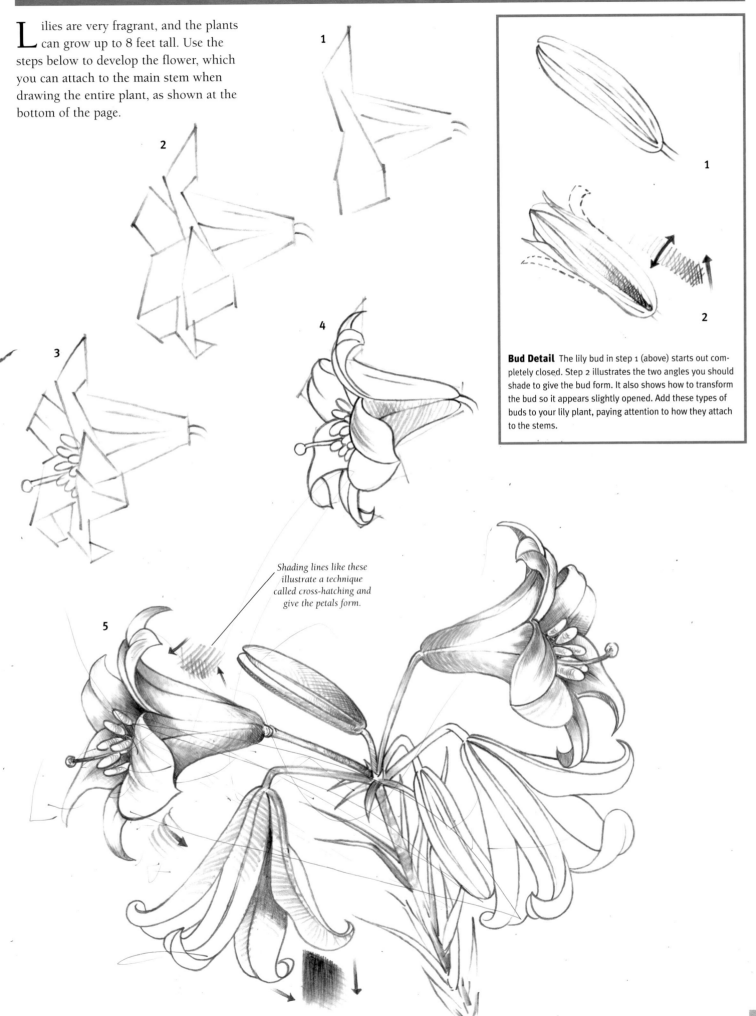

Bud Detail The lily bud in step 1 (above) starts out completely closed. Step 2 illustrates the two angles you should shade to give the bud form. It also shows how to transform the bud so it appears slightly opened. Add these types of buds to your lily plant, paying attention to how they attach to the stems.

Shading lines like these illustrate a technique called cross-hatching and give the petals form.

PRIMROSE BY WILLIAM F. POWELL

There are many primrose varieties with a wide range of colors. This exercise demonstrates how to draw a number of flowers and buds together. Take your time when placing them.

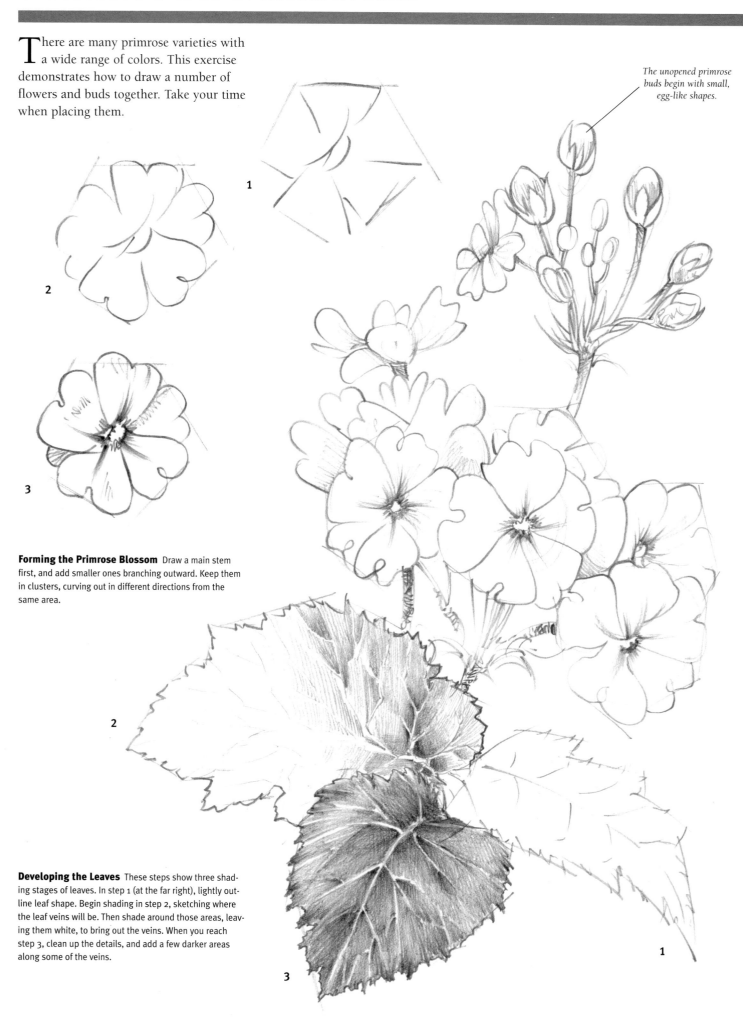

The unopened primrose buds begin with small, egg-like shapes.

Forming the Primrose Blossom Draw a main stem first, and add smaller ones branching outward. Keep them in clusters, curving out in different directions from the same area.

Developing the Leaves These steps show three shading stages of leaves. In step 1 (at the far right), lightly outline leaf shape. Begin shading in step 2, sketching where the leaf veins will be. Then shade around those areas, leaving them white, to bring out the veins. When you reach step 3, clean up the details, and add a few darker areas along some of the veins.

HIBISCUS BY WILLIAM F. POWELL

Hibiscus grow in single- and double-flowered varieties, and their colors include whites, oranges, pinks, and reds—even blues and purples. Some are multi- or bicolored. The example here is a single-flowered variety.

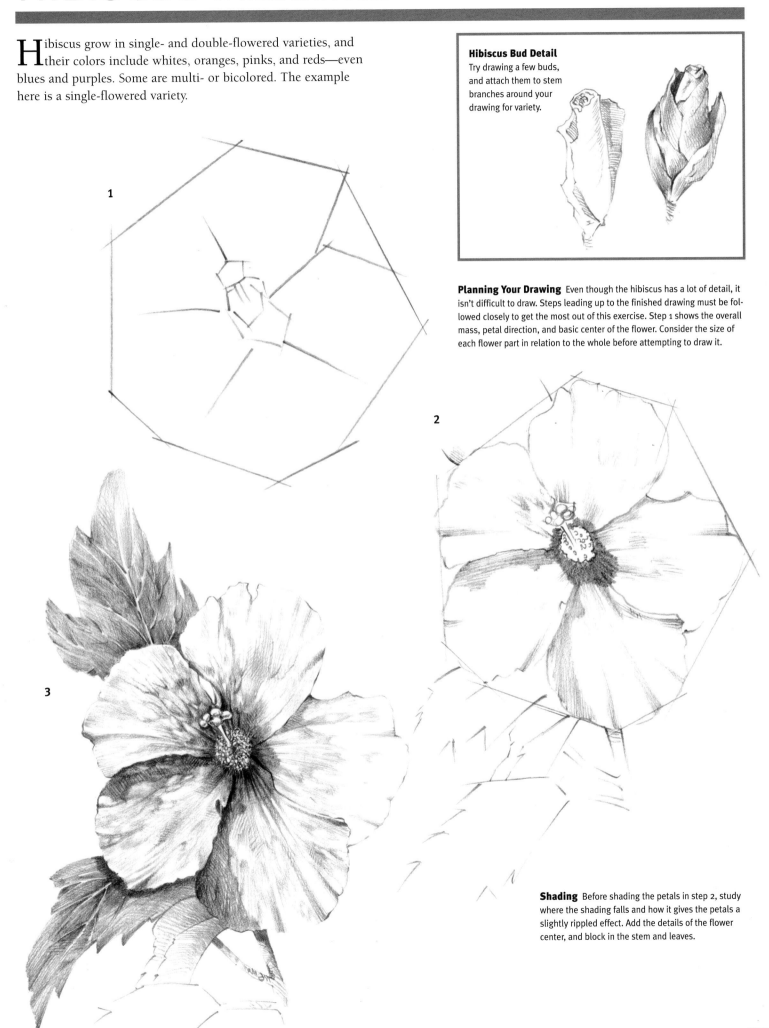

Hibiscus Bud Detail
Try drawing a few buds, and attach them to stem branches around your drawing for variety.

Planning Your Drawing Even though the hibiscus has a lot of detail, it isn't difficult to draw. Steps leading up to the finished drawing must be followed closely to get the most out of this exercise. Step 1 shows the overall mass, petal direction, and basic center of the flower. Consider the size of each flower part in relation to the whole before attempting to draw it.

Shading Before shading the petals in step 2, study where the shading falls and how it gives the petals a slightly rippled effect. Add the details of the flower center, and block in the stem and leaves.

HYBRID TEA ROSE BY WILLIAM F. POWELL

Hybrid tea roses have large blossoms with greatly varying colors. When drawing rose petals, think of each fitting into its own place in the overall shape; this helps position them correctly. Begin lightly with an HB pencil, and use plate-finish Bristol board.

Making Choices The block-in steps are the same no matter how you decide to finish the drawing, whether lightly outlined or completely shaded. For shading, use the side of a 2B pencil and blend with a paper stump.

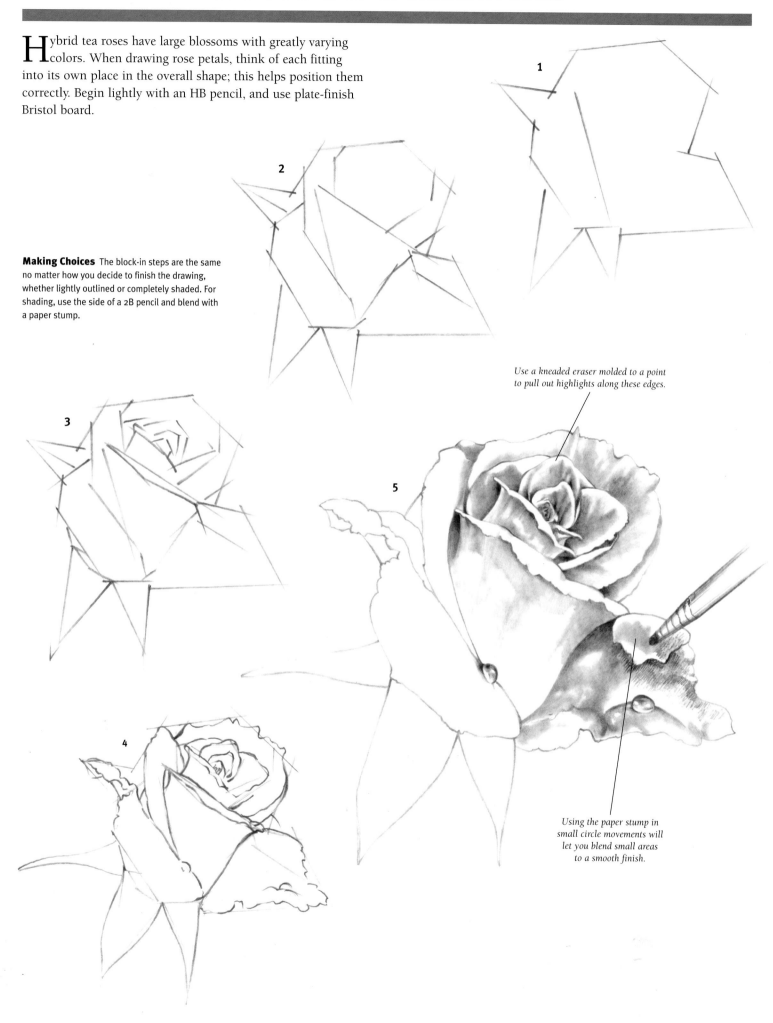

Use a kneaded eraser molded to a point to pull out highlights along these edges.

Using the paper stump in small circle movements will let you blend small areas to a smooth finish.

Floribunda Rose BY WILLIAM F. POWELL

Floribunda roses usually flower more freely than hybrid tea roses and grow in groups of blossoms. The petal arrangement in these roses is involved; but by studying it closely, you'll see an overlapping, swirling pattern.

Drawing the Rose Use a blunt-pointed HB pencil lightly on plate-finish Bristol board. Outline the overall area of the rose mass in step 1. Once this is done, draw the swirling petal design as shown in steps 2 and 3. Begin fitting the center petals into place in step 4. Use the side of an HB to shade as in step 5, being careful not to cover the water drops. They should be shaded separately.

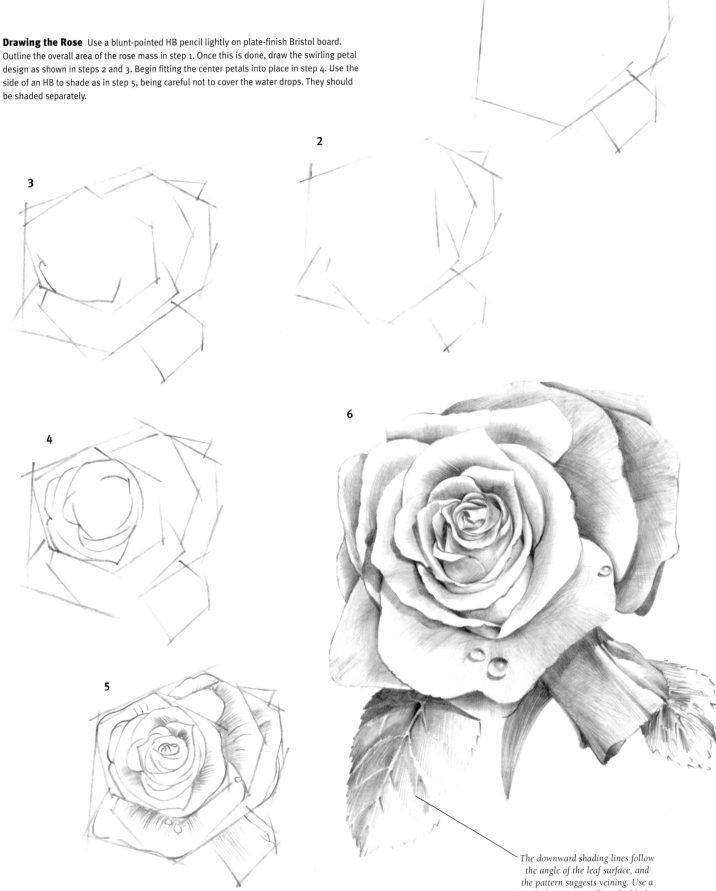

The downward shading lines follow the angle of the leaf surface, and the pattern suggests veining. Use a kneaded eraser to pull out highlights.

CHRYSANTHEMUMS BY WILLIAM F. POWELL

The two varieties of chrysanthemums on this page are the pompon and the Japanese anemone. The pompon chrysanthemum produces flowers one to two inches across that are more buttonlike than the larger, more globular types.

The Japanese anemone grows four inches or more across and produces flowers with irregular outlines that, in some cases, resemble forms of anemone sea life.

Follow the steps for each flower type, trying to capture the attitude and personality of each flower and petal formation. It's best to draw this exercise on plate-finish Bristol board using both HB and 2B pencils. Smooth bond paper also provides a good drawing surface.

Observe the difference in texture between the top of the Japanese anemone blossom below and its sides. The voluminous, bushy effect is achieved with many short, squiggly lines drawn in random directions, in contrast to the sloping lines of the lower petals.

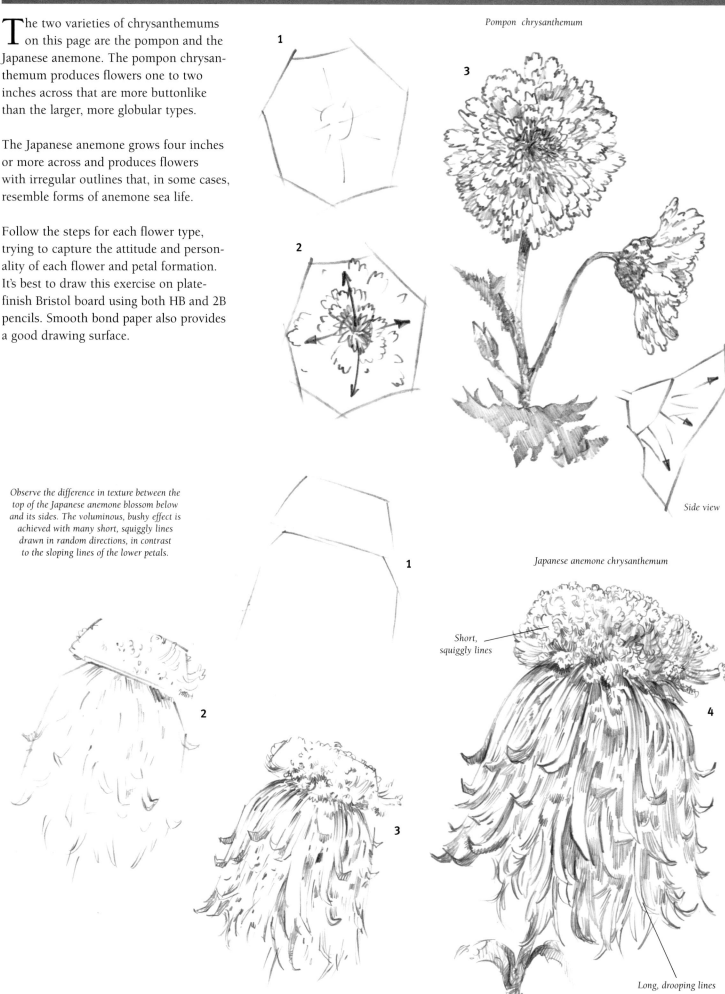

Pompon chrysanthemum

Side view

Japanese anemone chrysanthemum

Short, squiggly lines

Long, drooping lines

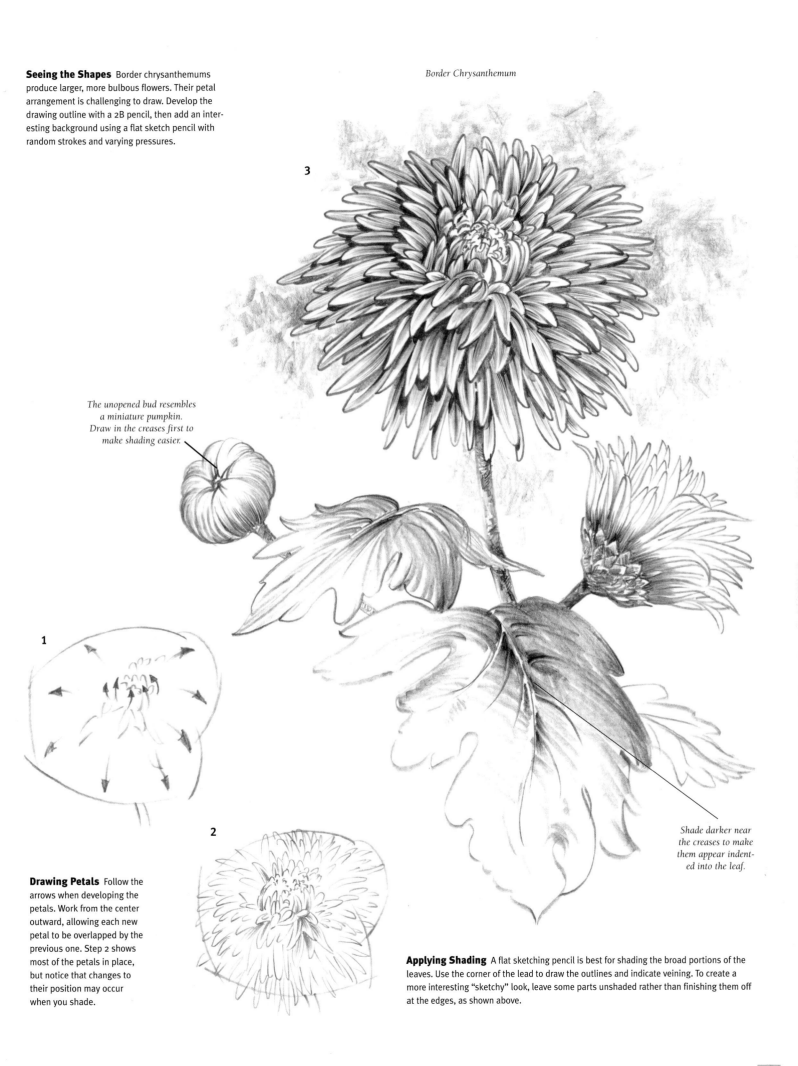

Seeing the Shapes Border chrysanthemums produce larger, more bulbous flowers. Their petal arrangement is challenging to draw. Develop the drawing outline with a 2B pencil, then add an interesting background using a flat sketch pencil with random strokes and varying pressures.

Border Chrysanthemum

3

The unopened bud resembles a miniature pumpkin. Draw in the creases first to make shading easier.

1

2

Drawing Petals Follow the arrows when developing the petals. Work from the center outward, allowing each new petal to be overlapped by the previous one. Step 2 shows most of the petals in place, but notice that changes to their position may occur when you shade.

Shade darker near the creases to make them appear indented into the leaf.

Applying Shading A flat sketching pencil is best for shading the broad portions of the leaves. Use the corner of the lead to draw the outlines and indicate veining. To create a more interesting "sketchy" look, leave some parts unshaded rather than finishing them off at the edges, as shown above.

BEARDED IRIS BY WILLIAM F. POWELL

The bearded iris is probably the most beautiful of the iris varieties. Its colors range from deep purples to blues, lavenders, and whites. Some flowers have delicate, lightly colored petals with dark veining. They range in height from less than a foot to over three feet.

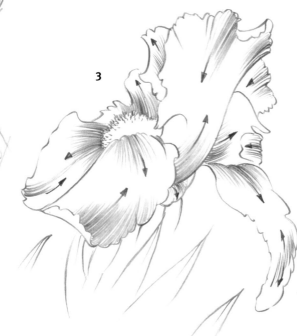

Beginning to Shade Follow the arrow directions in step 3 for blending and shading strokes; these strokes make the petal surfaces appear solid. Darken shadowed areas using the point of a 2B.

Using Guidelines Step 1 (above) shows the block-in lines for a side view of the iris, whereas step 1 (below) shows a frontal view. Whichever you choose to draw, make your initial outline shapes light, and use them as a general guide for drawing the graceful curves of this flower's petals.

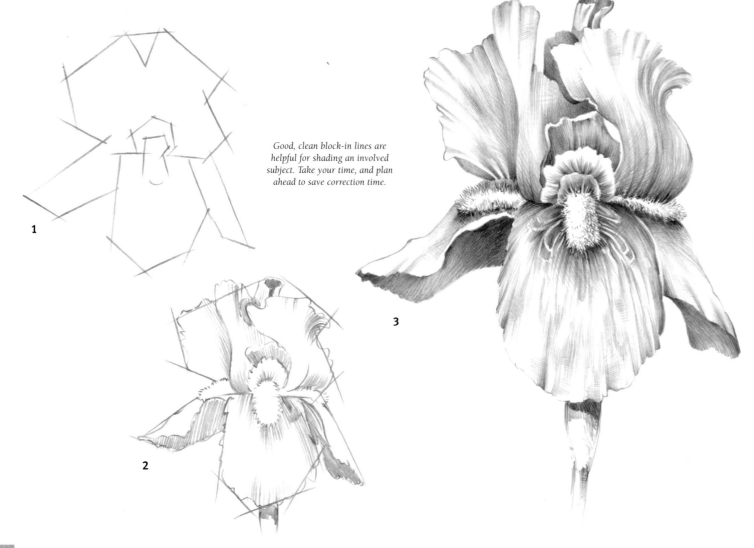

Good, clean block-in lines are helpful for shading an involved subject. Take your time, and plan ahead to save correction time.

Focusing on Details This final drawing is quite involved, but it's no more difficult than the previous drawings. It just has more flowers and shading steps. Once again, we must first draw the overall layout of the flowers before attempting any shading.

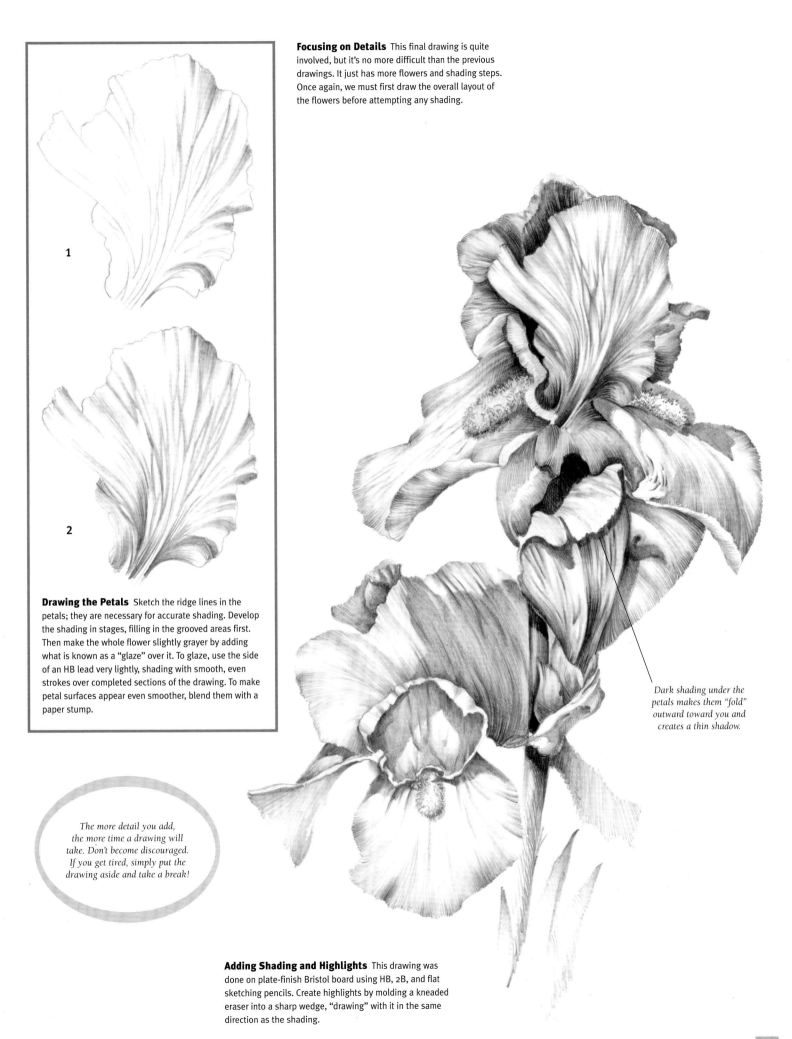

1

2

Drawing the Petals Sketch the ridge lines in the petals; they are necessary for accurate shading. Develop the shading in stages, filling in the grooved areas first. Then make the whole flower slightly grayer by adding what is known as a "glaze" over it. To glaze, use the side of an HB lead very lightly, shading with smooth, even strokes over completed sections of the drawing. To make petal surfaces appear even smoother, blend them with a paper stump.

The more detail you add, the more time a drawing will take. Don't become discouraged. If you get tired, simply put the drawing aside and take a break!

Dark shading under the petals makes them "fold" outward toward you and creates a thin shadow.

Adding Shading and Highlights This drawing was done on plate-finish Bristol board using HB, 2B, and flat sketching pencils. Create highlights by molding a kneaded eraser into a sharp wedge, "drawing" with it in the same direction as the shading.

STILL LIFE COMPOSITION BY WILLIAM F. POWELL

Creating a good still life composition is simply arranging the elements of a drawing in such a way that they make an eye-pleasing, harmonious scene. It's easy to do once you have a few guidelines to follow. The most important things to keep in mind are: (1) choosing a format that fits the subject, (2) establishing a center of interest and a line of direction that carries the viewer's eye into and around the picture, and (3) creating a sense of depth by overlapping objects, varying the values, and placing elements on different planes. Like everything else, the more you study and practice forming pleasing compositions, the better you'll become.

ARRANGING A STILL LIFE

Composing still lifes is a great experience because you select the lighting, you place the elements where you like, and the objects don't move! Begin by choosing the items to include, and then try different groupings, lighting, and backgrounds. Test out the arrangements in small, quick thumbnails, like the ones shown below. These studies are invaluable for working out the best possible composition.

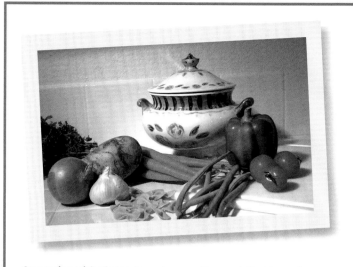

Composing with Photos Dynamic compositions rarely "just happen"—most are well planned, with objects specifically selected and arranged in an appealing manner to create good flow and depth. Taking snapshots of your arrangements will help you see how your setups will look when they're drawn on a flat surface.

SELECTING A FORMAT

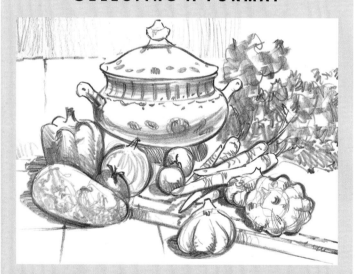

Horizontal Format The "landscape" format is a traditional one, perfect for drawing indoor or outdoor scenes. Here, as in any good composition, the overlapping vegetables lead the viewer's eye around the picture and toward the focal point—the tureen. Even the tile pattern points the way into the picture and toward the focal point.

Vertical Format In this "portrait" format, the carrot tops add height to the composition and counterbalance the arc of vegetables in the foreground. The tip of the head of garlic and the angle of the beans lead the viewer into the composition and toward the focal point. In the background, only a suggestion of shadows are drawn, and the vertical tiles are not clearly defined. This adds to the upward flow of the entire composition and keeps the viewer's attention focused on the tureen.

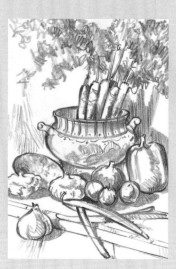

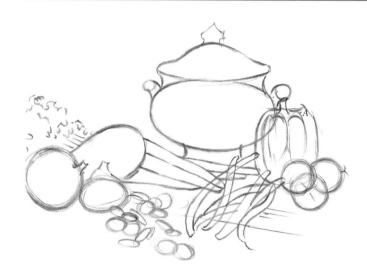

Step One From your thumbnail sketches, choose a horizontal format. Notice that the tureen is set off-center; if the focal point were dead center, your eye wouldn't be led around the whole drawing, which would make a boring composition. Then lightly block in the basic shapes with mostly loose, circular strokes, using your whole arm to keep the lines free.

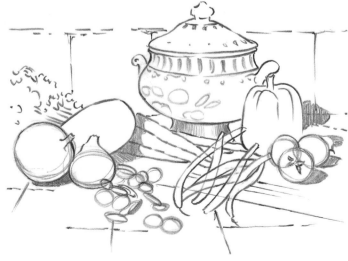

Step Two Next refine the shapes of the various elements, still keeping your lines fairly light to avoid creating harsh edges. Then, using the side of an HB pencil, begin indicating the cast shadows, as well as some of the details on the tureen.

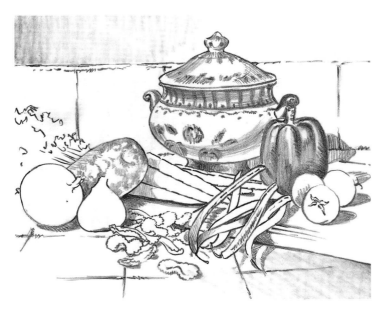

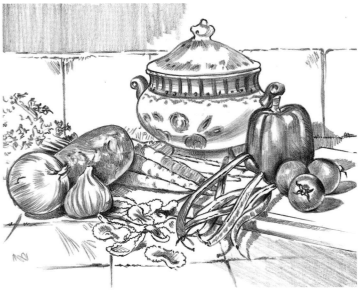

Step Three Continue adding details on the tureen and darkening the cast shadows. Then start shading some of the objects to develop their forms. You might want to begin with the bell pepper and the potato, using the point and side of an HB pencil.

Step Four Next build the forms of the other vegetables, using a range of values and shading techniques. To indicate the paper skins of the onion and the garlic, make strokes that curve with their shapes. For the rough texture of the potato, use more random strokes.

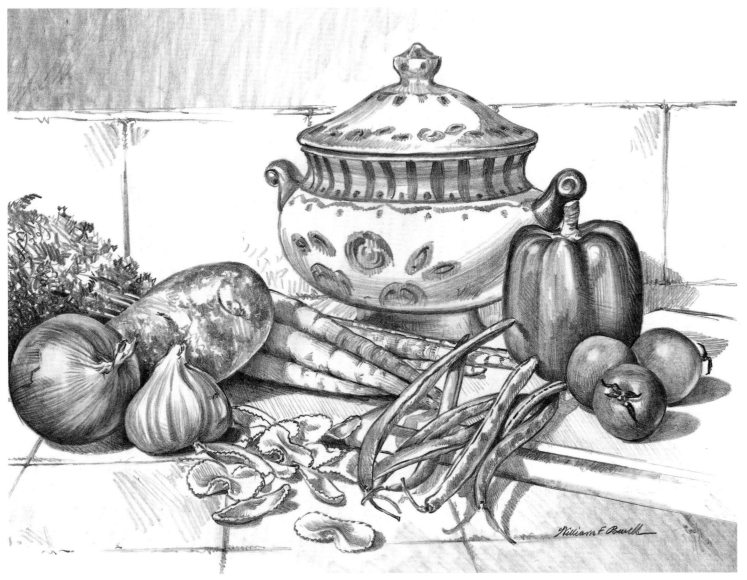

Step Five When you are finished developing the light, middle, and dark values, use a 2B pencil for the darkest areas in the cast shadows (the areas closest to the objects casting the shadows).

REFLECTIONS AND LACE BY WILLIAM F. POWELL

The shiny surface of a highly polished, silver creamer is perfect for learning to render reflective surfaces. For this exercise, use plate-finish Bristol board, HB and 2B pencils, and a kneaded eraser molded into a point. Begin by lightly drawing in the basic shapes of the egg and creamer.

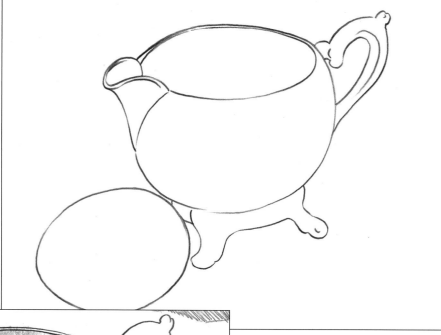

Step One Begin by lightly blocking in the basic shapes of the egg and the creamer. Don't go on to the next step until you're happy with the shapes and the composition.

Step Two Once the two central items are in place, establish the area for the lace, and add light shading to the table surface. Next position the reflection of the lace and egg on the creamer's surface. Begin lightly shading the inside and outside surfaces of the creamer, keeping in mind that the inside is not as reflective or shiny. Then start lightly shading the eggshell.

Step Three At this stage, smooth the shading on the egg and creamer with a paper stump. Then study how the holes in the lace change where the lace wrinkles and then settles back into a flat pattern. Begin drawing the lace pattern using one of the methods described on the opposite page.

You might often find objects for your still life drawings in the most unexpected places. Combine objects you believe aren't related, and they might surprise you by creating an appealing still life.

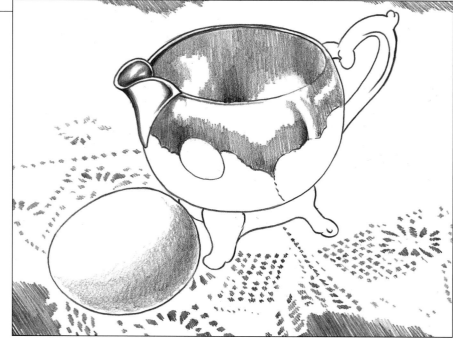

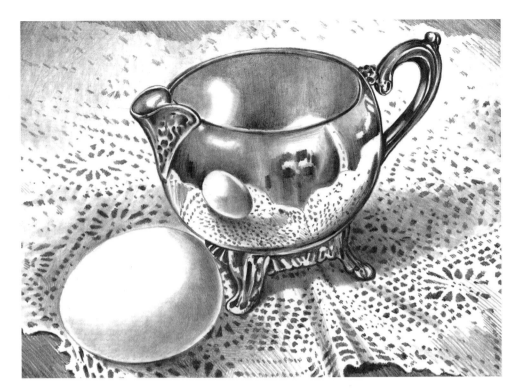

Step Four In the final drawing, pay close attention to the reflected images because they are key to successfully rendering the objects. Interestingly the egg's position in the reflection is completely different than its actual position on the table because in the reflection we see the back side of the egg.

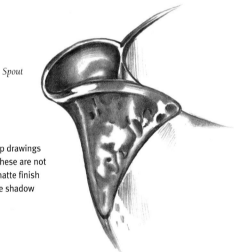

Spout

Foot and Spout Details These two close-up drawings show detail on the creamer's spout and feet. These are not as shiny as the rounded bowl. Re-create this matte finish by blending the edges and making the concave shadow patterns darker and sharper.

Foot

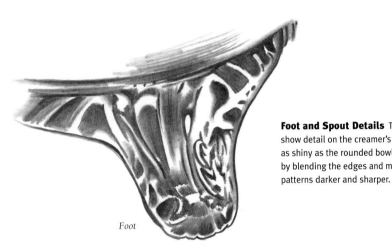

Lace Pattern Detail The drawings above show two approaches for creating the lace pattern. You can draw guidelines for each hole and then shade inside them (left), or you can lightly shade in the shape of each hole (right). Either way, you are drawing the negative shapes. (See page 13.) Once the pattern is established, shade over the areas where you see shadows, along with subtle shadows cast within most of the holes. Make the holes in the foreground darker than those receding into the composition, but keep them lighter than the darkest areas on the creamer. After this preliminary shading is completed, add details of dark and light spots on the lace.

BOTTLE AND BREAD BY WILLIAM F. POWELL

This exercise was drawn on vellum-finish Bristol board with an HB pencil. Vellum finish has a bit more "tooth" than the smoother plate finish does, resulting in darker pencil marks.

The simplest items in your kitchen can be gathered up into an inviting scene.

1

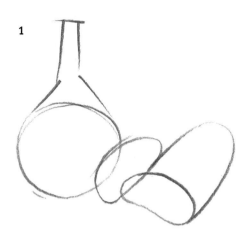

2

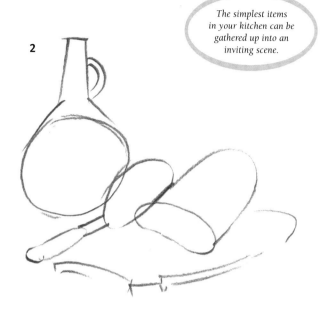

Paying Attention to Detail In the close-up examples below, the guidelines show the distorted wine level, which is caused by the bottle's uneven curves. An artist must make important observations like this in order to create natural, true-to-life drawings.

1

Blocking In the Composition Begin lightly sketching the wine bottle, bread loaf, knife, and cutting board, roughing in the prominent items first, then adding the remaining elements in step 2. Continue refining the shapes in step 3, and then indicate the placement for the backdrop.

3

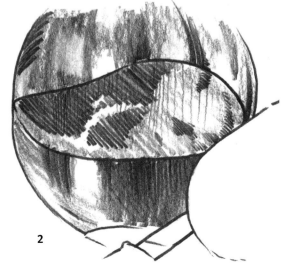

2

4

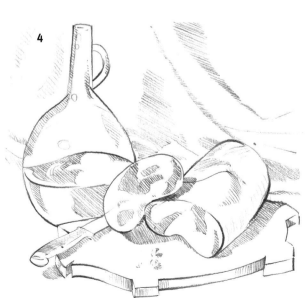

Placing Highlights and Shadows Lightly outline where the highlights will be so you don't accidentally fill them in with pencil. Now add shadows with uniform diagonal strokes. Use vertical strokes on the sides of the cutting board.

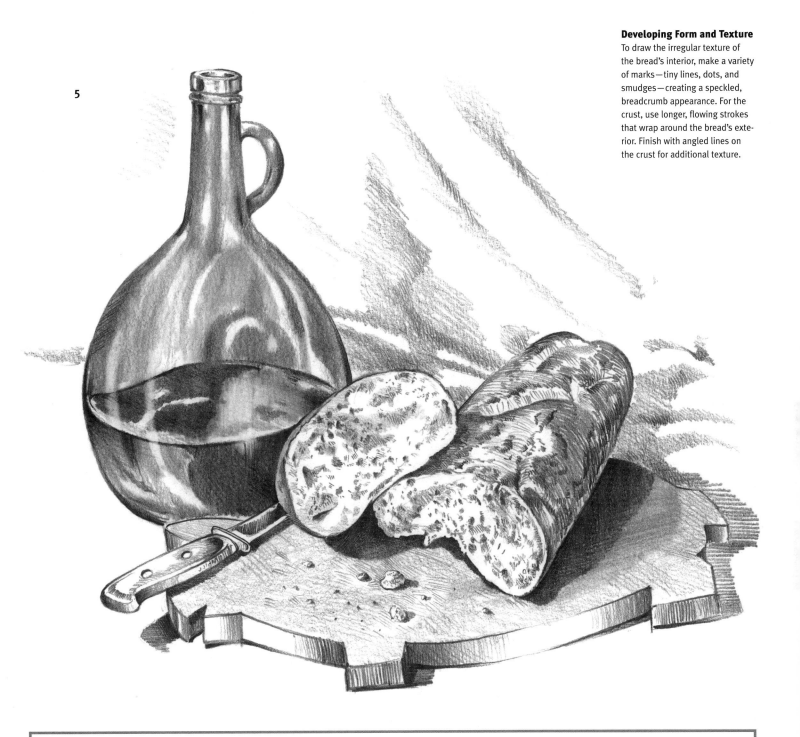

5

Developing Form and Texture
To draw the irregular texture of the bread's interior, make a variety of marks—tiny lines, dots, and smudges—creating a speckled, breadcrumb appearance. For the crust, use longer, flowing strokes that wrap around the bread's exterior. Finish with angled lines on the crust for additional texture.

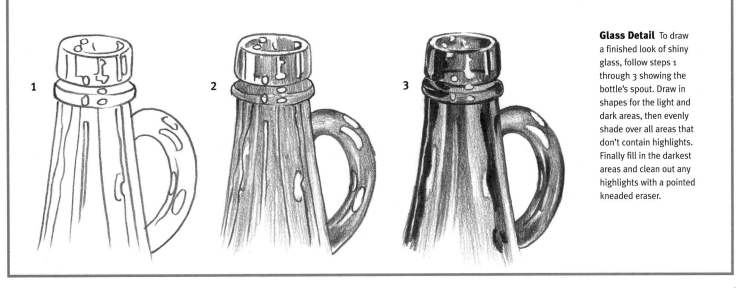

1

2

3

Glass Detail To draw a finished look of shiny glass, follow steps 1 through 3 showing the bottle's spout. Draw in shapes for the light and dark areas, then evenly shade over all areas that don't contain highlights. Finally fill in the darkest areas and clean out any highlights with a pointed kneaded eraser.

INTRODUCTION TO ANIMALS

The myriad breeds and species of animals that exist throughout the world offer endless possibilities for drawing subjects. Whether it's an adorable puppy, a slithering snake, or a galloping horse, an animal subject provides a wide range of shapes, lines, and textures to challenge and inspire you. And drawing animals isn't difficult at all—just follow the simple, step-by-step instructions in the following lessons. As you learn to draw by starting with basic shapes and progressing through finished renderings, you'll also discover various shading techniques and finishing touches that will bring your animal drawings to life. And with just a little practice, you'll be able to create your own artwork featuring all your favorite animal subjects.

DRAWING ANIMALS BY MICHAEL BUTKUS

Animals are fascinating subjects, and you can spend many hours at the zoo with your sketchpad, studying their movements, their body structures, and their coat textures. (See pages 86–87 for more on drawing animals from life.) And because pencil is such a versatile tool, you can easily sketch a rough-coated goat or finely stroke a smooth-haired deer. Of course, you don't have to go to the zoo to find models; try copying the drawings here, or find a wildlife book for reference, and draw the animals that appeal to you.

Studying the Head When drawing the head, pay special attention to the giraffe's most distinctive features. Emphasize the narrow, tapered muzzle and the heavy-lidded eyes, adding long, curved eyelashes. To make sure the knobbed horns don't look "pasted on," draw them as a continuous line from the forehead, curving back where they attach to the head.

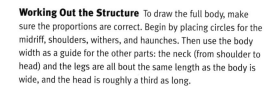

Working Out the Structure To draw the full body, make sure the proportions are correct. Begin by placing circles for the midriff, shoulders, withers, and haunches. Then use the body width as a guide for the other parts: the neck (from shoulder to head) and the legs are all bout the same length as the body is wide, and the head is roughly a third as long.

Developing Markings Start drawing this trio by sketching and refining their general shapes and then outlining the markings with a sharp-pointed HB. Then shade in the spots with a round-tip HB, making your strokes darker in the shadow areas, both on the spots and between them.

DRAWING FUR AND HAIR

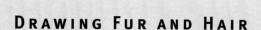

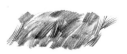

Smooth Coat Shade the undercoat with the side of a blunt 2B and pick out random coat hairs with a sharp HB pencil.

Rough Coat Using the side of your pencil, shade in several directions. With your pencil, use different strokes and various pressures.

Long Hair Make wavy strokes in the direction the hair grows, lifting the pencil at the end of each stroke.

Short Hair Use a blunt HB to make short, overlapping strokes, lifting the pencil at the end to taper the tips.

MAKING YOUR SUBJECT UNIQUE

Before you begin drawing any animal subject, ask yourself what it is that makes that animal distinct from all others. For example, sheep, horses, and giraffes all have hooves and a similar body structure, but a bighorn sheep has curled horns and a shaggy coat, a horse has a smooth coat and a single-toe hoof, and a giraffe has an elongated neck and legs and boldly patterned markings. Focusing on these distinguishing characteristics will make your drawings believable and lifelike.

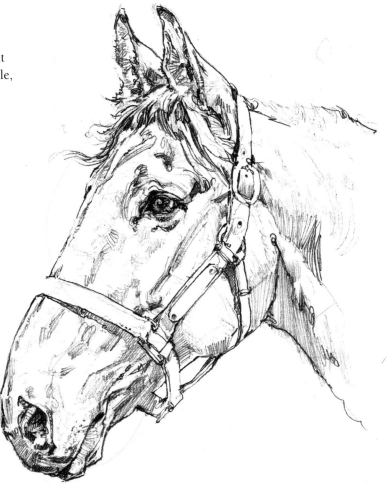

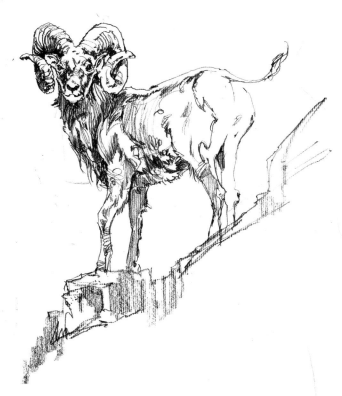

Creating a Portrait To capture this horse's likeness, focus on its features: the large nostril, wide eye, pointed ears, and strong cheekbone all distinguish this horse from, say, the sheep on the left or the giraffe on the opposite page. Use a sharp-pointed pencil for the outline and details, and the flat side of the lead for shadows. Then go back over the shading with the point to accentuate the underlying muscles, leaving large areas of white to suggest a smooth, glossy coat.

Depicting Hair To show the texture of this bighorn's coat, use the point of a 2B to apply long, wavy strokes on the body. Then draw short, wispy tendrils on the legs and underbelly.

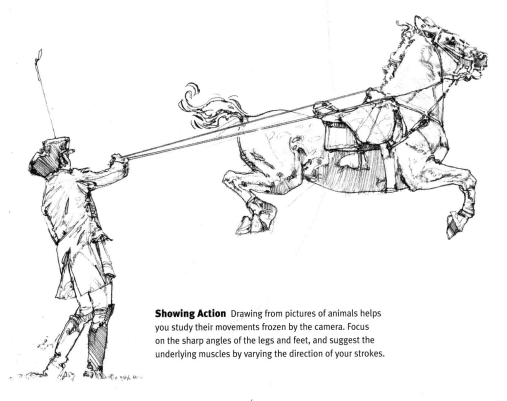

Focusing on Feet Horses have solid, single-toed hooves, whereas giraffes, sheep, and other ruminants have split (cloven) hooves. Notice that the horse's hoof is angled a little more than the giraffe's and that the giraffe's toes are not perfectly symmetrical.

Showing Action Drawing from pictures of animals helps you study their movements frozen by the camera. Focus on the sharp angles of the legs and feet, and suggest the underlying muscles by varying the direction of your strokes.

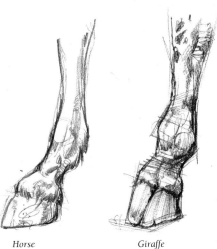

Horse *Giraffe*

DOBERMAN PINSCHER BY MIA TAVONATTI

Doberman Pinschers are known for their sleek, dark coats. When drawing the shiny coat, be sure to always sketch in the direction that the hair grows, as this will give your drawing a more realistic appearance.

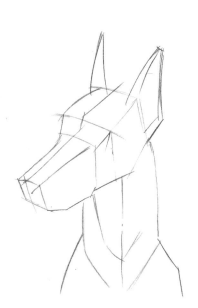

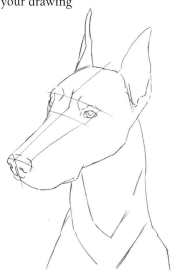

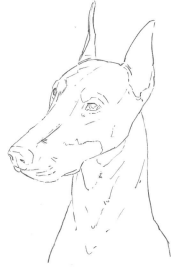

Step Three Next erase any guidelines that are no longer needed. Then begin placing light, broken lines made up of short dashes to indicate where the value changes in the coat are. These initial lines will act as a map for later shading.

Step Two Using the lines from the previous step as a guide, adjust the outline of the ears, head, and neck to give them a more contoured appearance. Then add the eyes and nose, following the facial guidelines. Finally refine the outline of the muzzle.

Step One With a sharp HB pencil, block in the boxy shape of the Doberman's head and shoulders with quick, straight lines. Even at this early stage, you want to establish a sense of dimension and form, which you'll build upon as the drawing progresses.

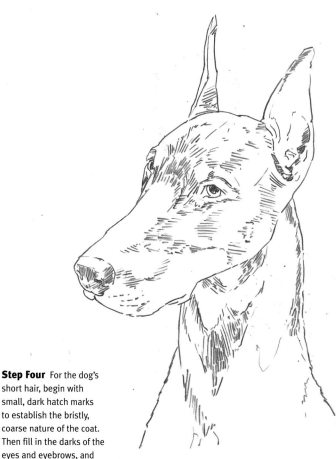

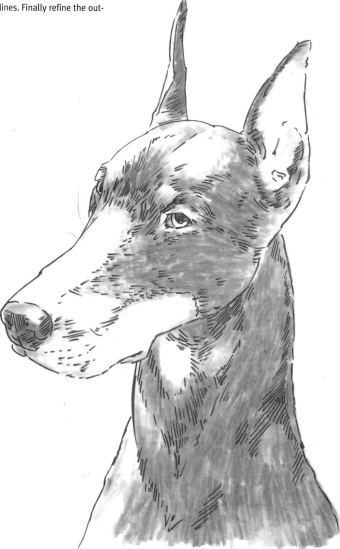

Step Four For the dog's short hair, begin with small, dark hatch marks to establish the bristly, coarse nature of the coat. Then fill in the darks of the eyes and eyebrows, and dot in a few light rows of whiskers at the tip of the muzzle.

Step Five Now fill in the remaining darks. First create some graphite dust by rubbing a pencil over a sheet of fine sandpaper. Then pick up the graphite dust with a medium-sized blending stump and shade in the dark areas of the dog's fur and nose. To avoid hard edges, blend to create soft gradations where the two values meet.

GREAT DANE BY WILLIAM F. POWELL

Great Danes have elegant stature and unique faces. While their enormous size (they can reach 30 inches tall at the shoulder) may be slightly intimidating, they are actually very gentle and affectionate, especially with children.

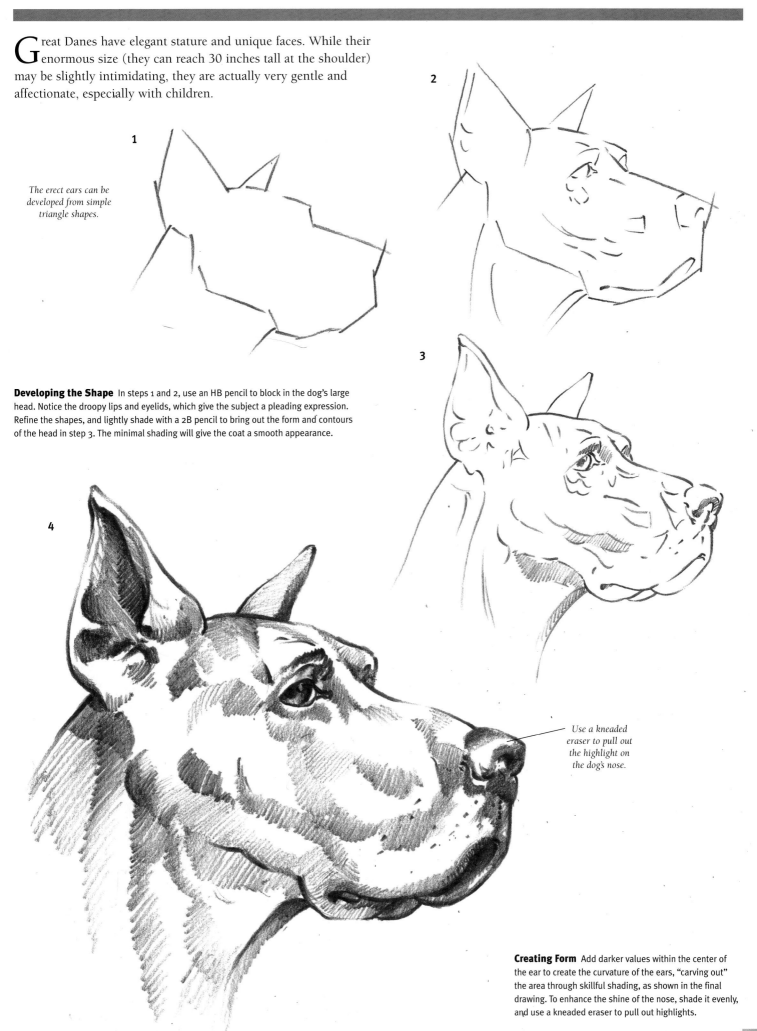

The erect ears can be developed from simple triangle shapes.

Developing the Shape In steps 1 and 2, use an HB pencil to block in the dog's large head. Notice the droopy lips and eyelids, which give the subject a pleading expression. Refine the shapes, and lightly shade with a 2B pencil to bring out the form and contours of the head in step 3. The minimal shading will give the coat a smooth appearance.

Use a kneaded eraser to pull out the highlight on the dog's nose.

Creating Form Add darker values within the center of the ear to create the curvature of the ears, "carving out" the area through skillful shading, as shown in the final drawing. To enhance the shine of the nose, shade it evenly, and use a kneaded eraser to pull out highlights.

Siberian Husky Puppy BY MIA TAVONATTI

The Husky is an athletic sled dog with a thick coat. It has a deep chest and a bushy tail, evident even at the young age of this little pup.

Step One First suggest the position of the spine and tail with one gently curving gesture line. Then use this line to position the round shape of the head, body, hindquarters. Next draw guidelines for the pup's facial features, at the same time establishing the general shape of the muzzle.

Step Two Now outline the entire torso using smooth, quick lines based on the initial shapes. Place the triangular ears and suggest the upper portion of the four legs.

Step Three Once you're satisfied with the pose and the way it has taken shape, begin to develop the puppy's coat. Apply a series of short, parallel strokes that follow the previous outline, producing the appearance of a thick coat. Using the same kind of strokes, outline the color pattern of the coat. Then place the eyes, nose, mouth, and tongue, and refine the paws.

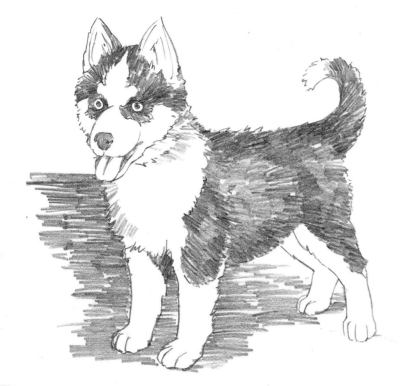

Step Four Next erase any guidelines you don't need and begin shading the dark areas of the fur with the broad side of the pencil. Use straight strokes that follow the direction of hair growth, radiating from the center of the face and chest. Next shade in the nose and pupils. Then add a background to contrast with the white of the puppy's chest. Apply straight, broad strokes with the side of the pencil, using horizontal hatching lines.

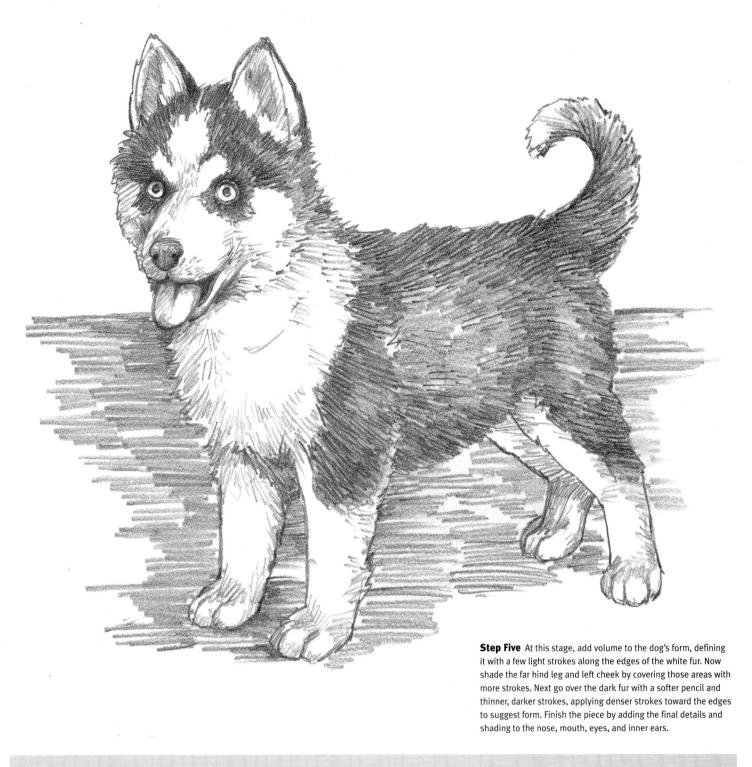

Step Five At this stage, add volume to the dog's form, defining it with a few light strokes along the edges of the white fur. Now shade the far hind leg and left cheek by covering those areas with more strokes. Next go over the dark fur with a softer pencil and thinner, darker strokes, applying denser strokes toward the edges to suggest form. Finish the piece by adding the final details and shading to the nose, mouth, eyes, and inner ears.

COMPARING THE PUPPY AND THE DOG

Young puppies and full-sized dogs have the same features but in different proportions. *Proportion* refers to the proper relation of one part to another or to the whole—particularly in terms of size or shape—and it is a key factor in achieving a good likeness. A puppy isn't just a small dog. Although a puppy has all the same parts as its adult counterpart, the puppy's body appears more compact than the dog's—and its paws, ears, and eyes seem much larger in proportion to the rest of its body. In contrast, the adult dog seems longer, leaner, and taller. Its muzzle appears larger in proportion to the rest of its body, and its teeth are noticeably bigger. Keeping these proportional differences in mind and incorporating them in your drawings will help you make your artwork look convincingly realistic.

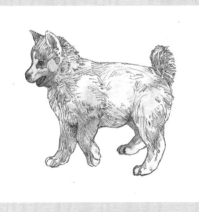

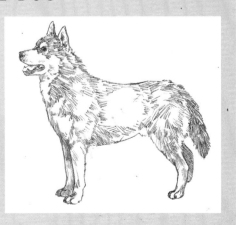

ENGLISH BULLDOG BY WILLIAM F. POWELL

The powerful English Bulldog, with its stocky, muscular body, is a fun, challenging breed to draw. Even though the pronounced underbite of this dog gives it a gruff expression, it is known to be very affectionate and docile.

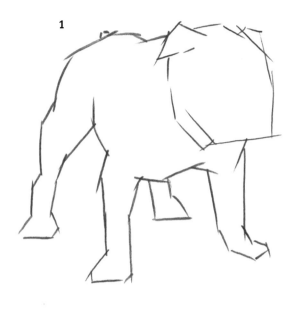

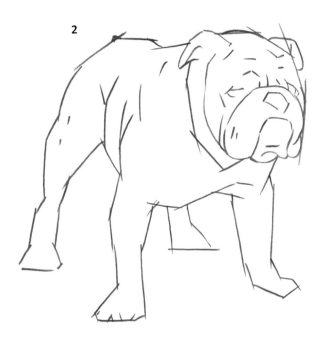

Blocking In In step 1, block in the general outline with short, straight lines. Keep the legs short and bowed to give the dog its compact, stocky appearance. As you sketch the features in step 2, study the low placement of the eyes, as well as how the nose is pushed into the face.

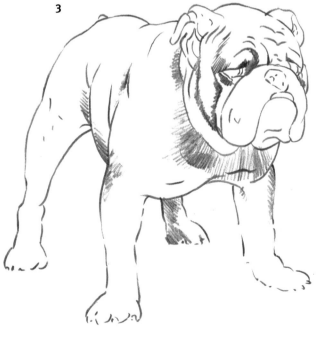

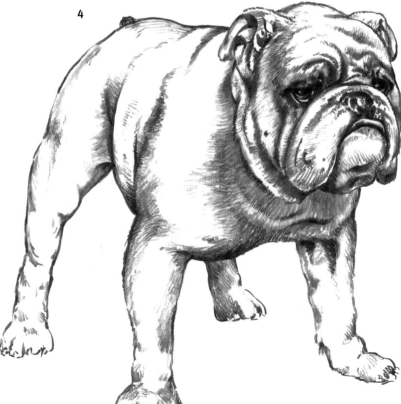

Placing Shadows and Details Begin shading with a sharp 2B pencil, developing the folds on the face and the contours and shadows along the body. Keep the pencil fairly sharp to make the folds distinct and the fur smooth. Use a sharp pencil to add the details in the eyes. As in all the drawings, work at your own pace, and don't rush when shading the fur. Your attention to detail will be apparent in the final rendering.

MINIATURE SCHNAUZER BY WILLIAM F. POWELL

The Miniature Schnauzer's bushy eyebrows and long beard give it a striking appearance. Almost square in profile, the Miniature Schnauzer (along with its larger counterparts, the Standard and Giant Schnauzers) exhibits a straight, level back and well-developed legs.

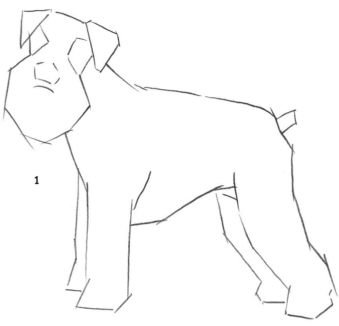

1

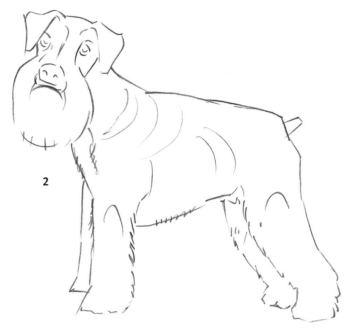

2

Creating a Basic Outline As you block in the body in step 1, make the face wider around the cheeks to accommodate the full beard. Next add triangle shapes on top of the head so the ears appear to flop forward. In step 2, place the wide-set eyes and broad nose, and suggest a furry outline.

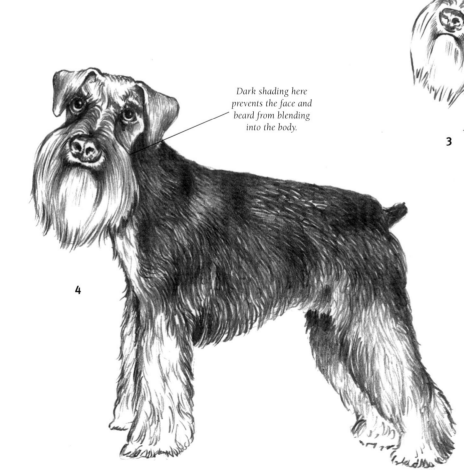

Dark shading here prevents the face and beard from blending into the body.

3

4

Forming Texture Slowly lay in the coat with quick strokes along the back in step 3. Make certain the hair closest to the face is dark, so the outline of the face is visible. Fewer strokes are needed on the chest and legs because the coat is generally lighter in these areas. You can also mold a kneaded eraser into a sharp edge and "draw" with it in the direction of the hair to create highlights.

SHAR-PEI PUPPY BY WILLIAM F. POWELL

The Shar-Pei is probably best known for its loose folds of skin. These wrinkles seem to give this breed a worried expression. The puppy shown here has looser skin than an adult; eventually the body will fill out, and the folds will become less obvious.

Indicate the folds with short, zigzagging lines.

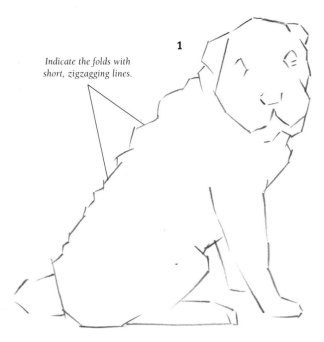

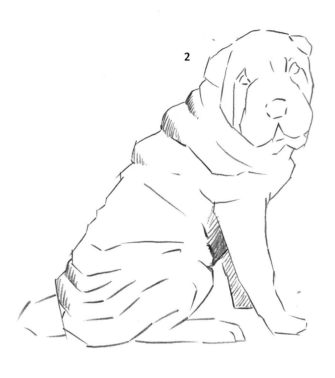

Depicting the Shar-Pei As you block in the dog's shape in step 1, use short strokes placed at wide angles to sketch the outline. To develop the folds in step 2, start by lightly shading inside the creases. Give equal attention to each fold so the dog appears realistic. Continue to develop the shading with short slash marks in step 3, keeping the values darker between the folds.

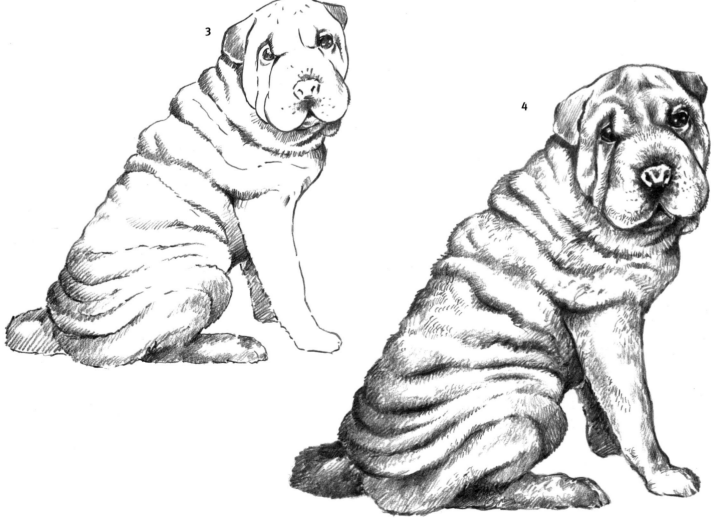

OLD ENGLISH SHEEPDOG BY WILLIAM F. POWELL

The most distinctive feature of the Old English Sheepdog is its long fluffy coat, which sometimes covers the dog's eyes and hides the ears. This particular rendering doesn't require many fine details, but the coat does require much attention.

Suggesting the Overall Shape Lay down a basic outline in step 1, adding some suggestions of hair in step 2. Keep your lines loose and free.

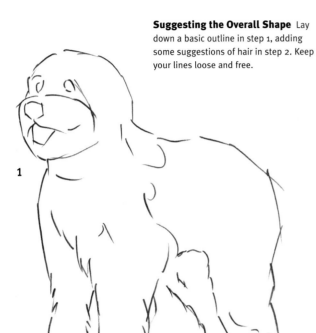

1

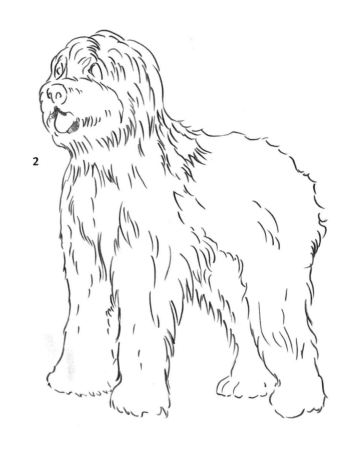

2

Rendering the Hair As you begin to develop the coat, notice how the nose, tongue, and eyes differ in texture; they are quite smooth in contrast. You can use a blunt-pointed pencil to lay in the hair, adding more shading layers to the back end of the body to indicate the darker color.

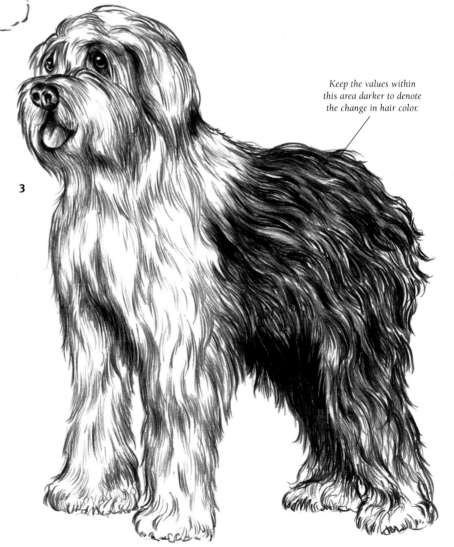

3

Keep the values within this area darker to denote the change in hair color.

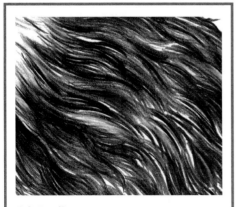

Hair Detail Enhance the texture of the dog's hair by molding a kneaded eraser into a sharp edge and erasing with the edge in the direction of the strokes. This brings out highlights and creates shadows between the strands.

CHOW CHOW BY WILLIAM F. POWELL

The very recognizable Chow Chow can have a rough or smooth coat, which should be rendered with a soft, sharp pencil. Notice how finely detailed this rendering appears; each hair of the coat is carefully drawn. It should be obvious what this dog's coat would feel like.

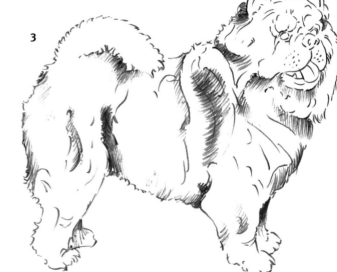

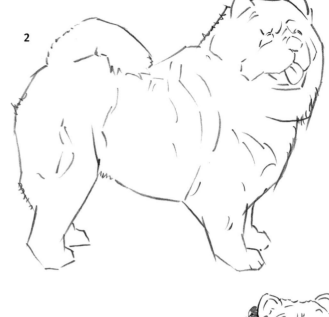

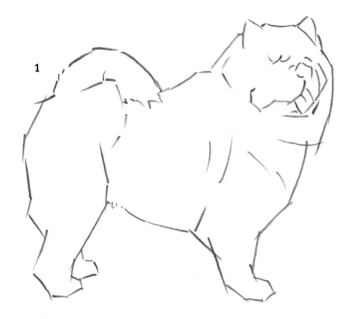

Sketching the Chow Chow In steps 1 and 2, sketch a preliminary outline of the dog, and add the facial features. With a sharp pencil, begin shading the darkest areas within the fur in step 3. This fur texture shows many highlights, so the kneaded eraser will also be useful for enhancing the realism of the drawing.

A few strokes curving toward the center of the tail makes it appear bushy and light in color.

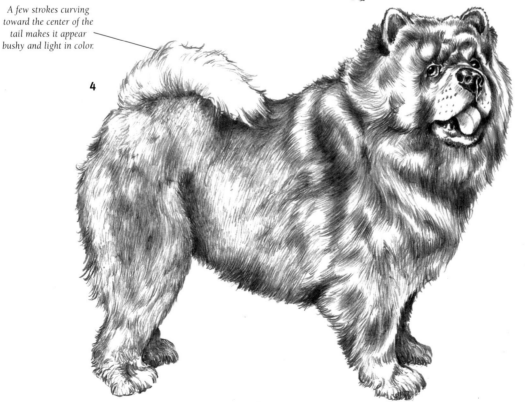

Bouvier des Flandres by William F. Powell

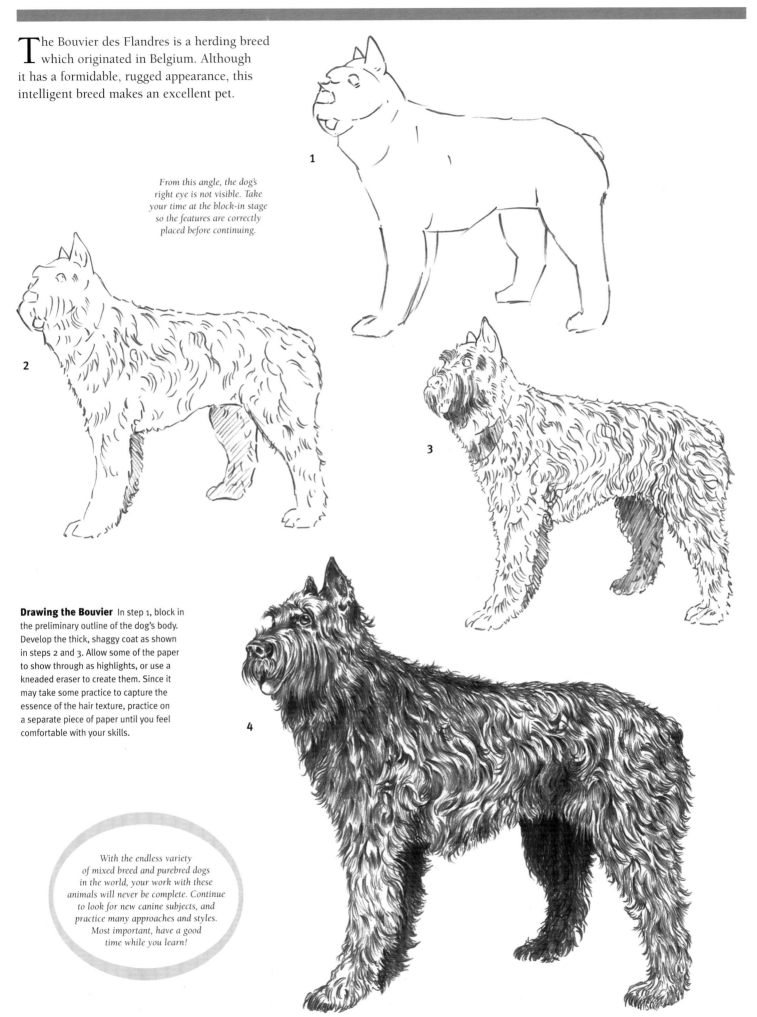

The Bouvier des Flandres is a herding breed which originated in Belgium. Although it has a formidable, rugged appearance, this intelligent breed makes an excellent pet.

From this angle, the dog's right eye is not visible. Take your time at the block-in stage so the features are correctly placed before continuing.

1

2

3

Drawing the Bouvier In step 1, block in the preliminary outline of the dog's body. Develop the thick, shaggy coat as shown in steps 2 and 3. Allow some of the paper to show through as highlights, or use a kneaded eraser to create them. Since it may take some practice to capture the essence of the hair texture, practice on a separate piece of paper until you feel comfortable with your skills.

4

With the endless variety of mixed breed and purebred dogs in the world, your work with these animals will never be complete. Continue to look for new canine subjects, and practice many approaches and styles. Most important, have a good time while you learn!

RAGDOLL KITTENS BY MIA TAVONATTI

Ragdolls get their name from their very relaxed nature. To draw these soft, fluffy kittens, use short, quick strokes to suggest the fur. Then use a blending stump to soften some of your marks, creating the smooth appearance of the fur.

Step One Sketch out the balanced, triangular composition of the basket and three kittens. Then build each feline shape with ovals indicating the position of the head, chest, and hindquarters. Next mark a few guidelines for the facial features and suggest the general shape of the legs and paws. Continue to develop the kittens, adding triangular shapes to the ears that follow the tilt of each head. Then sketch the tails of the two cats outside the basket.

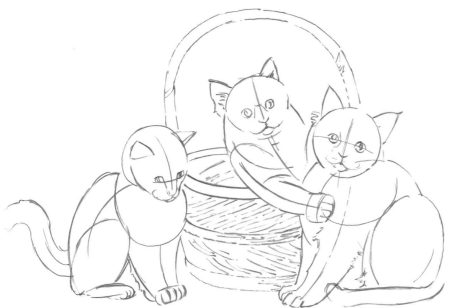

Step Two At this point, erase the initial guidelines and focus on refining the outline of the cats. Add the eyes, nose, and mouth to each kitten and define the individual sections of the paws. Then begin to create the weave pattern of the basket with parallel diagonal strokes.

Step Three Next complete the outline of the kittens, retracing the initial sketch with short, broken marks to suggest fluffy hair. Further develop the texture of the basket, adding more parallel horizontal strokes to define the separate bands. Then add curved strokes to the basket handle, to suggest roundness.

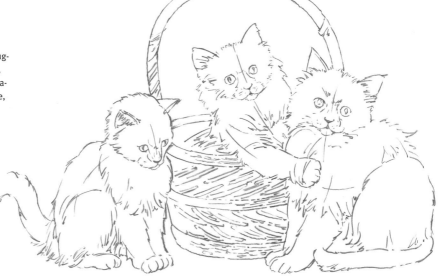

Step Four Continue to add texture to the basket and the kittens, switching between an H and a 2B pencil. Vary the thickness of each stroke by alternating between the sharp point and the flat side of the pencil lead. As you develop each area, be careful to do so at the same rate to maintain an even balance.

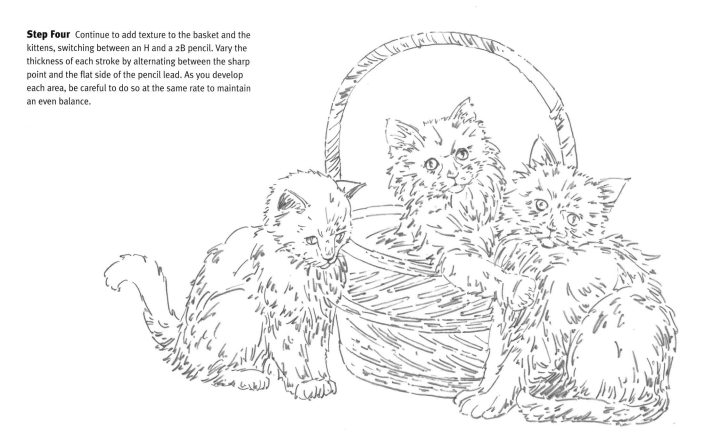

Step Five To finish, darken the basket shadows by stroking over them with the flat side of the pencil tip, following the direction of previously placed strokes. Use the same technique to add cast shadows under the kittens and the basket. These dark areas will contrast nicely with the white highlights on the kittens. To finish the kittens' coats, lightly shade with a blending stump to produce softer, more subtle shadows.

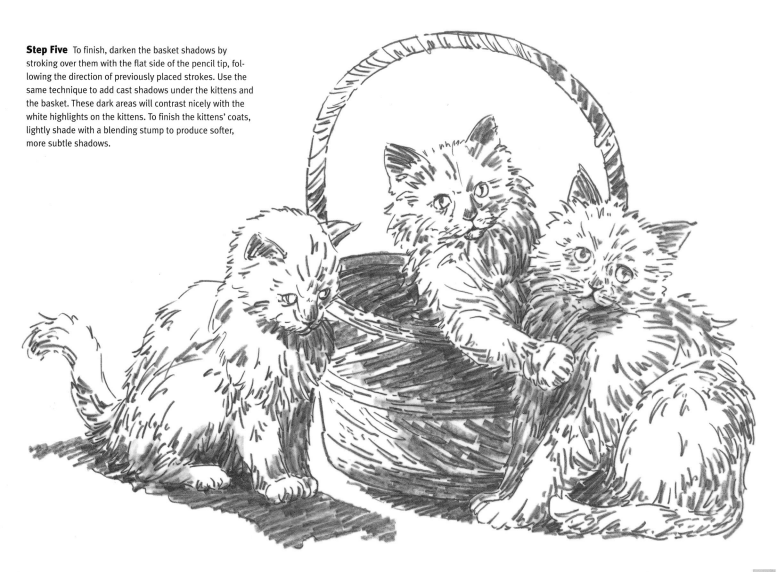

PERSIAN CAT BY MIA TAVONATTI

The Persian is a stocky cat with long, silky hair. It has a large, round face with short, broad features and small ears. To depict the quality of this Persian's fur, keep your pencil strokes uniform and deliberate. Notice that this example has been developed much further than the previous examples were.

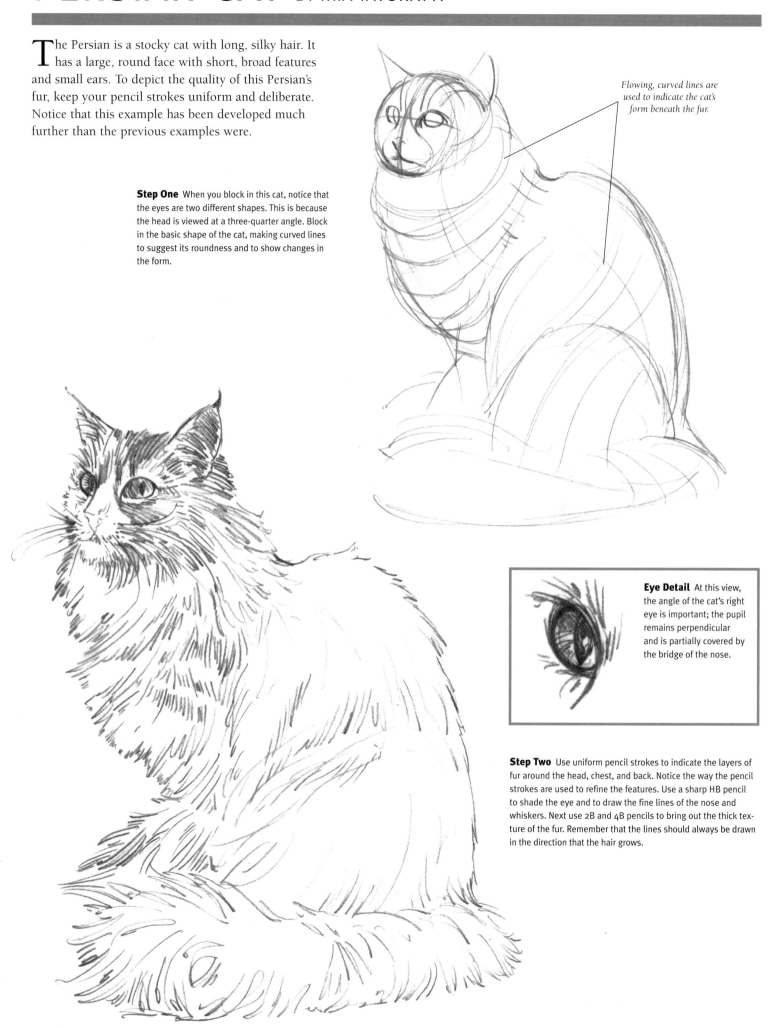

Flowing, curved lines are used to indicate the cat's form beneath the fur.

Step One When you block in this cat, notice that the eyes are two different shapes. This is because the head is viewed at a three-quarter angle. Block in the basic shape of the cat, making curved lines to suggest its roundness and to show changes in the form.

Eye Detail At this view, the angle of the cat's right eye is important; the pupil remains perpendicular and is partially covered by the bridge of the nose.

Step Two Use uniform pencil strokes to indicate the layers of fur around the head, chest, and back. Notice the way the pencil strokes are used to refine the features. Use a sharp HB pencil to shade the eye and to draw the fine lines of the nose and whiskers. Next use 2B and 4B pencils to bring out the thick texture of the fur. Remember that the lines should always be drawn in the direction that the hair grows.

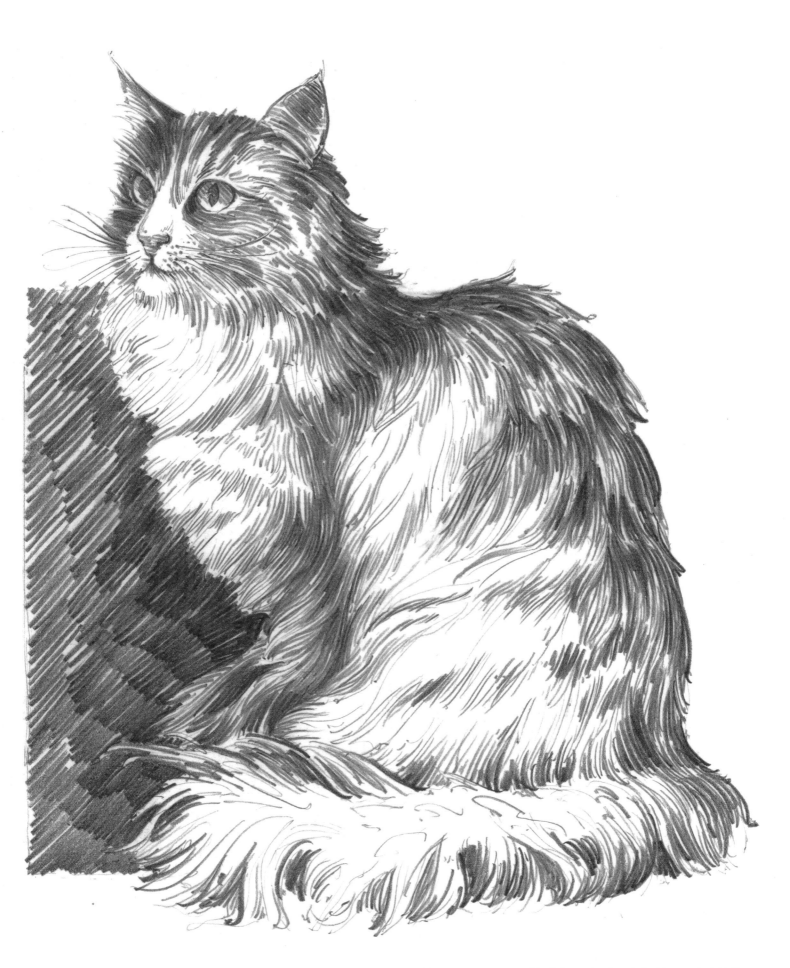

Step Three The final rendering shows an effective use of contrasting values. The minimal shading in the white areas on the cat's chest and side reflect where the light strikes the coat. The middle values are shown in the fur along the left side of the cat's face and on the cat's left ear. Use a 4B or 6B pencil for darker strokes along the backbone, neck, right side of the face, and parts of the tail. Notice how the dark background is used to create the shape of the light-colored fur on the cat's chest and tail.

TABBY CAT BY MIA TAVONATTI

Patterns and textures can add interest to an otherwise ordinary subject. For this sketch, the pairing of a ridged carpet and striped cat produces an eye-catching study in contrasts.

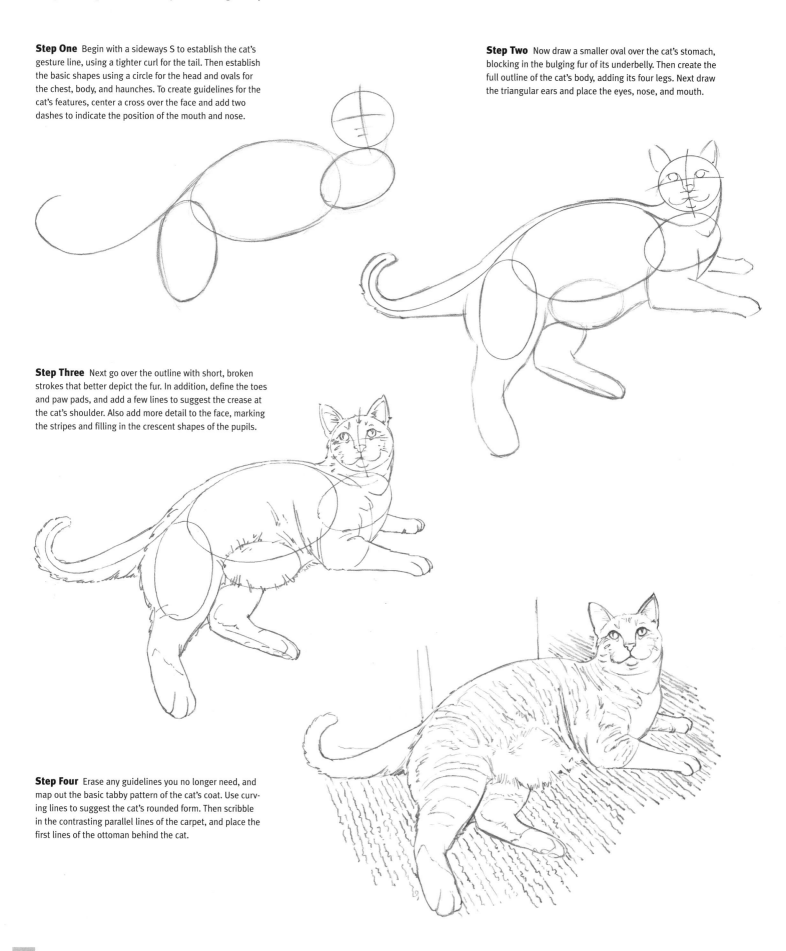

Step One Begin with a sideways S to establish the cat's gesture line, using a tighter curl for the tail. Then establish the basic shapes using a circle for the head and ovals for the chest, body, and haunches. To create guidelines for the cat's features, center a cross over the face and add two dashes to indicate the position of the mouth and nose.

Step Two Now draw a smaller oval over the cat's stomach, blocking in the bulging fur of its underbelly. Then create the full outline of the cat's body, adding its four legs. Next draw the triangular ears and place the eyes, nose, and mouth.

Step Three Next go over the outline with short, broken strokes that better depict the fur. In addition, define the toes and paw pads, and add a few lines to suggest the crease at the cat's shoulder. Also add more detail to the face, marking the stripes and filling in the crescent shapes of the pupils.

Step Four Erase any guidelines you no longer need, and map out the basic tabby pattern of the cat's coat. Use curving lines to suggest the cat's rounded form. Then scribble in the contrasting parallel lines of the carpet, and place the first lines of the ottoman behind the cat.

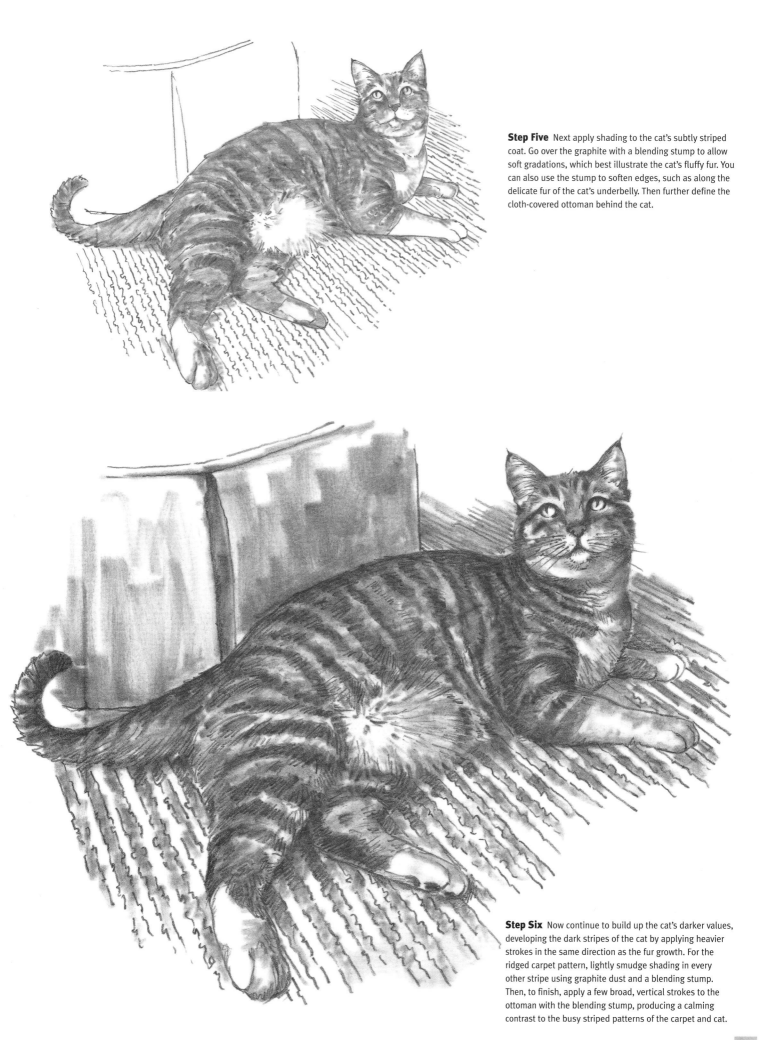

Step Five Next apply shading to the cat's subtly striped coat. Go over the graphite with a blending stump to allow soft gradations, which best illustrate the cat's fluffy fur. You can also use the stump to soften edges, such as along the delicate fur of the cat's underbelly. Then further define the cloth-covered ottoman behind the cat.

Step Six Now continue to build up the cat's darker values, developing the dark stripes of the cat by applying heavier strokes in the same direction as the fur growth. For the ridged carpet pattern, lightly smudge shading in every other stripe using graphite dust and a blending stump. Then, to finish, apply a few broad, vertical strokes to the ottoman with the blending stump, producing a calming contrast to the busy striped patterns of the carpet and cat.

COMMON CAT BEHAVIORS BY MIA TAVONATTI

This grooming cat presents a slightly challenging pose, so it's important that you take your time blocking it in. Use ovals to establish the placement of the major body parts, and draw guidelines along the skull and backbone to help you place the curves of the cat's body. Remember that the cat's front left leg is supporting the weight of its upper body, so it needs to be placed correctly. If it isn't, the cat will look as if it is about to fall over.

For a difficult pose like this one, it is important to observe your subject closely.

Careful, uniform pencil strokes suggest a short, smooth coat.

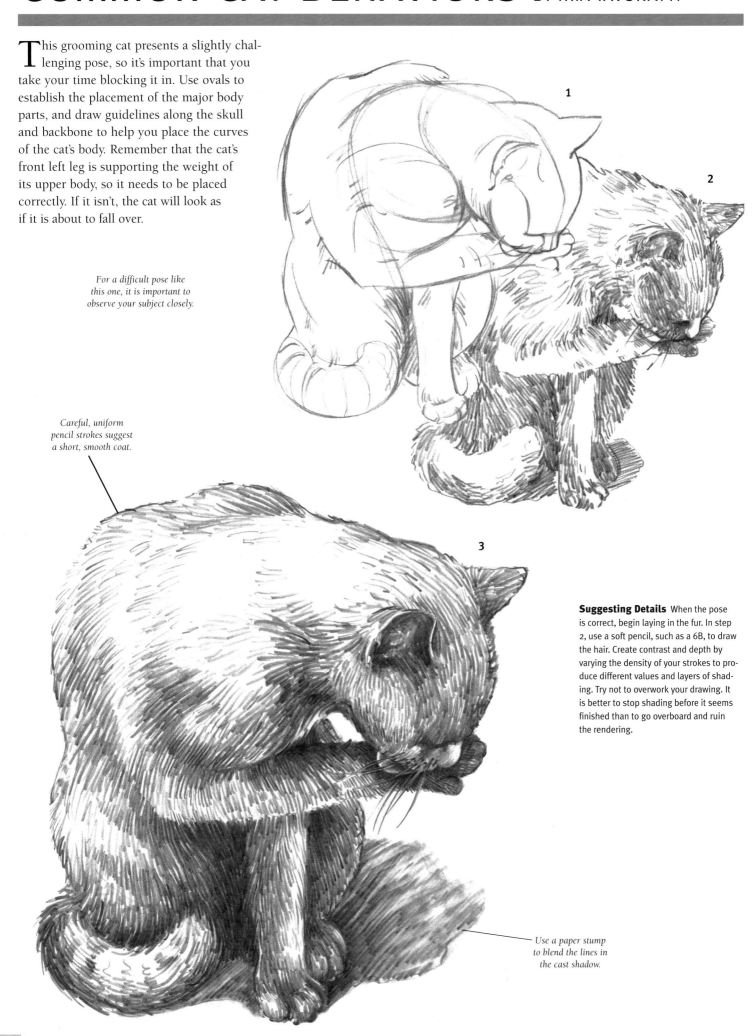

Suggesting Details When the pose is correct, begin laying in the fur. In step 2, use a soft pencil, such as a 6B, to draw the hair. Create contrast and depth by varying the density of your strokes to produce different values and layers of shading. Try not to overwork your drawing. It is better to stop shading before it seems finished than to go overboard and ruin the rendering.

Use a paper stump to blend the lines in the cast shadow.

Cats use body language to express themselves. A cat will mark its territory by rubbing its body against something to transfer its personal scent to the object. Sometimes a cat will rub against people's legs to show affection and send a greeting. The contrast between the rounded, diagonal body of this cat and the vertical lines of the wall makes an effective composition.

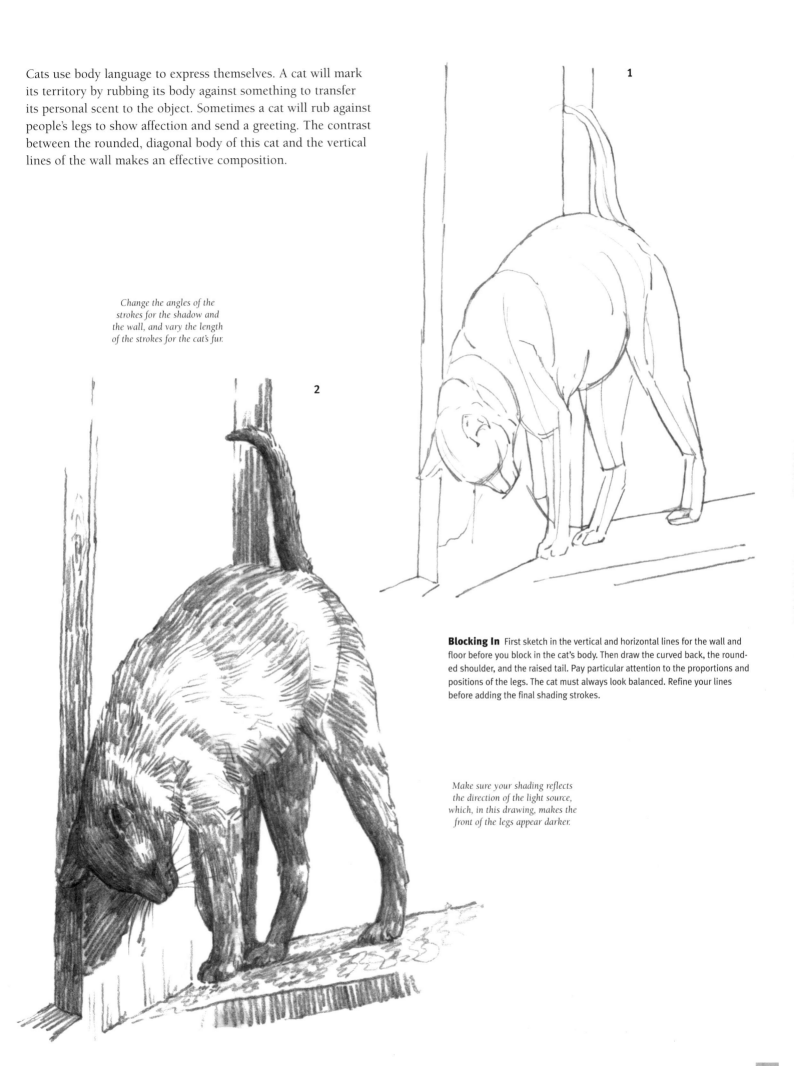

Change the angles of the strokes for the shadow and the wall, and vary the length of the strokes for the cat's fur.

2

1

Blocking In First sketch in the vertical and horizontal lines for the wall and floor before you block in the cat's body. Then draw the curved back, the rounded shoulder, and the raised tail. Pay particular attention to the proportions and positions of the legs. The cat must always look balanced. Refine your lines before adding the final shading strokes.

Make sure your shading reflects the direction of the light source, which, in this drawing, makes the front of the legs appear darker.

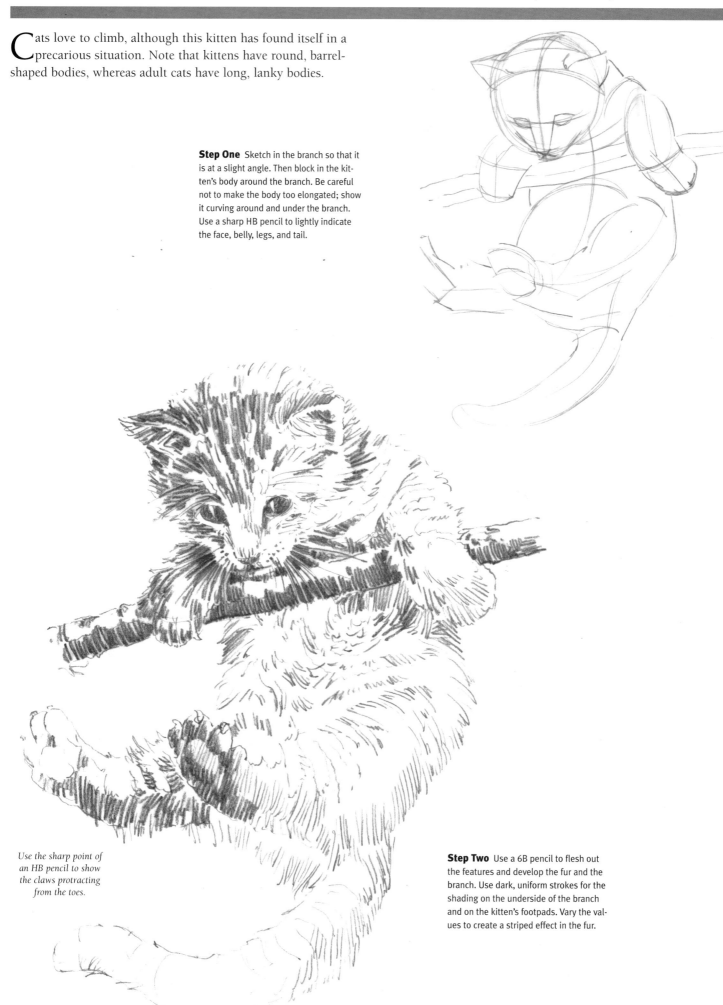

Cats love to climb, although this kitten has found itself in a precarious situation. Note that kittens have round, barrel-shaped bodies, whereas adult cats have long, lanky bodies.

Step One Sketch in the branch so that it is at a slight angle. Then block in the kitten's body around the branch. Be careful not to make the body too elongated; show it curving around and under the branch. Use a sharp HB pencil to lightly indicate the face, belly, legs, and tail.

Use the sharp point of an HB pencil to show the claws protracting from the toes.

Step Two Use a 6B pencil to flesh out the features and develop the fur and the branch. Use dark, uniform strokes for the shading on the underside of the branch and on the kitten's footpads. Vary the values to create a striped effect in the fur.

Step Three Now develop the rendering to your satisfaction. Use an HB pencil for the whiskers over the eyes and the fine lines around the nose, eyes, and mouth. Continue creating the texture of the kitten's coat by making deliberate strokes of different lengths in the varying directions of fur growth. Remember to leave uniform areas of white to suggest this tabby's stripes.

Notice that the kitten has an expression of determination— not of fear.

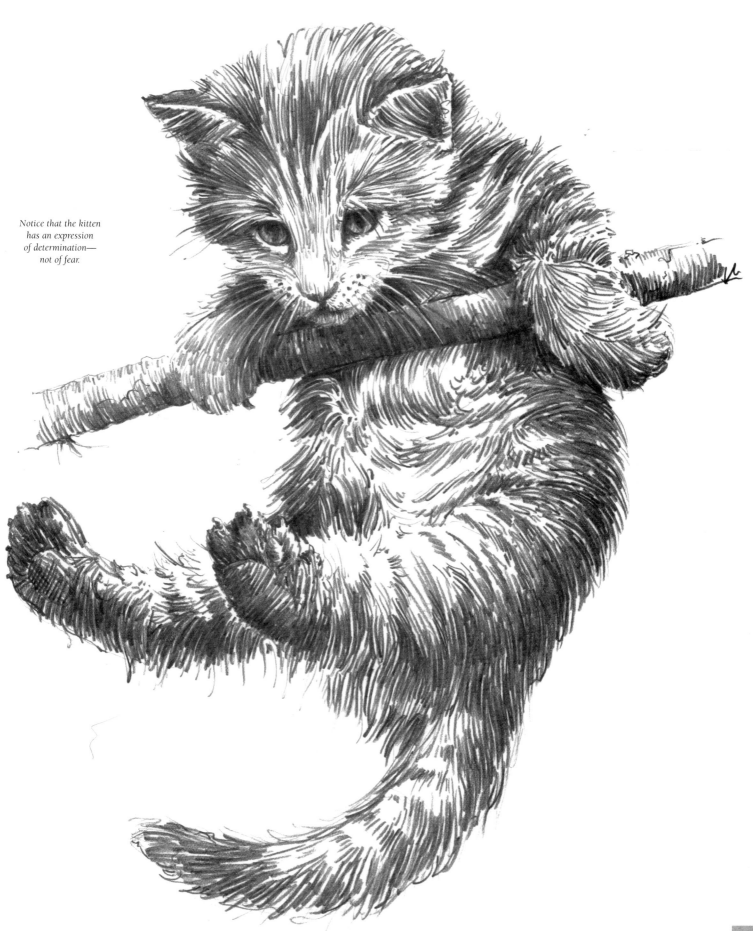

HORSE PORTRAIT BY MIA TAVONATTI

Horses are fantastic drawing subjects, as their inherent beauty and grace can be quite captivating. Pay careful attention to the detail of the eye to express this gentle creature's warmth and intelligence.

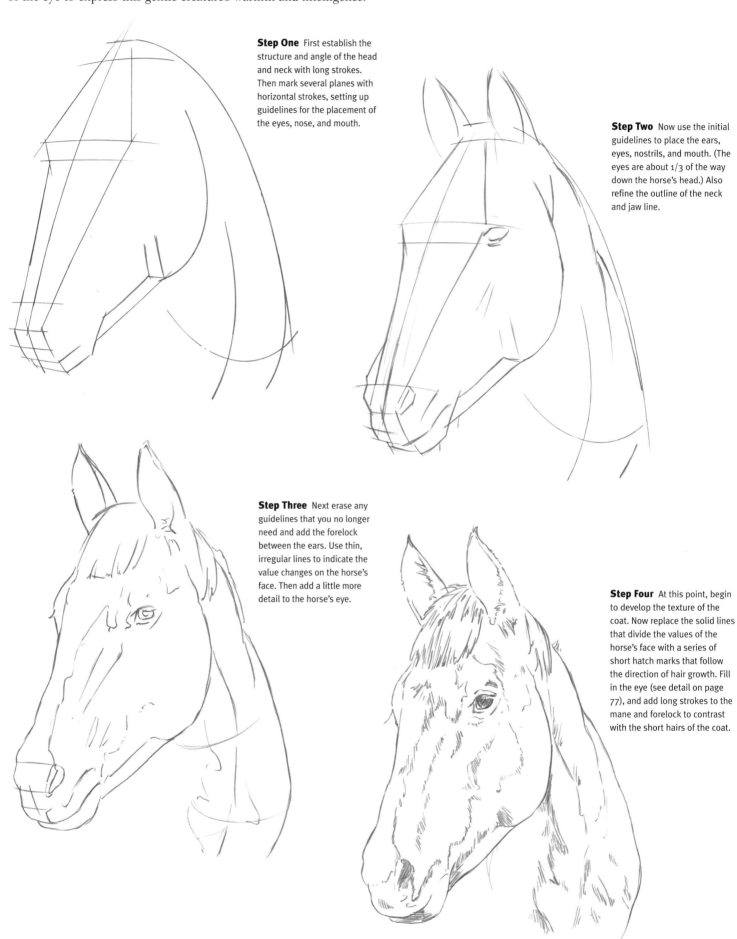

Step One First establish the structure and angle of the head and neck with long strokes. Then mark several planes with horizontal strokes, setting up guidelines for the placement of the eyes, nose, and mouth.

Step Two Now use the initial guidelines to place the ears, eyes, nostrils, and mouth. (The eyes are about 1/3 of the way down the horse's head.) Also refine the outline of the neck and jaw line.

Step Three Next erase any guidelines that you no longer need and add the forelock between the ears. Use thin, irregular lines to indicate the value changes on the horse's face. Then add a little more detail to the horse's eye.

Step Four At this point, begin to develop the texture of the coat. Now replace the solid lines that divide the values of the horse's face with a series of short hatch marks that follow the direction of hair growth. Fill in the eye (see detail on page 77), and add long strokes to the mane and forelock to contrast with the short hairs of the coat.

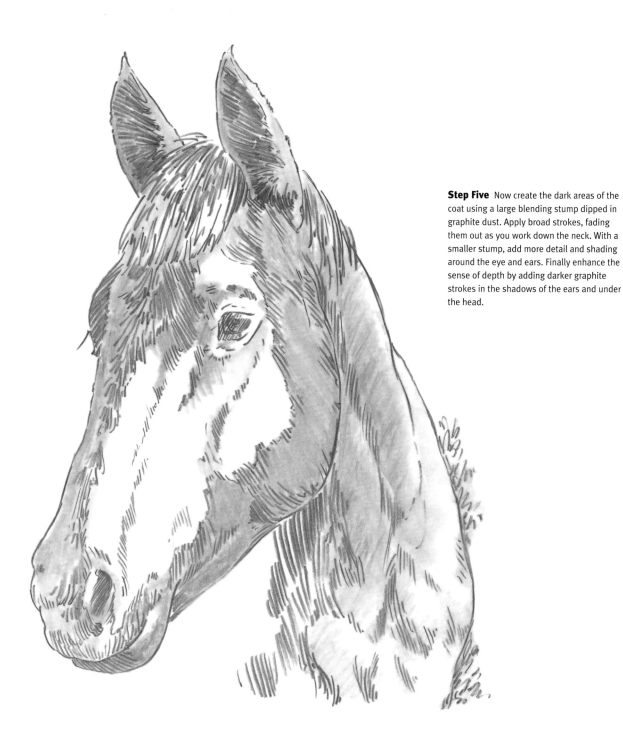

Step Five Now create the dark areas of the coat using a large blending stump dipped in graphite dust. Apply broad strokes, fading them out as you work down the neck. With a smaller stump, add more detail and shading around the eye and ears. Finally enhance the sense of depth by adding darker graphite strokes in the shadows of the ears and under the head.

HORSE DETAILS

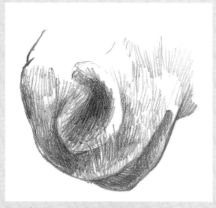

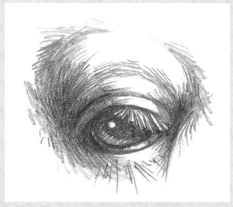

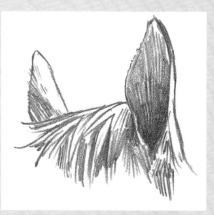

Muzzle The muzzle has subtle, curved forms, which are defined with careful shading. The area around the nostril is raised, as is the area just above the mouth; indicate this shape by pulling out highlights with a kneaded eraser.

Eye Horses' eyes have a lot of detail, from the creases around the eyes to the straight, thick eyelashes that protect them. To create a sense of life in the eye, leave a light crescent-shaped area to show reflected light, and leave a stark white highlight above it.

Ears Render the horse's forelock hair with long, slightly curving strokes. Then shade the interior of the ear with upward, parallel strokes, making them darkest at the bottom and gradually lighter as you move up the ear.

HORSE HEAD IN PROFILE BY WALTER T. FOSTER

For this profile, start by blocking in the basic shape of the horse's head, then gradually develop the form, being more careful and deliberate with your lines and shading strokes. Remember to observe your subject closely so you can render a good likeness.

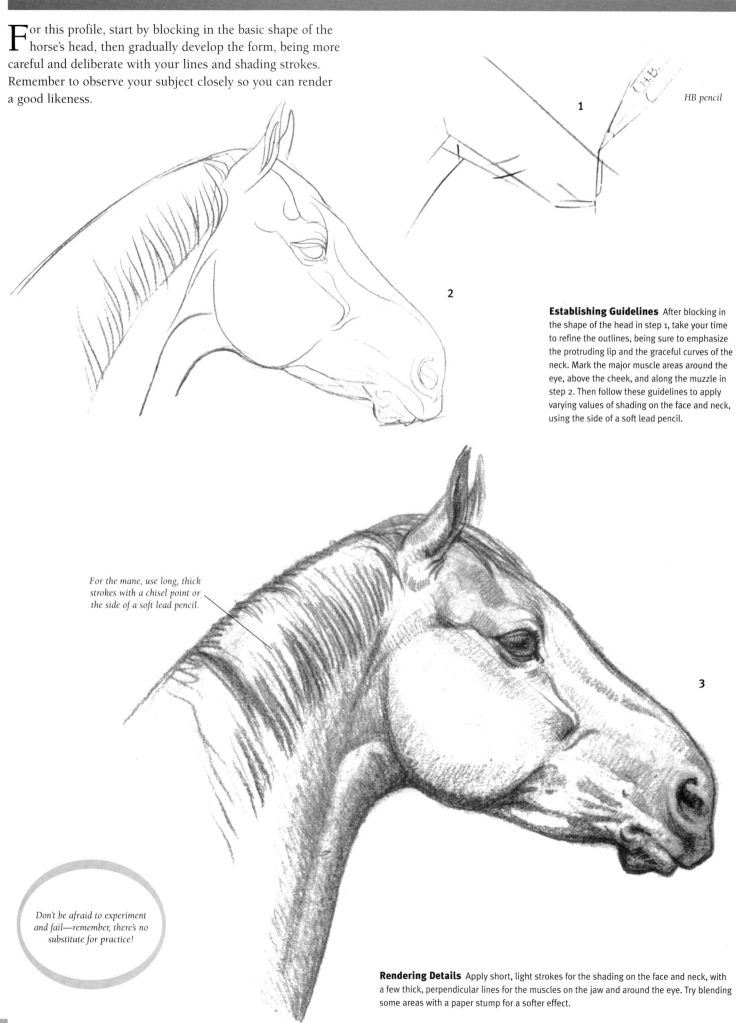

HB pencil

Establishing Guidelines After blocking in the shape of the head in step 1, take your time to refine the outlines, being sure to emphasize the protruding lip and the graceful curves of the neck. Mark the major muscle areas around the eye, above the cheek, and along the muzzle in step 2. Then follow these guidelines to apply varying values of shading on the face and neck, using the side of a soft lead pencil.

For the mane, use long, thick strokes with a chisel point or the side of a soft lead pencil.

Don't be afraid to experiment and fail—remember, there's no substitute for practice!

Rendering Details Apply short, light strokes for the shading on the face and neck, with a few thick, perpendicular lines for the muscles on the jaw and around the eye. Try blending some areas with a paper stump for a softer effect.

ADVANCED HORSE HEADS BY MICHELE MALTSEFF

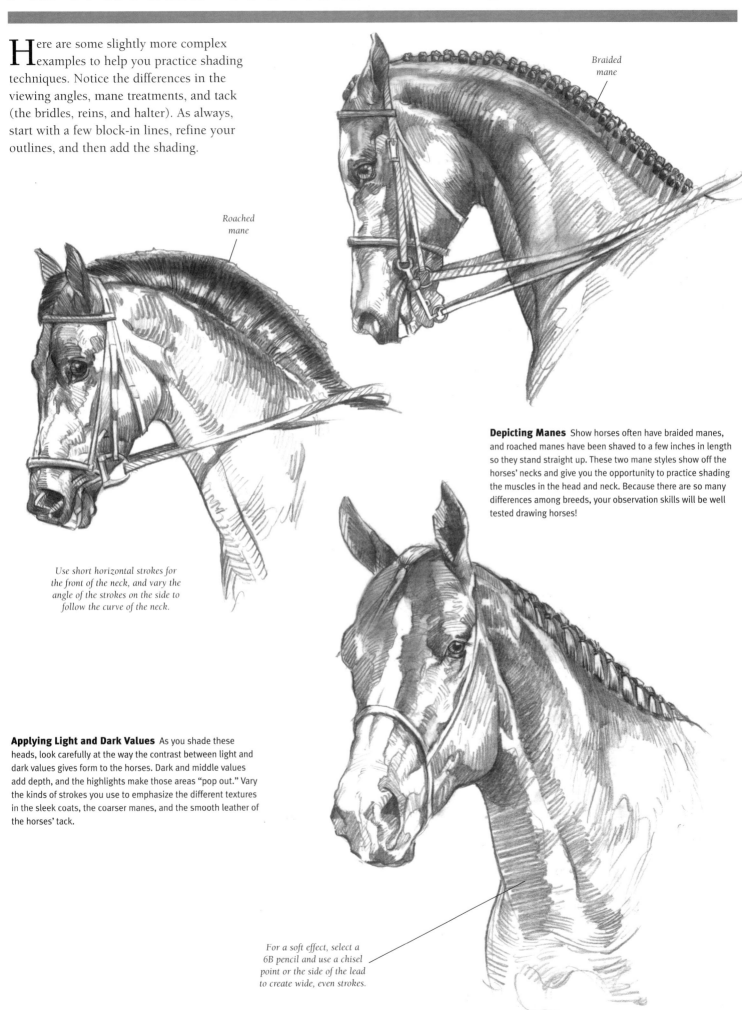

Here are some slightly more complex examples to help you practice shading techniques. Notice the differences in the viewing angles, mane treatments, and tack (the bridles, reins, and halter). As always, start with a few block-in lines, refine your outlines, and then add the shading.

Braided mane

Roached mane

Depicting Manes Show horses often have braided manes, and roached manes have been shaved to a few inches in length so they stand straight up. These two mane styles show off the horses' necks and give you the opportunity to practice shading the muscles in the head and neck. Because there are so many differences among breeds, your observation skills will be well tested drawing horses!

Use short horizontal strokes for the front of the neck, and vary the angle of the strokes on the side to follow the curve of the neck.

Applying Light and Dark Values As you shade these heads, look carefully at the way the contrast between light and dark values gives form to the horses. Dark and middle values add depth, and the highlights make those areas "pop out." Vary the kinds of strokes you use to emphasize the different textures in the sleek coats, the coarser manes, and the smooth leather of the horses' tack.

For a soft effect, select a 6B pencil and use a chisel point or the side of the lead to create wide, even strokes.

PONY BY MIA TAVONATTI

Ponies are not just small horses; they are a distinct species. Smaller in size than horses, ponies are also more sure-footed and have a stronger sense of self-preservation.

Step One With an HB pencil, sketch the bulk of the pony onto your paper. Use overlapping ovals for the chest, body, and haunches. Then place the gentle curves of the neck, blocking in the head with short, angular strokes. Add ovals to block in the curvature of the jaw and muzzle.

Step Two Building on the lines from step 1, outline the entire pony. Block in the legs, carefully sketching the hooves and joints. Quickly suggest the mane and tail with a few long strokes, and place the mouth, nostril, eye, and ears.

Step Three Now erase the initial oval guides and shade the outside legs with long, vertical strokes. Then create the texture of the mane and tail with long, straight strokes to represent strands of hair. To give the body form, add a few marks to suggest the major muscles. You can give the face form with a few areas of light, solid shading. Then outline the halter.

PARTS OF HORSES AND PONIES

You certainly don't need to learn the names of every bone and muscle in order to draw an animal accurately. But it is helpful to have a little knowledge of the basic anatomy of your subject. For example, an understanding of the underlying shapes of the horse's skeletal and musculature structures will result in more realistic depictions of the horse's form. (Ponies have the same basic structure as horses, although sizes and proportions differ.) Knowing the shapes of the bones will help you draw lifelike legs, hooves, and faces. And familiarity with the major muscle groups will help you place your shadows and highlights accurately, bringing the horse or pony's form to life.

Drawing the horse's body is easy if you break down the animal into basic shapes. Start with circles, cylinders, and trapezoids—as shown on the horse at right—to help you get a good general sense of the size and proportion of the parts of the horse, such as the head, neck, belly, and legs. Then simply connect these shapes, refine the lines, and add a few details to produce a realistic outline of your equine subject.

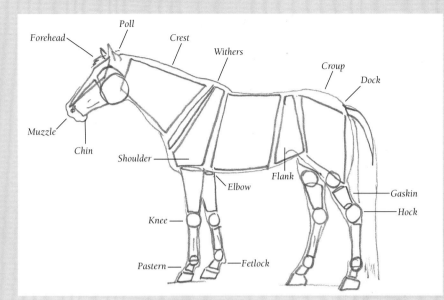

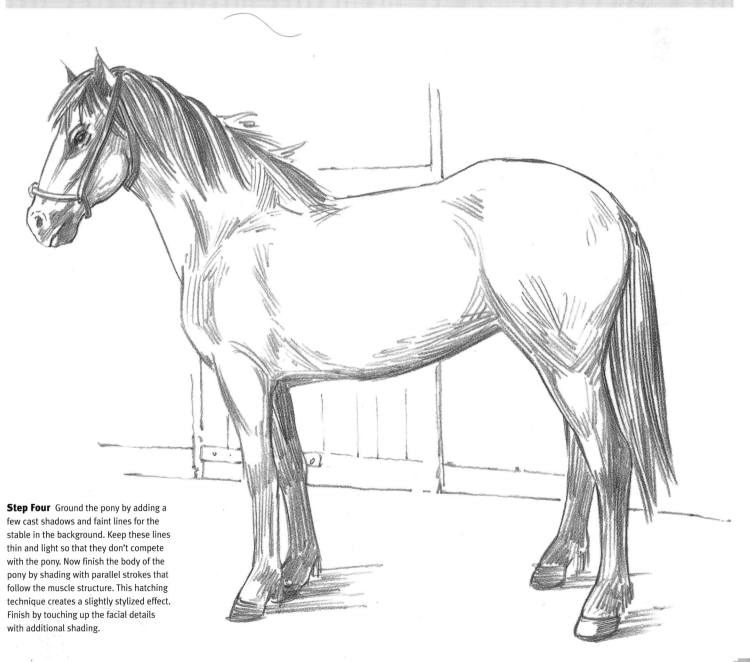

Step Four Ground the pony by adding a few cast shadows and faint lines for the stable in the background. Keep these lines thin and light so that they don't compete with the pony. Now finish the body of the pony by shading with parallel strokes that follow the muscle structure. This hatching technique creates a slightly stylized effect. Finish by touching up the facial details with additional shading.

CLYDESDALE BY MICHELE MALTSEFF

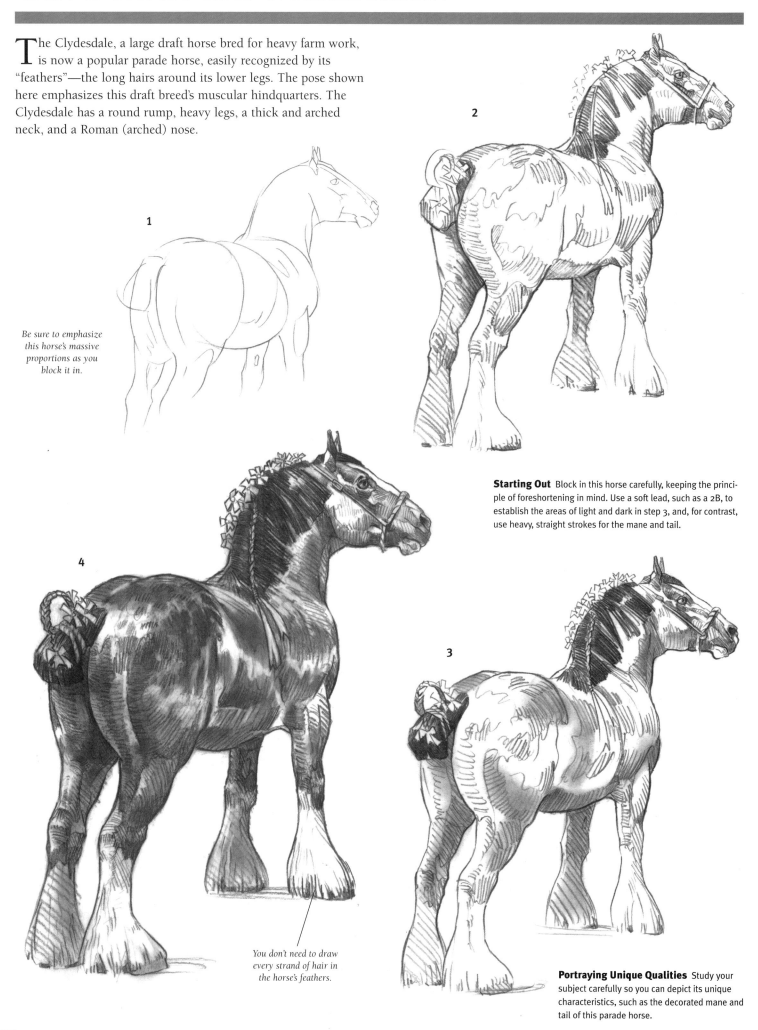

The Clydesdale, a large draft horse bred for heavy farm work, is now a popular parade horse, easily recognized by its "feathers"—the long hairs around its lower legs. The pose shown here emphasizes this draft breed's muscular hindquarters. The Clydesdale has a round rump, heavy legs, a thick and arched neck, and a Roman (arched) nose.

1

Be sure to emphasize this horse's massive proportions as you block it in.

2

Starting Out Block in this horse carefully, keeping the principle of foreshortening in mind. Use a soft lead, such as a 2B, to establish the areas of light and dark in step 3, and, for contrast, use heavy, straight strokes for the mane and tail.

4

You don't need to draw every strand of hair in the horse's feathers.

3

Portraying Unique Qualities Study your subject carefully so you can depict its unique characteristics, such as the decorated mane and tail of this parade horse.

CIRCUS HORSE BY MICHELE MALTSEFF

Horses used in the circus are large-boned breeds such as European Warmbloods. These breeds have broad backs and strong builds combined with an elegant, graceful carriage. This striking pinto provides good practice for your shading techniques because its coat has both light- and dark-colored areas.

Developing Your Sketch Use large ovals and circles when blocking in this horse to establish its size and strength. The reins are attached to the surcingle around the horse's body, so the head needs to be angled sharply toward the horse's chest, and the neck is greatly arched. In your final rendering, shade the white areas lightly, and use an eraser to pull out the highlights in the dark patches and in the tail.

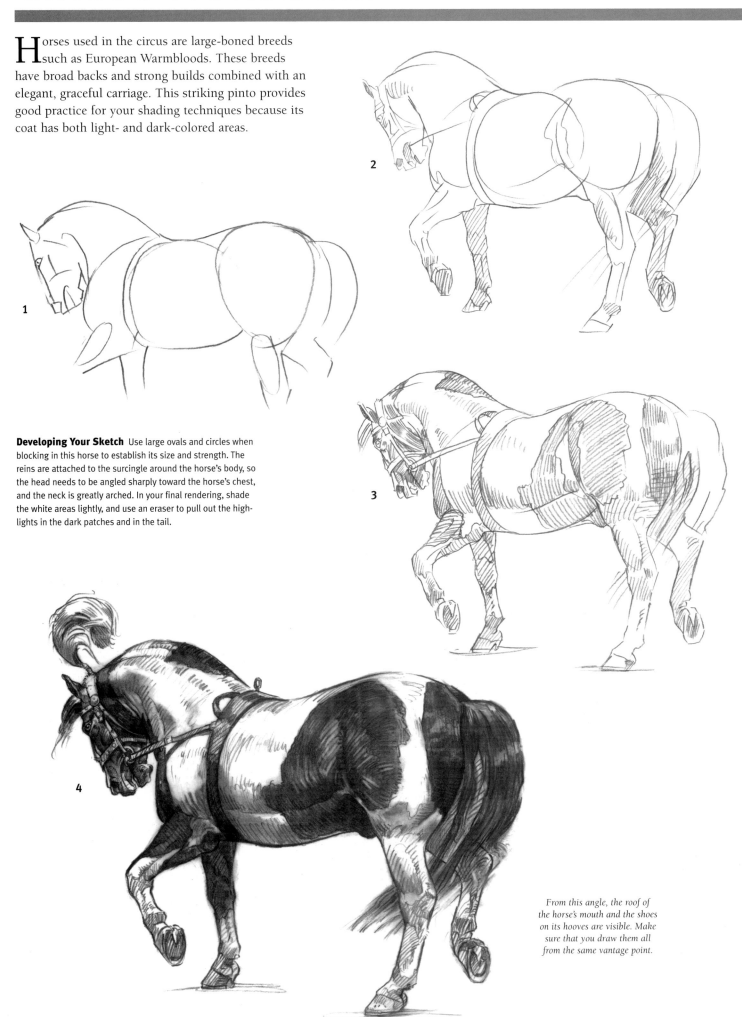

From this angle, the roof of the horse's mouth and the shoes on its hooves are visible. Make sure that you draw them all from the same vantage point.

DRAWING AT THE ZOO BY WILLIAM F. POWELL

When going to the zoo, you can observe all the different animals and draw them in a variety of poses. This is another great way to practice seeing the important shapes and to train your hand to draw them quickly! Make several rough sketches of an animal—plus a few with some detail whenever you get the chance. You can also write comments in the margins of your sketchbook—noting the animal's expressions, mannerisms, patterns, fur textures, and colors—so that you can refer to them later, when you're back in your work space.

DRAWING FROM LIFE

When working outside (also called "on location"), it often pays to keep your art materials to a minimum so that they're easily transportable. When going to the zoo, try taking only a small sketchbook, a few HB pencils, and a sharpening implement. You might include an eraser if you plan to make rendered drawings. Another thing to consider is the weather: Heat and glare can make drawing uncomfortable, so you may also want to take a hat, water, and even bug repellent, if necessary.

Sketching Quickly The zoo is a wonderful place to sketch birds, although most don't stand still for very long. Quickly sketched the general pose of each crane and then add more detail on the head of the grooming crane. Sometimes it's good to bring my camera along to record details for future drawings. And if you can't get close enough to the animal to see clearly, use your camera lens as "binoculars" and zoom in!

Observing Animals One of the joys of sketching live birds and animals is the spontaneous and natural actions you are privy to. If you find a large pelican like this one drying its wings in the sun, for example, you'll have a little more time to draw, so you might be able to add the details and some shading on the body, head, and wings.

Taking "Notes" When catching sight of magnificent animals like these, make a quick sketch and take some photos on site. Then develop your final drawing back at your work space, using your sketches and photos for reference.

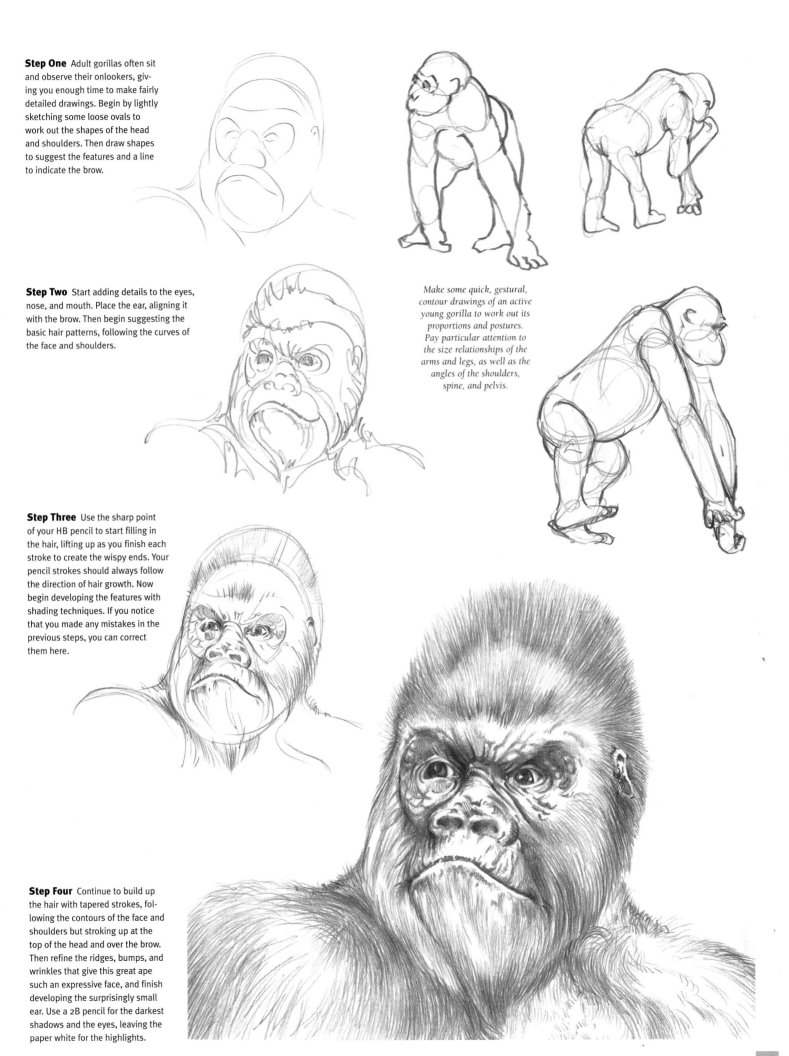

Step One Adult gorillas often sit and observe their onlookers, giving you enough time to make fairly detailed drawings. Begin by lightly sketching some loose ovals to work out the shapes of the head and shoulders. Then draw shapes to suggest the features and a line to indicate the brow.

Step Two Start adding details to the eyes, nose, and mouth. Place the ear, aligning it with the brow. Then begin suggesting the basic hair patterns, following the curves of the face and shoulders.

Make some quick, gestural, contour drawings of an active young gorilla to work out its proportions and postures. Pay particular attention to the size relationships of the arms and legs, as well as the angles of the shoulders, spine, and pelvis.

Step Three Use the sharp point of your HB pencil to start filling in the hair, lifting up as you finish each stroke to create the wispy ends. Your pencil strokes should always follow the direction of hair growth. Now begin developing the features with shading techniques. If you notice that you made any mistakes in the previous steps, you can correct them here.

Step Four Continue to build up the hair with tapered strokes, following the contours of the face and shoulders but stroking up at the top of the head and over the brow. Then refine the ridges, bumps, and wrinkles that give this great ape such an expressive face, and finish developing the surprisingly small ear. Use a 2B pencil for the darkest shadows and the eyes, leaving the paper white for the highlights.

FLAMINGO BY WILLIAM F. POWELL

Although the flamingo is best known for its color, its interesting textures make it an ideal subject for graphite pencil sketching. Pay attention to details as you render this bird's stubbly head and neck feathers, soft back and wing feathers, smooth beak, and tough legs and feet.

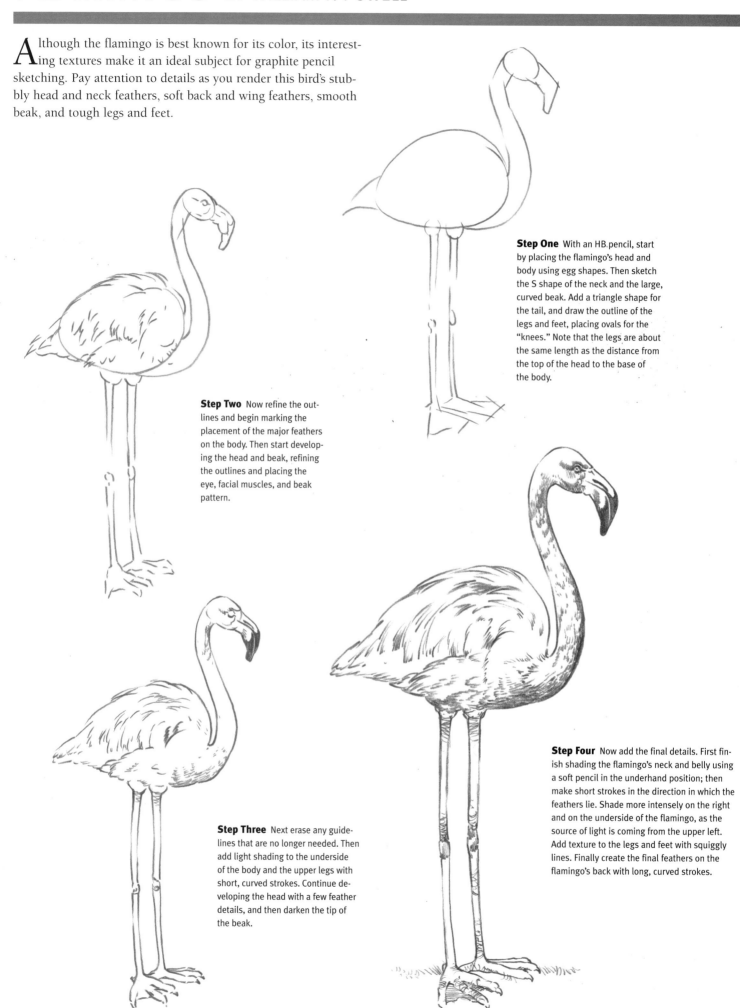

Step One With an HB pencil, start by placing the flamingo's head and body using egg shapes. Then sketch the S shape of the neck and the large, curved beak. Add a triangle shape for the tail, and draw the outline of the legs and feet, placing ovals for the "knees." Note that the legs are about the same length as the distance from the top of the head to the base of the body.

Step Two Now refine the outlines and begin marking the placement of the major feathers on the body. Then start developing the head and beak, refining the outlines and placing the eye, facial muscles, and beak pattern.

Step Three Next erase any guidelines that are no longer needed. Then add light shading to the underside of the body and the upper legs with short, curved strokes. Continue developing the head with a few feather details, and then darken the tip of the beak.

Step Four Now add the final details. First finish shading the flamingo's neck and belly using a soft pencil in the underhand position; then make short strokes in the direction in which the feathers lie. Shade more intensely on the right and on the underside of the flamingo, as the source of light is coming from the upper left. Add texture to the legs and feet with squiggly lines. Finally create the final feathers on the flamingo's back with long, curved strokes.

ELEPHANT BY WILLIAM F. POWELL

This elephant makes a simple subject because even its details are larger than average! Use simple shading to indicate its ridged tusk, wrinkled body, smooth tusks, and bent tail.

Step One Begin drawing the elephant with large overlapping circles and ovals to place the elephant's head and establish the general bulk of the body.

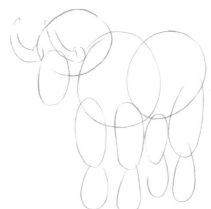

Step Two Next draw thin, vertical ovals to indicate the legs and the widest part of the trunk. Then draw the curved shapes of the tusks on either side of the base of the trunk.

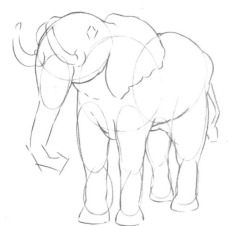

Step Three Now, using the basic shapes as a guide, draw the outline of the elephant's body, ears, head, and legs as shown. Then sketch the shape of the trunk and the general outline of the tail.

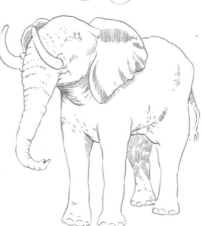

Step Four Now refine the outlines and erase any guidelines that remain. Then apply shading to the neck, ears, tail, and legs, reserving the darkest applications for the final step. Use short strokes to suggest the wrinkles on the trunk and some folds of skin on the body.

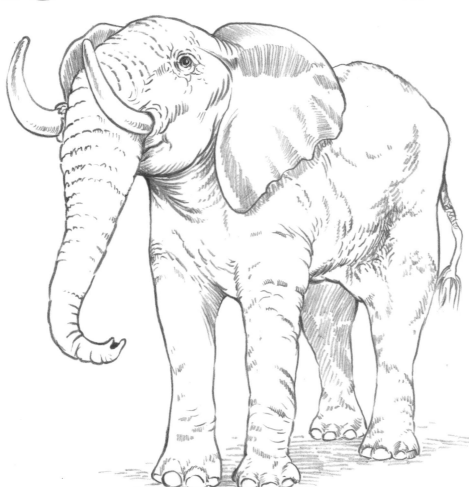

Step Five Using a 2B pencil, reinforce the darkest shadows, such as on the tail and beneath the head. Then fill in the detail of the eye, leaving a small spot unshaded for the highlight. Finally finish developing the shading and texture of the elephant, and then add a light cast shadow around the feet to anchor the elephant to the ground.

KANGAROO BY WILLIAM F. POWELL

With the kangaroo, it's especially important to draw what you see, not what you expect to see. Study the features of the animal for beginning. For example, notice that the kangaroo's ears, tail, and feet are disproportionately large in comparison to its other features. Attention to detail will produce a more accurate final drawing.

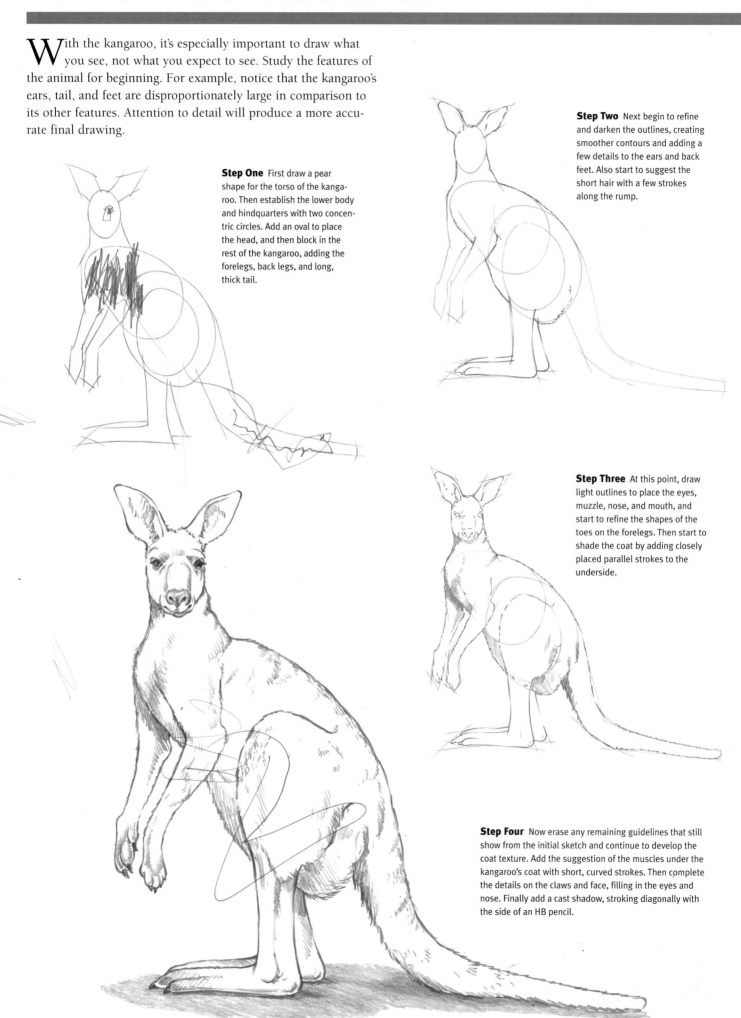

Step One First draw a pear shape for the torso of the kangaroo. Then establish the lower body and hindquarters with two concentric circles. Add an oval to place the head, and then block in the rest of the kangaroo, adding the forelegs, back legs, and long, thick tail.

Step Two Next begin to refine and darken the outlines, creating smoother contours and adding a few details to the ears and back feet. Also start to suggest the short hair with a few strokes along the rump.

Step Three At this point, draw light outlines to place the eyes, muzzle, nose, and mouth, and start to refine the shapes of the toes on the forelegs. Then start to shade the coat by adding closely placed parallel strokes to the underside.

Step Four Now erase any remaining guidelines that still show from the initial sketch and continue to develop the coat texture. Add the suggestion of the muscles under the kangaroo's coat with short, curved strokes. Then complete the details on the claws and face, filling in the eyes and nose. Finally add a cast shadow, stroking diagonally with the side of an HB pencil.

TOUCAN BY WILLIAM F. POWELL

Birds come in all shapes, sizes, and textures. This toucan's long, smooth feathers require long, soft strokes. Soft shading is also used to indicate the smooth texture of this bird's beak.

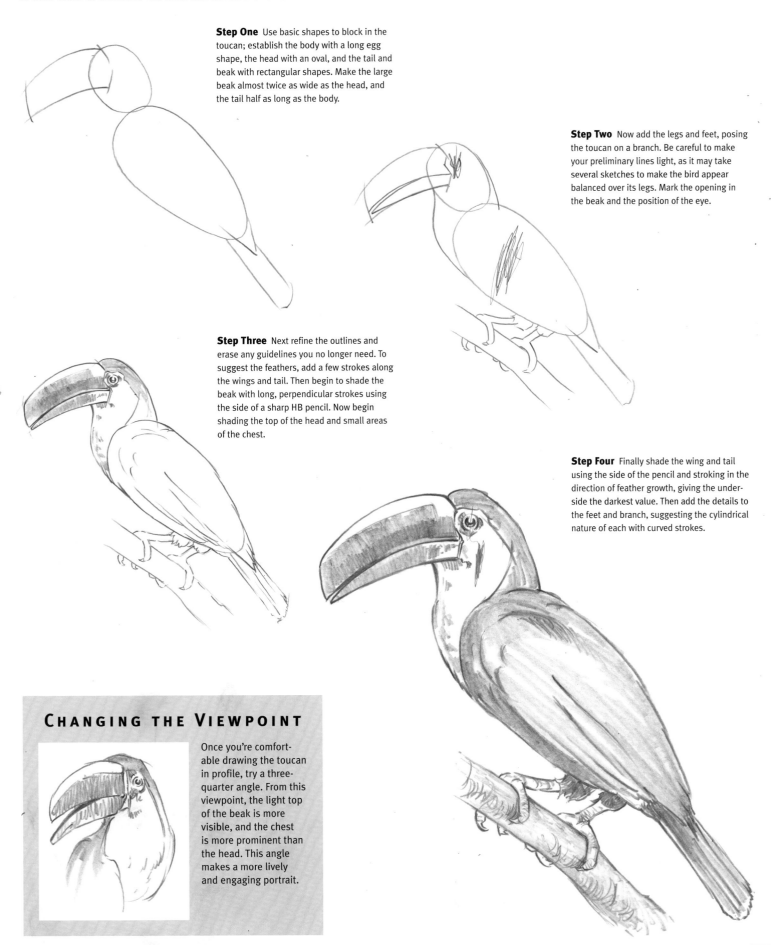

Step One Use basic shapes to block in the toucan; establish the body with a long egg shape, the head with an oval, and the tail and beak with rectangular shapes. Make the large beak almost twice as wide as the head, and the tail half as long as the body.

Step Two Now add the legs and feet, posing the toucan on a branch. Be careful to make your preliminary lines light, as it may take several sketches to make the bird appear balanced over its legs. Mark the opening in the beak and the position of the eye.

Step Three Next refine the outlines and erase any guidelines you no longer need. To suggest the feathers, add a few strokes along the wings and tail. Then begin to shade the beak with long, perpendicular strokes using the side of a sharp HB pencil. Now begin shading the top of the head and small areas of the chest.

Step Four Finally shade the wing and tail using the side of the pencil and stroking in the direction of feather growth, giving the under-side the darkest value. Then add the details to the feet and branch, suggesting the cylindrical nature of each with curved strokes.

CHANGING THE VIEWPOINT

Once you're comfort-able drawing the toucan in profile, try a three-quarter angle. From this viewpoint, the light top of the beak is more visible, and the chest is more prominent than the head. This angle makes a more lively and engaging portrait.

TORTOISE BY WILLIAM F. POWELL

The hard shell of the tortoise produces an interesting shading challenge—you must develop the rounded form by focusing on the highlights and shadows of your subject. As you draw, pay careful attention to the variations in the size and intensity of the shadows.

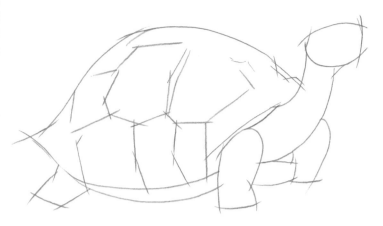

Step One First sketch the roughly oval shape of the tortoise shell and body with an HB pencil. Then draw an egg shape for the head and sketch in the curved neck and stocky legs. Now add rough lines to indicate the general pattern of the shell.

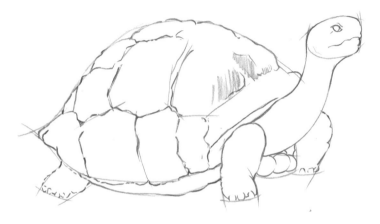

Step Two Next refine the outlines, giving the shell a bumpy perimeter and smoothing the lines of the legs, head, and neck. Then mark the positions of the eye, mouth, and toes and sketch the round segments on the shell just beneath the tortoise's neck.

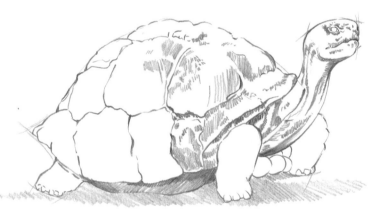

Step Three Now begin to develop the shading on the shell with light, parallel strokes. Start shading the neck with patches of short strokes stretching from the shell toward the head, giving the skin a dry, wrinkled look. Then darken the underside of the tortoise and add a light cast shadow with the side of a soft pencil.

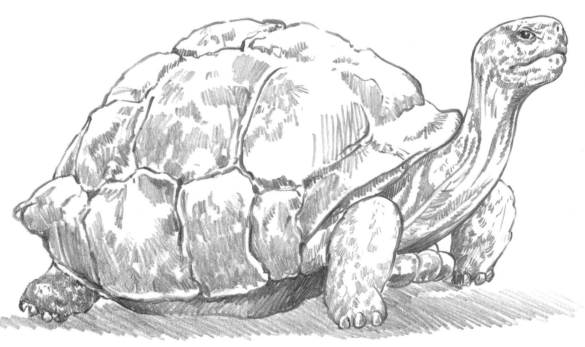

Step Four Continue to apply light shading to the shell, varying the direction of my strokes and leaving plenty of white on the light-colored shell. Develop the texture of the legs and add dimension to the toenails. Then fill in the eye, leaving a highlight in the upper-right quadrant.

Rattlesnake BY William F. Powell

Snake patterns are typically quite repetitive, which makes them easy to render. Just remember to apply perspective to your drawing, sketching smaller shapes on parts of the reptile that are farther from the viewer.

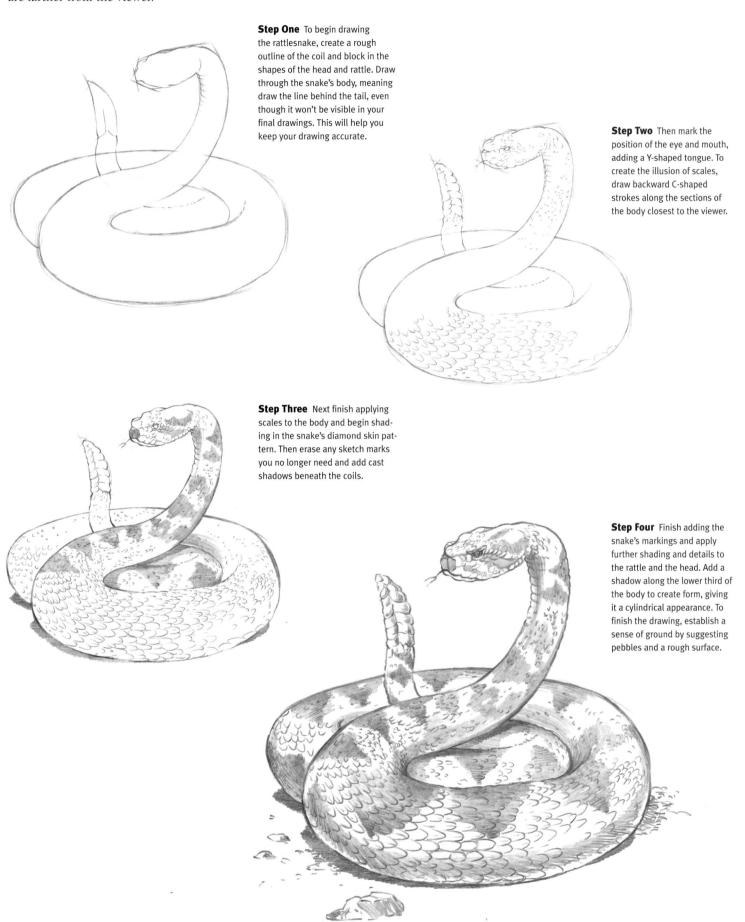

Step One To begin drawing the rattlesnake, create a rough outline of the coil and block in the shapes of the head and rattle. Draw through the snake's body, meaning draw the line behind the tail, even though it won't be visible in your final drawings. This will help you keep your drawing accurate.

Step Two Then mark the position of the eye and mouth, adding a Y-shaped tongue. To create the illusion of scales, draw backward C-shaped strokes along the sections of the body closest to the viewer.

Step Three Next finish applying scales to the body and begin shading in the snake's diamond skin pattern. Then erase any sketch marks you no longer need and add cast shadows beneath the coils.

Step Four Finish adding the snake's markings and apply further shading and details to the rattle and the head. Add a shadow along the lower third of the body to create form, giving it a cylindrical appearance. To finish the drawing, establish a sense of ground by suggesting pebbles and a rough surface.

GIANT PANDA BY WILLIAM F. POWELL

Pandas are an easy subject to approach when you begin with simple shapes. Start with a circles for the head and body; then add ovals for the arms, legs, and paws. Add the details, such as the eyes, nose, and bamboo leaves. Then use soft, short strokes to indicate the texture of the panda's thick black-and-white fur. When rendering hair, always stroke in the direction it grows.

Step One First establish the panda's overall shape and pose. Start with a circle for the head and a larger oval for the body. Then draw a series of ovals for the arms, legs, and feet, dividing the left arm into upper and lower sections. Also mark the general shape and position of the ears, the eye mask, and the nose.

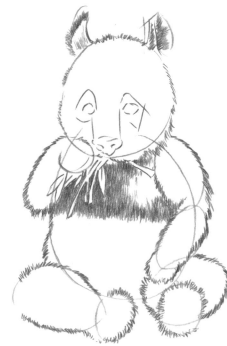

Step Two Next place the eyes, refine the shape of the nose, and sketch in the branch of bamboo. Use the side of a soft pencil and make short, soft marks around the outlines to indicate fur. Then begin shading all the black areas on the coat with an HB pencil, stroking downward in the direction of the hair growth.

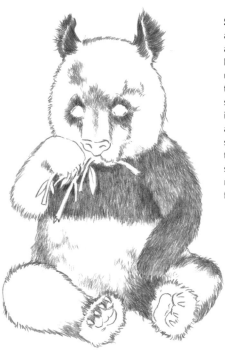

Step Three Now erase any remaining guidelines and continue shading the black areas of fur. Then use a blending stump to smooth the pencil strokes, creating the illusion of soft fur. Add a few closely spaced strokes in the white fur to give it dimension and suggest the underlying muscles. Then draw the footpads and toenails.

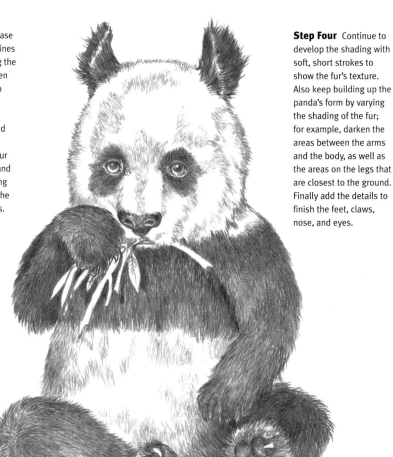

Step Four Continue to develop the shading with soft, short strokes to show the fur's texture. Also keep building up the panda's form by varying the shading of the fur; for example, darken the areas between the arms and the body, as well as the areas on the legs that are closest to the ground. Finally add the details to finish the feet, claws, nose, and eyes.

GIRAFFE BY WILLIAM F. POWELL

Accurate proportions are important when drawing the giraffe; when blocking in your drawing, consider how making the legs too short or the neck too thick would alter the animal's appearance. Use the head as a unit of measurement to draw the rest of the body in correct proportion—for example, pay attention to how many heads long the legs and neck are.

Step One To begin, block in the basic shape of the giraffe, adjusting the lines until you are satisfied with the proportions. Notice that the giraffe's neck is as long as its legs, and its hindquarters slope down sharply.

Step Two Now begin to refine the shapes of the legs and rump, smoothing the outline. Then begin placing the features and blocking in the pattern of the coat. For this species of giraffe, the spots all have slightly different irregular shapes, with small gaps between them.

Step Three Now erase any stray sketch marks and focus your attention on rendering the giraffe's face. (See the details in the box below.) Then fill in all the dark patches of the coat, adding the mane with a 2B pencil and short, dense diagonal strokes.

DRAWING THE HEAD

Start with a circle for the head and two smaller circles for the muzzle; then add the horns and ears. Draw a curved jaw line, and sketch in the eyes—and eyelashes—and inner ear details. Then refine all the outlines and shade the face, using a soft pencil for the dark areas and changing the direction of the strokes to follow the forms.

Step Four In this final step, after shading the face, add the shading beneath the giraffe's body and head. To keep the giraffe from appearing to float on the page, draw the ground with tightly spaced diagonal strokes.

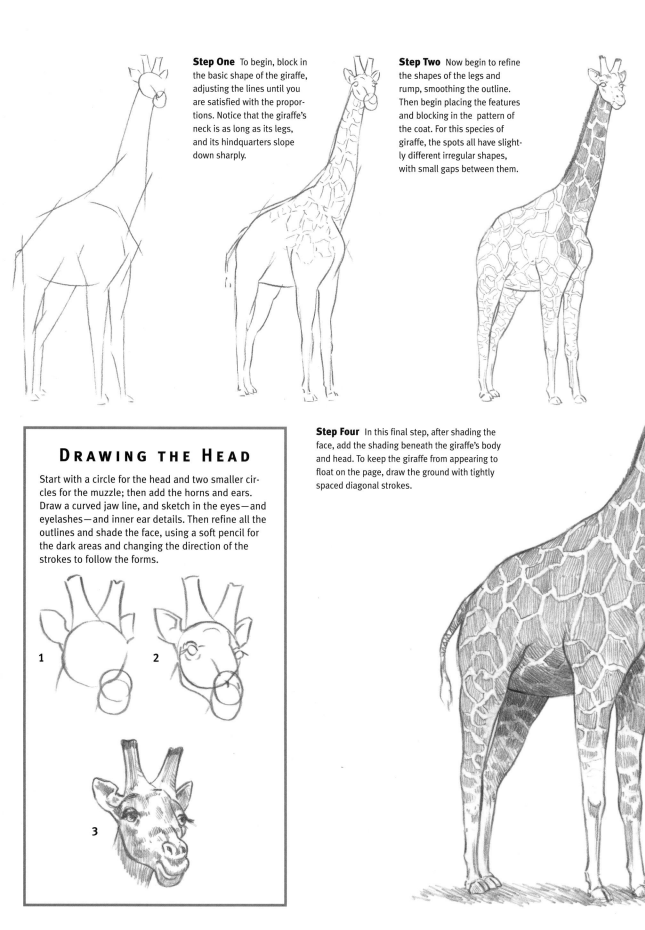

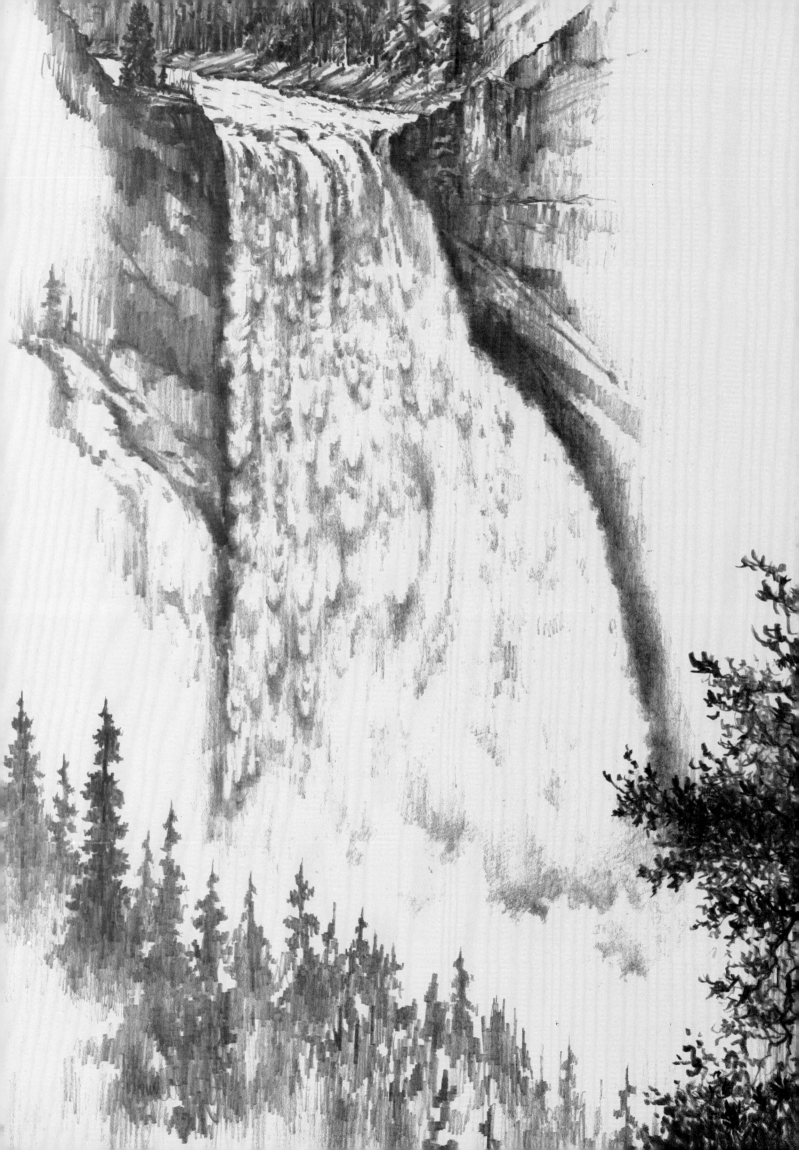

INTRODUCTION TO
LANDSCAPES

You can discover beautiful landscapes almost anywhere—in your vacation photographs, at local parks, and even in your own back-yard! Throughout the following lessons, you'll learn how to draw any outdoor scene, from rushing rapids to lush foliage and majestic mountains. You'll learn how to choose suitable subjects, create a sense of depth through perspective, and utilize varying points of view. You'll also discover simple techniques for developing common landscape elements—such as trees, clouds, rocks, and water—and how to apply a variety of shading methods to convey a sense of realism. Soon you'll be able to apply your newfound skills and draw your own scenic masterpieces!

LANDSCAPE COMPOSITION BY WILLIAM F. POWELL

Most landscapes have a *background*, a *middle ground*, and a *foreground*. The background represents areas that are farthest in distance; the foreground represents the areas that appear closest in distance; the middle ground is in between. The background, middle ground, and foreground do not have to take up equal space in a composition. Below, the middle ground and foreground are placed low, so the elements in the background become the area of interest.

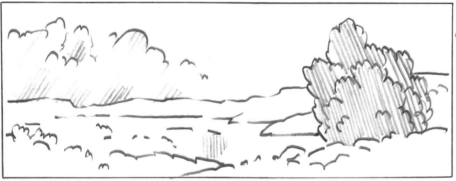

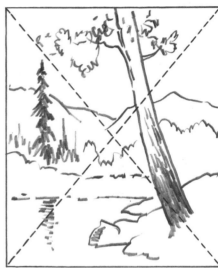

Choosing a Viewpoint The wide horizontal landscape above illustrates a *panoramic* view. The tree shapes on the left and the right lean slightly toward the center, drawing the eye into the middle of the composition. In the example to the right, notice how the elements direct the eye to the center by subtly "framing" that area. Below, the road in the foreground leads back to the small structure, which is the focus of the drawing.

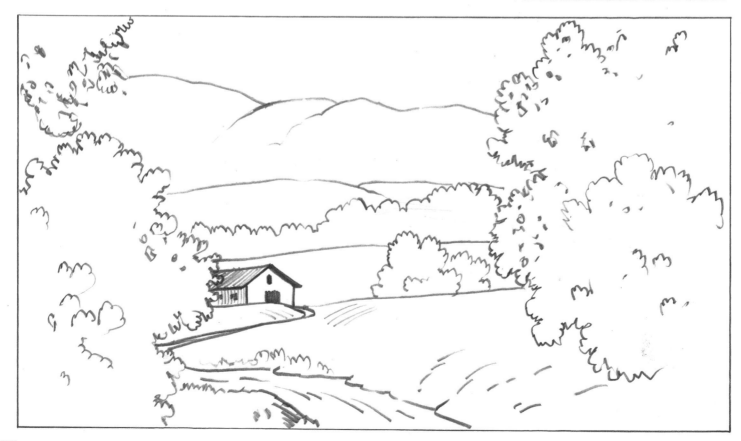

96

PERSPECTIVE TIPS BY WILLIAM F. POWELL

To create a realistic landscape, you should be familiar with some basic principles of perspective. In the line drawing below, the horizontal edges of the planes move closer together as they recede to the left and right, eventually merging at vanishing points outside the picture area. (Refer to pages 8–9 to get an understanding of the basics of perspective.) Then sketch some simple boxes for practice, moving on to more involved subjects, such as buildings.

Once you've correctly drawn the building with straight lines, you can add details that make the structure appear aged, such as the sagging roof and holes in the walls.

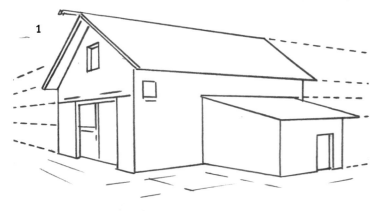

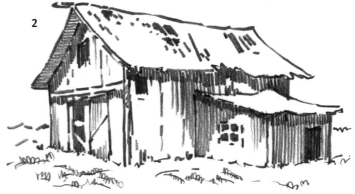

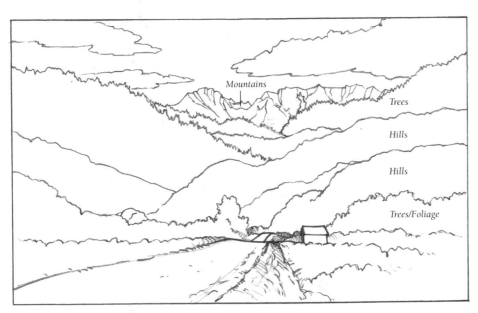

Showing Depth and Distance The illusion of depth is obvious in the line drawing to the left; the road narrows as it travels back into the distance, and the hills overlap each other. To offset the slanting curves of the hills and foliage, a structure was placed just to the right of center.

Practice creating the illusion of depth by sketching some overlapping elements similar to the ones in this landscape. Vary the lines for the areas representing foliage and trees; make them appear bumpy and bushy. For the road, draw two relatively straight lines that move closer together as they recede.

Applying Atmospheric Perspective As objects recede into the distance, they appear smaller and less detailed. Notice that the trees and bushes that surround the little church make it appear far away. Study the arrow directions in the foreground; they help illustrate the correct perspective lines along the ground plane.

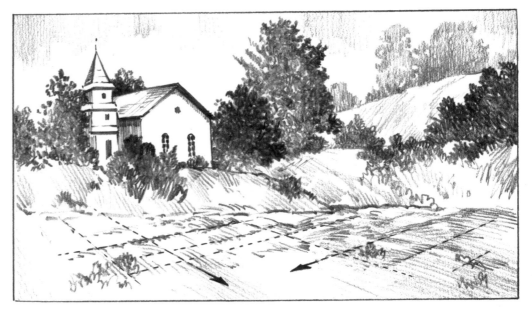

CLOUDS BY WILLIAM F. POWELL

Clouds are great elements to include in a landscape because they can set the mood of the drawing. Some clouds create a dramatic mood, while others evoke a calm feeling.

Rendering Cloud Shapes Use a soft pencil, such as a 2B, to lightly outline the basic cloud shapes. Then use the side of the pencil lead to shade the sky in the background. Your shading will give the clouds fullness and form.

Study the various cloud types on this page, and practice drawing them on your own. Try to create puffy, cottonlike clouds, and thin, smoky ones. Observe clouds you see in the sky, and sketch those as well.

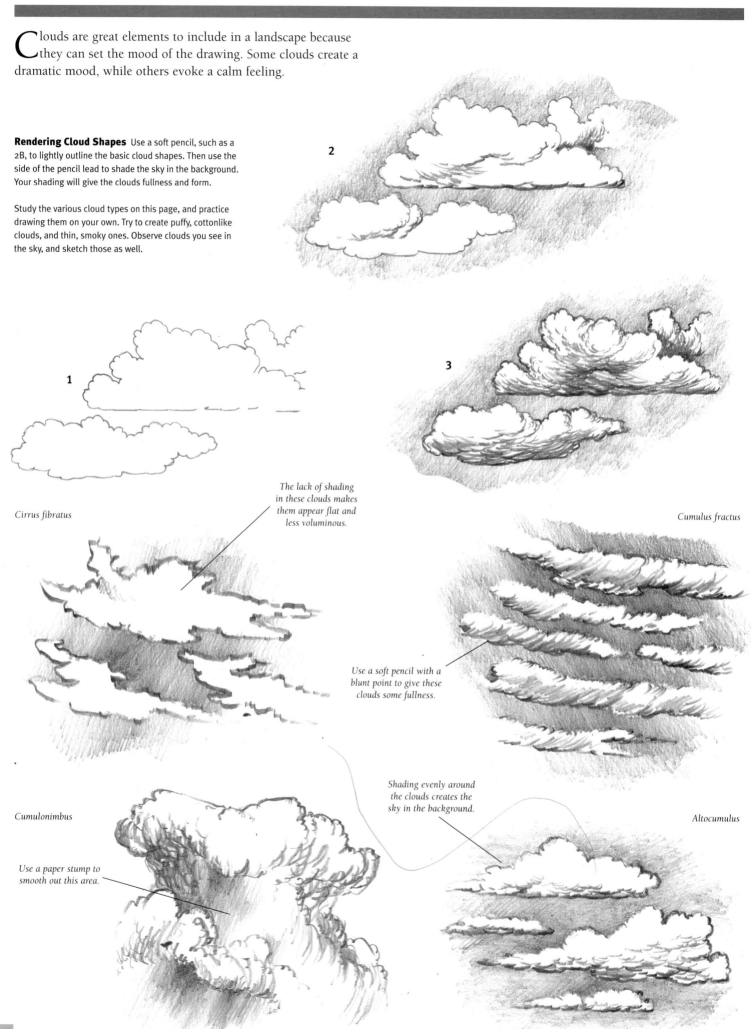

Cirrus fibratus

The lack of shading in these clouds makes them appear flat and less voluminous.

Cumulus fractus

Use a soft pencil with a blunt point to give these clouds some fullness.

Cumulonimbus

Use a paper stump to smooth out this area.

Shading evenly around the clouds creates the sky in the background.

Altocumulus

Applying Shading Techniques The various shading techniques used for the clouds on this page produce distinct feelings. The strong, upsweeping strokes in the drawing to the right evoke power and energy, while the bubbly, puffy texture of the clouds below have a calmer effect.

Use different pencils sharpened to a variety of tips to create the special effects shown. Use your finger or the side of a paper stump to blend the broader areas and the point of the stump for smaller, more intricate details.

Draw with the pencil pointing toward the outer cloud edge.

Draw cloud forms loosely with a flat sketch pencil.

To create dark, stormy clouds shade with the flat side of a 2B pencil.

Use a jagged chisel edge to create texture in the cloud shadows.

99

ROCKS BY WILLIAM F. POWELL

Because rocks come in many shapes, the best approach is to closely observe the ones you're drawing. To begin, lightly block in the basic shapes in step 1 to establish the different planes.

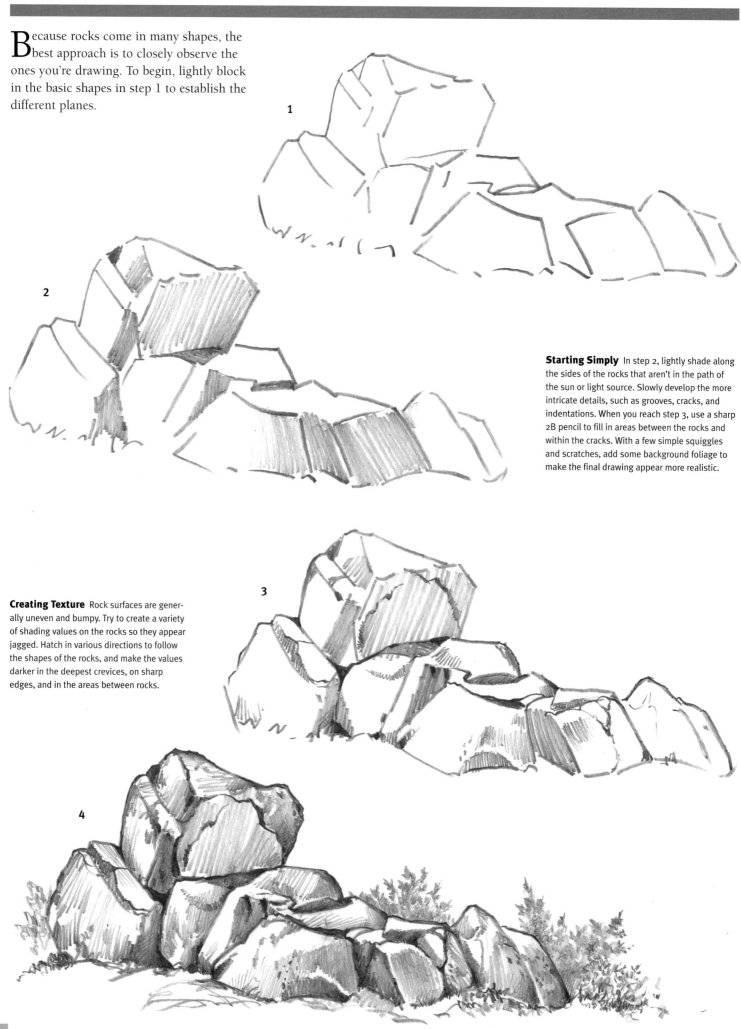

Starting Simply In step 2, lightly shade along the sides of the rocks that aren't in the path of the sun or light source. Slowly develop the more intricate details, such as grooves, cracks, and indentations. When you reach step 3, use a sharp 2B pencil to fill in areas between the rocks and within the cracks. With a few simple squiggles and scratches, add some background foliage to make the final drawing appear more realistic.

Creating Texture Rock surfaces are generally uneven and bumpy. Try to create a variety of shading values on the rocks so they appear jagged. Hatch in various directions to follow the shapes of the rocks, and make the values darker in the deepest crevices, on sharp edges, and in the areas between rocks.

1

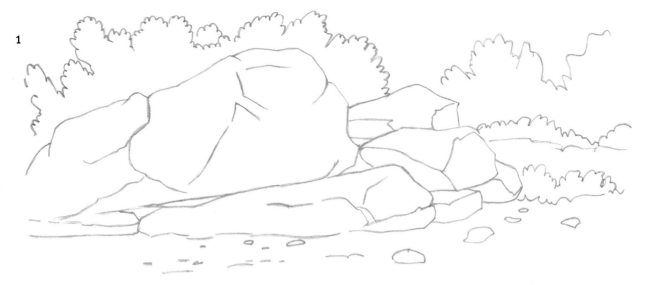

Rendering Sunlit Rocks Use the same steps for the rocks on this page, but apply more shading to the entire surfaces. To make the rocks appear as though sunlight is shining on them, use a kneaded eraser to eliminate shading in the appropriate areas, or leave areas of the paper white.

2

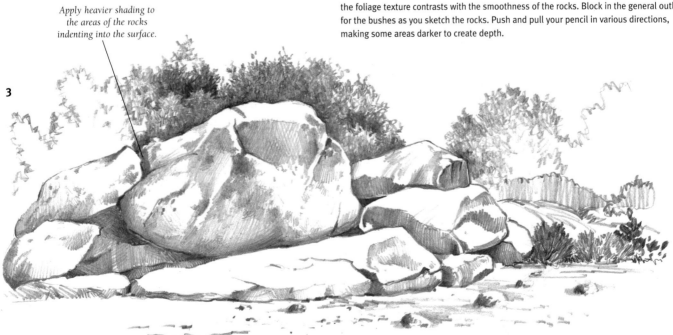

Adding Greenery Foliage provides an effective, natural background for rocks, because the foliage texture contrasts with the smoothness of the rocks. Block in the general outline for the bushes as you sketch the rocks. Push and pull your pencil in various directions, making some areas darker to create depth.

Apply heavier shading to the areas of the rocks indenting into the surface.

3

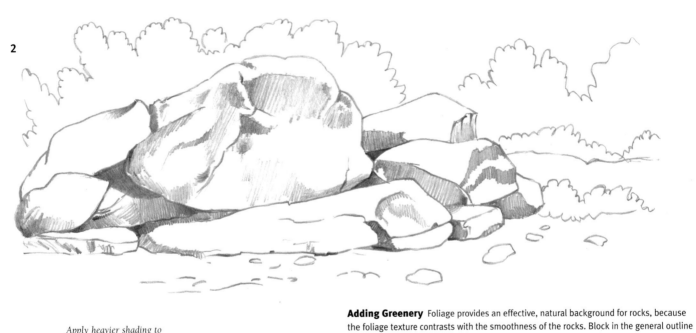

TREE SHAPES BY WILLIAM F. POWELL

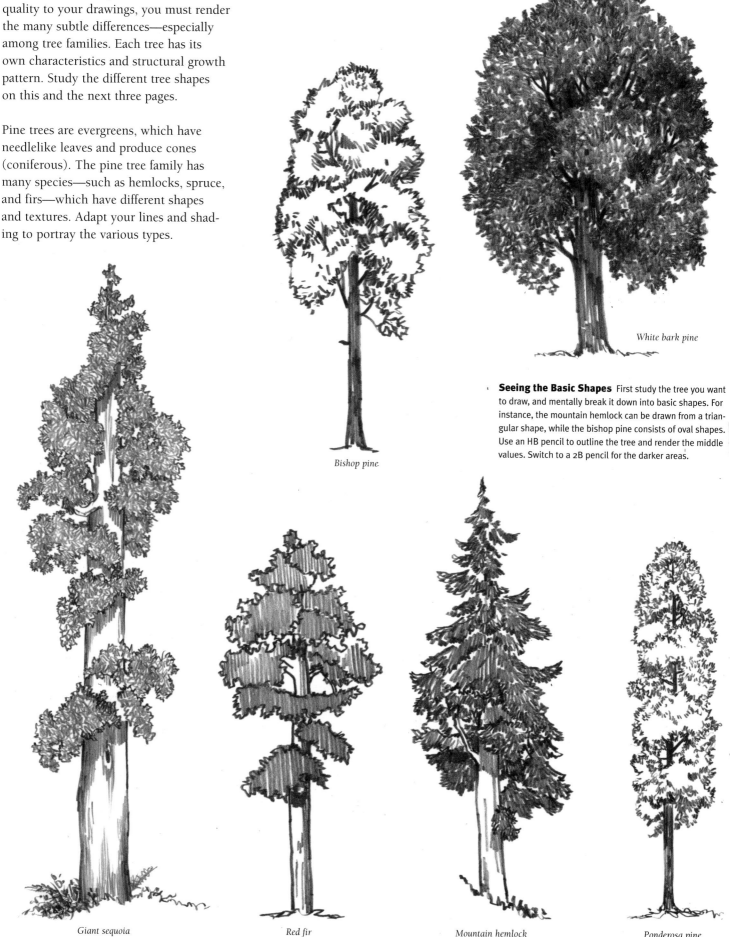

Tree shapes vary tremendously. Some are tall and thin, while others are short and wide. To provide an authentic quality to your drawings, you must render the many subtle differences—especially among tree families. Each tree has its own characteristics and structural growth pattern. Study the different tree shapes on this and the next three pages.

Pine trees are evergreens, which have needlelike leaves and produce cones (coniferous). The pine tree family has many species—such as hemlocks, spruce, and firs—which have different shapes and textures. Adapt your lines and shading to portray the various types.

White bark pine

Bishop pine

Seeing the Basic Shapes First study the tree you want to draw, and mentally break it down into basic shapes. For instance, the mountain hemlock can be drawn from a triangular shape, while the bishop pine consists of oval shapes. Use an HB pencil to outline the tree and render the middle values. Switch to a 2B pencil for the darker areas.

Giant sequoia

Red fir

Mountain hemlock

Ponderosa pine

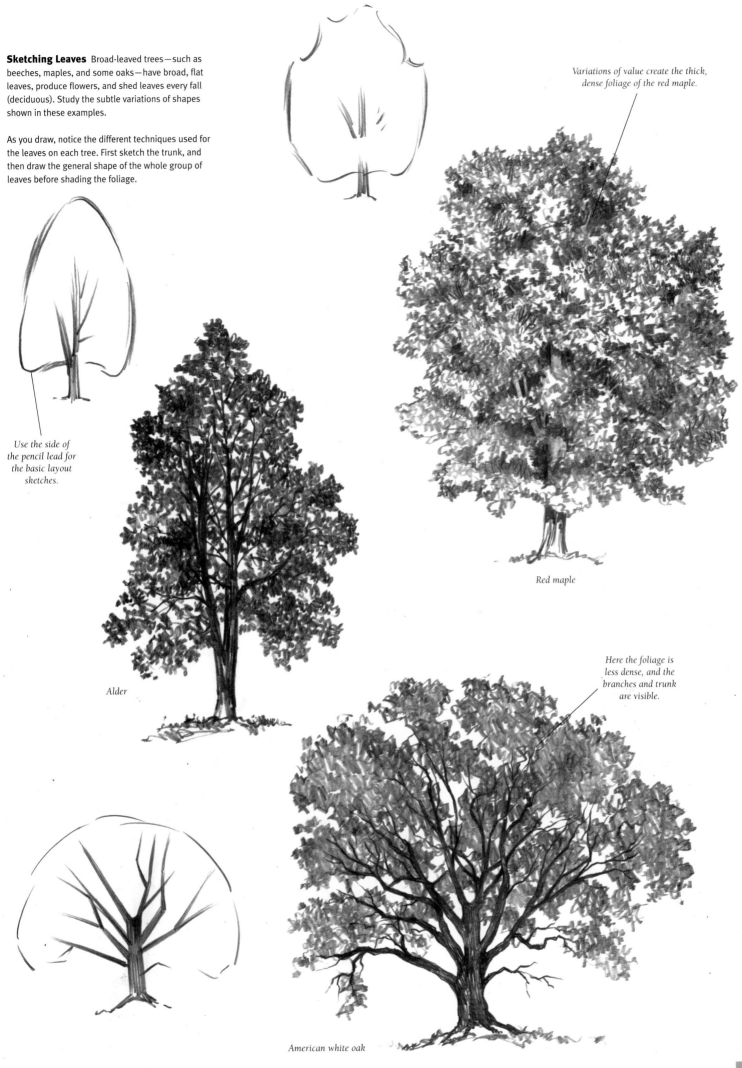

Sketching Leaves Broad-leaved trees—such as beeches, maples, and some oaks—have broad, flat leaves, produce flowers, and shed leaves every fall (deciduous). Study the subtle variations of shapes shown in these examples.

As you draw, notice the different techniques used for the leaves on each tree. First sketch the trunk, and then draw the general shape of the whole group of leaves before shading the foliage.

Use the side of the pencil lead for the basic layout sketches.

Variations of value create the thick, dense foliage of the red maple.

Red maple

Alder

Here the foliage is less dense, and the branches and trunk are visible.

American white oak

TREE SHAPES (CONT.)

A variety of tree families is represented on these pages. Notice the difference in shapes and textures between the trunks and leaves.

You will need a round HB and flat sketch pencils to draw these trees. Refer to the small layout sketches to lightly block in the guidelines. Experiment with a variety of strokes to develop the unique appearance of each tree.

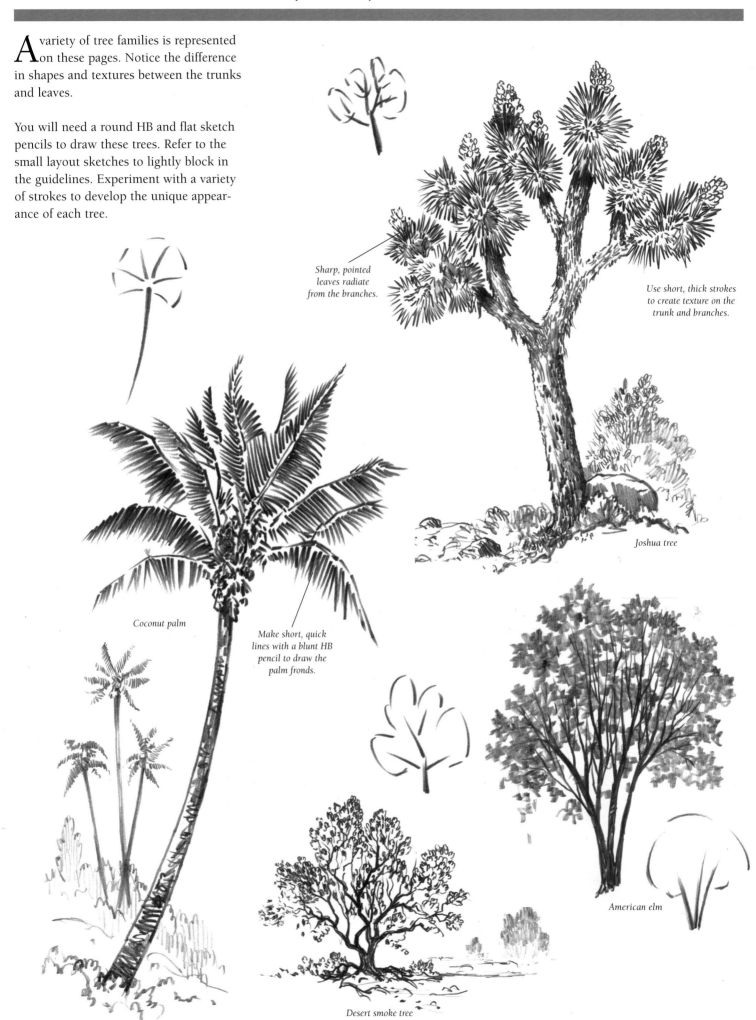

Sharp, pointed leaves radiate from the branches.

Use short, thick strokes to create texture on the trunk and branches.

Joshua tree

Coconut palm

Make short, quick lines with a blunt HB pencil to draw the palm fronds.

American elm

Desert smoke tree

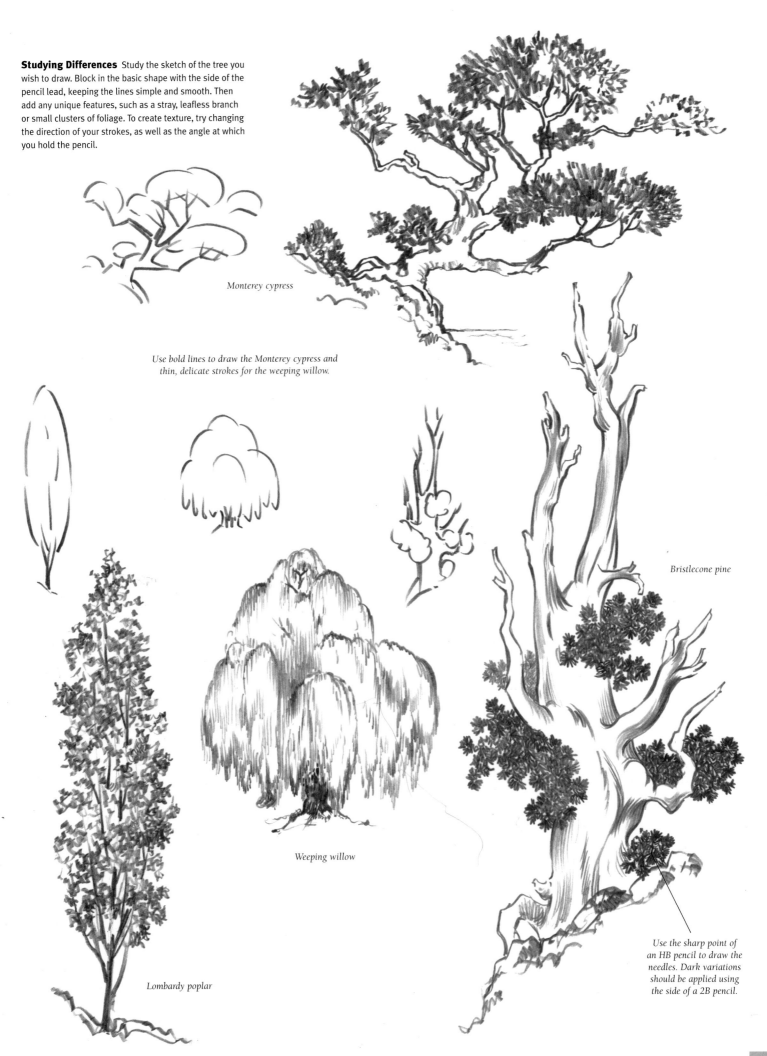

Studying Differences Study the sketch of the tree you wish to draw. Block in the basic shape with the side of the pencil lead, keeping the lines simple and smooth. Then add any unique features, such as a stray, leafless branch or small clusters of foliage. To create texture, try changing the direction of your strokes, as well as the angle at which you hold the pencil.

Monterey cypress

Use bold lines to draw the Monterey cypress and thin, delicate strokes for the weeping willow.

Bristlecone pine

Weeping willow

Lombardy poplar

Use the sharp point of an HB pencil to draw the needles. Dark variations should be applied using the side of a 2B pencil.

STRUCTURES BY WILLIAM F. POWELL

Although the building in this landscape lies in the background, it still appears to be the main focus. Start with simple shapes and lines to lay out most of the elements in step 1. The building should be the correct size in relation to the trees, and all elements should be drawn in proper perspective.

1

2

3

4

5

6

Focusing on Development In steps 2 through 4, refine the shapes, and begin to add some detail within the foliage and along the edge of the road. When you begin shading in step 5, start in the background, filling in the shadows first. As you progress, work on the entire drawing so it doesn't appear as though you emphasized a certain area. Although the structure is the main focus, the entire drawing should be finished with the same level of thought and care.

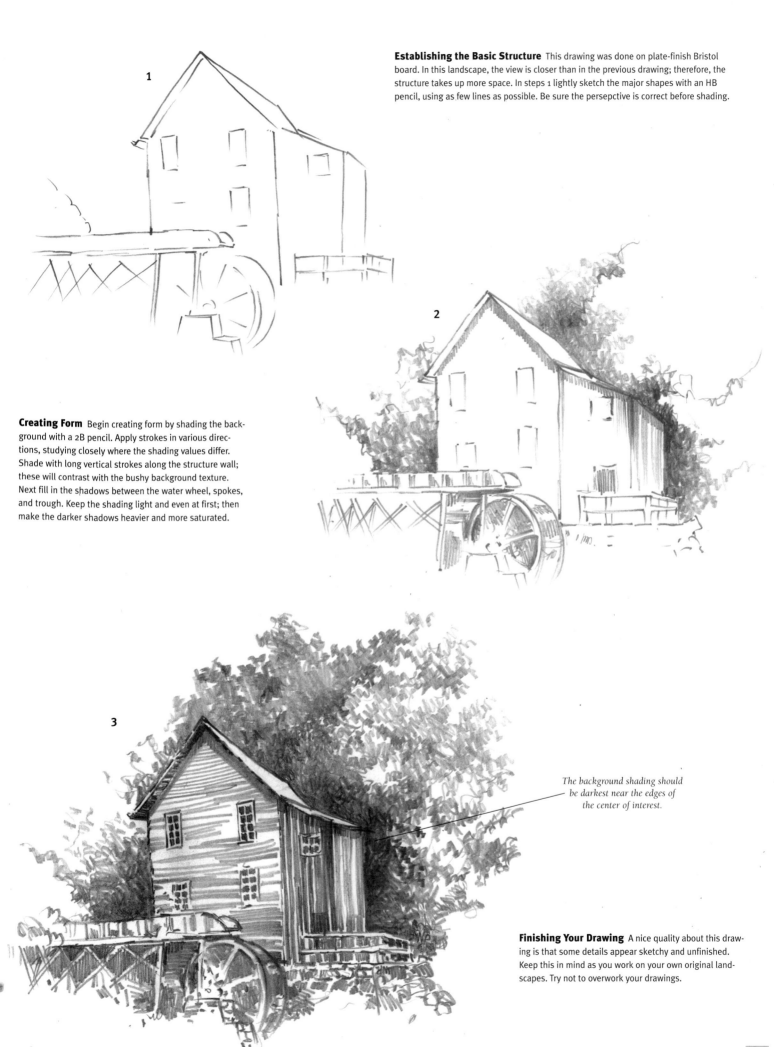

Establishing the Basic Structure This drawing was done on plate-finish Bristol board. In this landscape, the view is closer than in the previous drawing; therefore, the structure takes up more space. In steps 1 lightly sketch the major shapes with an HB pencil, using as few lines as possible. Be sure the persepctive is correct before shading.

Creating Form Begin creating form by shading the background with a 2B pencil. Apply strokes in various directions, studying closely where the shading values differ. Shade with long vertical strokes along the structure wall; these will contrast with the bushy background texture. Next fill in the shadows between the water wheel, spokes, and trough. Keep the shading light and even at first; then make the darker shadows heavier and more saturated.

The background shading should be darkest near the edges of the center of interest.

Finishing Your Drawing A nice quality about this drawing is that some details appear sketchy and unfinished. Keep this in mind as you work on your own original landscapes. Try not to overwork your drawings.

MOUNTAINS BY WILLIAM F. POWELL

A mountain landscape can be blocked in with a few straight lines, as shown in step 1. Refine the shapes into the rugged mountains in step 2, keeping in mind that it isn't necessary to include every indentation and curvature you see. Just include the major ones to capture the essence of the subject. As you shade in steps 3 and 4, remember that areas indenting deepest into the mountain should be shaded darker to bring out the rocky texture.

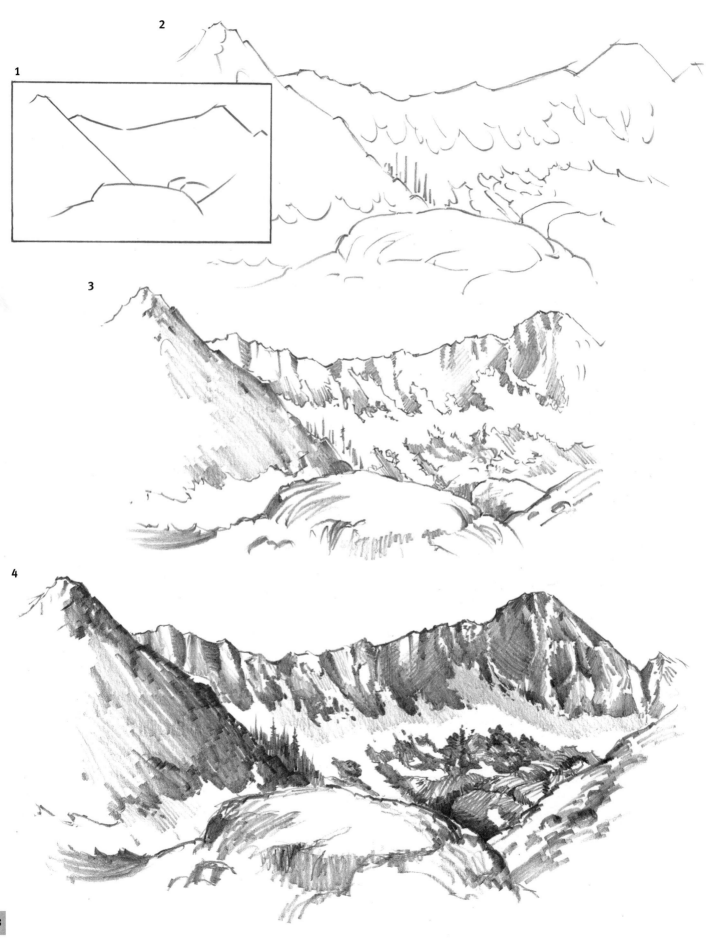

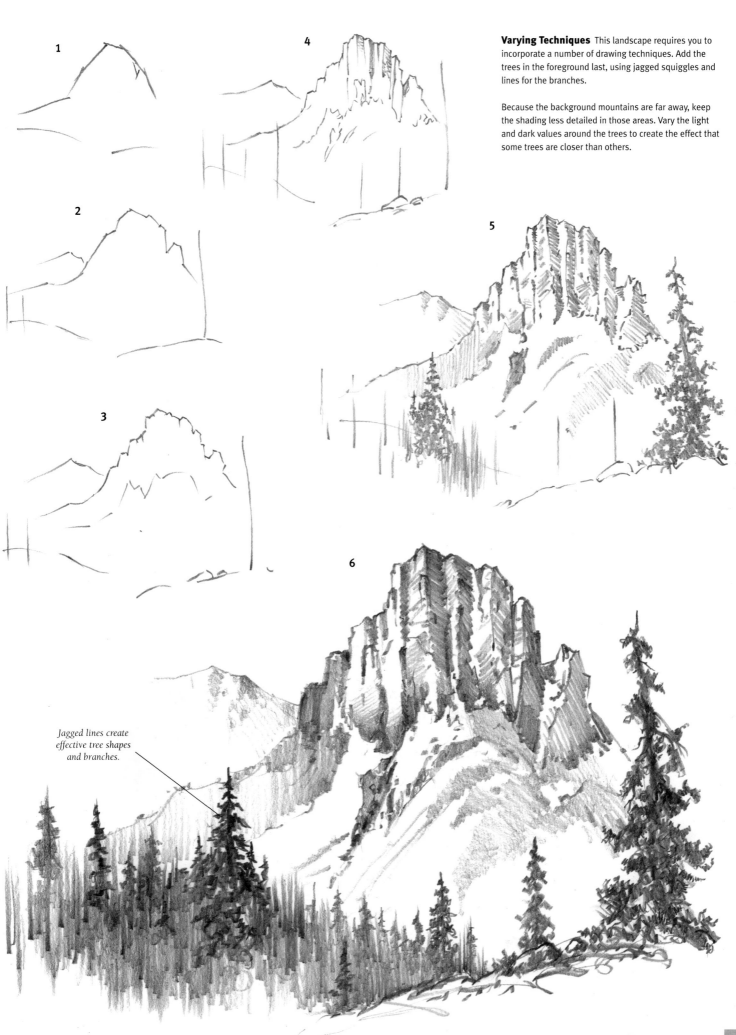

Varying Techniques This landscape requires you to incorporate a number of drawing techniques. Add the trees in the foreground last, using jagged squiggles and lines for the branches.

Because the background mountains are far away, keep the shading less detailed in those areas. Vary the light and dark values around the trees to create the effect that some trees are closer than others.

1

2

3

4

5

6

Jagged lines create effective tree shapes and branches.

DESERTS BY WILLIAM F. POWELL

Deserts make excellent landscape subjects because they pro-vide a variety of challenging textures and shapes. In step 1, lay out the major elements with an HB pencil then refine the shapes. Then add a few light shadows in step 2. The finished drawing shows minimal shading, which creates the illusion of expansive light around the entire landscape.

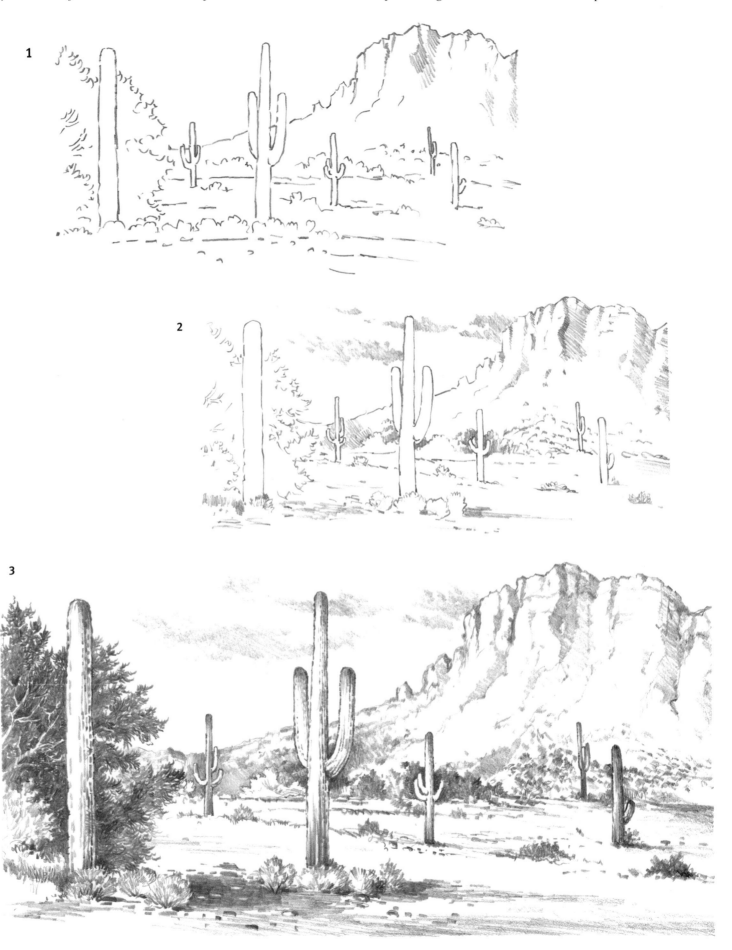

Emphasizing Size The great vertical stature of these incredible rocks produces a dramatic desert landscape. From this angle, it seems as though you are peering up at them; therefore, the rocks have an overpowering presence. Block in all the basic shapes before shading. Use a sharp 2B pencil to fill in the crevices and cracks. This drawing is unique because the shading in the foreground is darker than the shading in the background. This effect is caused by the position of the light source (the sun); it is to the left of the main rock formations, creating shadows on the right side of the rocks.

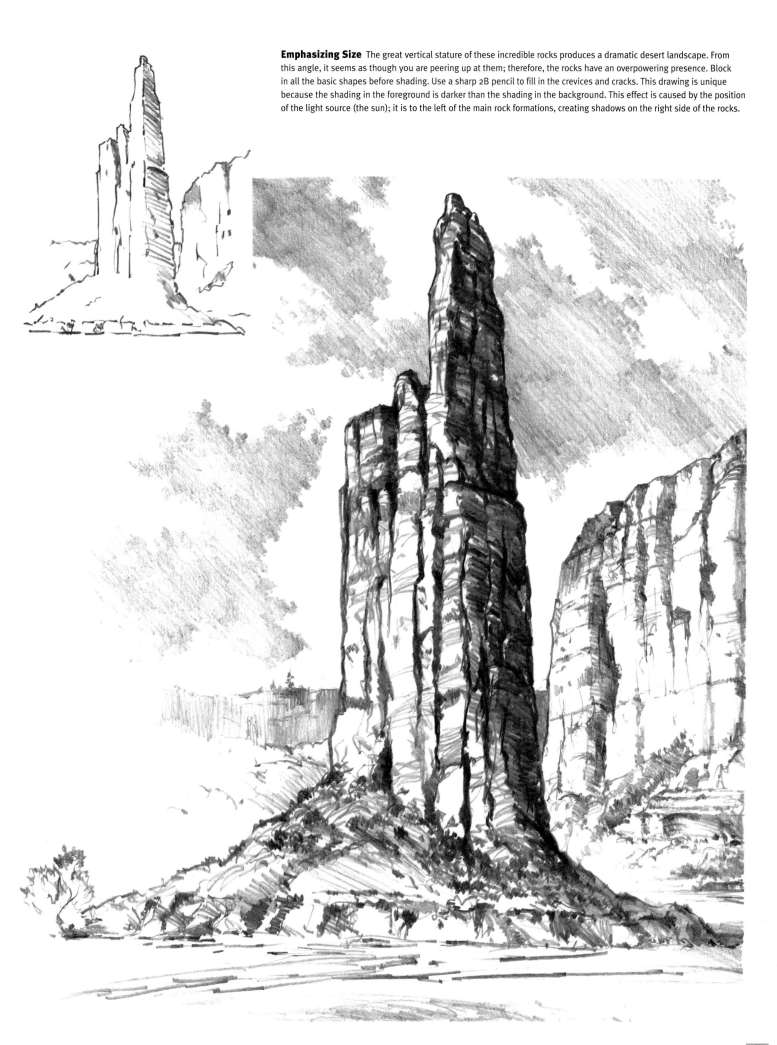

CREEK WITH ROCKS BY WILLIAM F. POWELL

Drawing landscapes containing creeks and rocks is a great way to improve artistic skills because of the variety of surface textures. It's imperative that your preliminary drawing accurately shows depth by overlapping elements, uses proper perspective, and maintains a pleasing balance of elements. This eliminates the need to make corrections later.

1

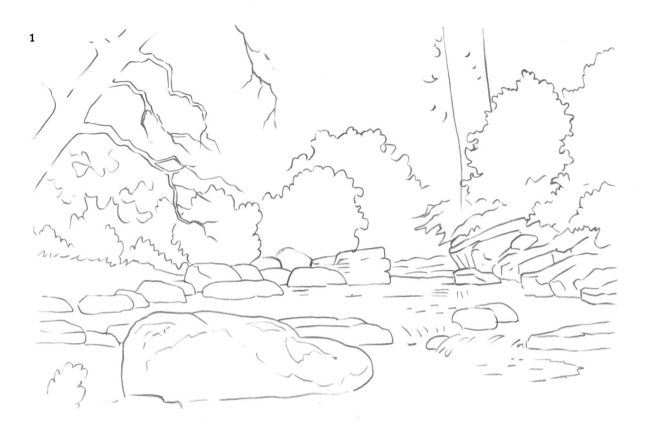

Starting with a Basic Sketch Begin shading the trees in the distance; then work your way to the middle ground and foreground. Remember—don't completely shade each object before moving to the next one. Work on the entire drawing so it maintains a sense of unity. You don't want one area to unbalance the landscape or appear as though you spent more time on it. Even though there are many light and dark areas throughout the drawing, the degree of shading should remain relatively consistent.

2

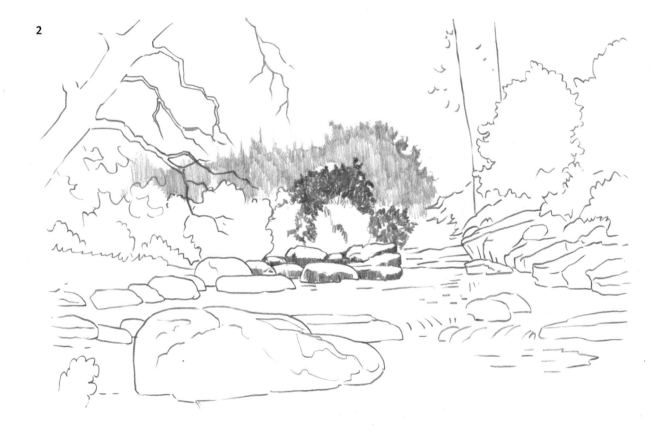

3

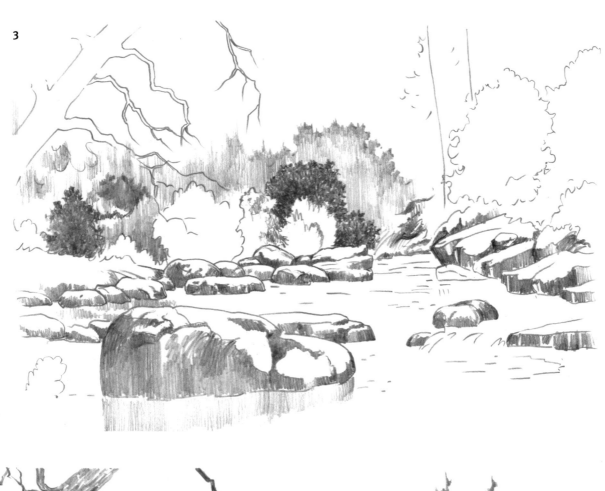

4

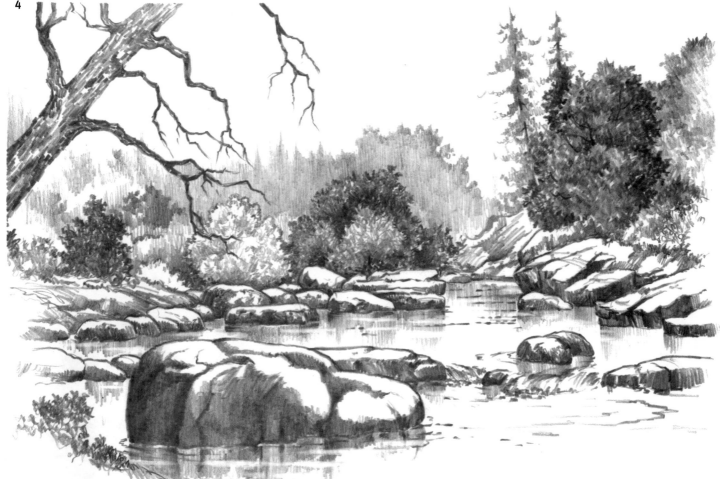

Rendering Texture Use the side of an HB pencil, shading in even strokes, to create the reflections in the water. Keep in mind that an object's reflection is somewhat distorted in moving water and mirrored in still water. For example, the reflection of the sharp rock edges here appears blurred and uneven. Closely study your landscape so you don't miss any of the details. Apply strokes in directions that correspond with the rocks' rugged, uneven texture, and fill in the areas between the cracks with a sharp 2B or 4B pencil.

SYCAMORE LANE BY WILLIAM F. POWELL

A good sketch will go a long way toward capturing the mood of a scene. In this drawing, the tree is obviously old and majestic. The trunk leans dramatically from its base to the middle of the drawing at the top. The winding road serves two purposes—it leads the eye into the drawing and creates contrast, which balances out the nearly straight line of the trunk.

Use an HB pencil to block in the mass shapes.

Step One To begin this scene, place the basic shapes, refine them, and then add values. Apply light and middle values to establish a backdrop for more intense shading.

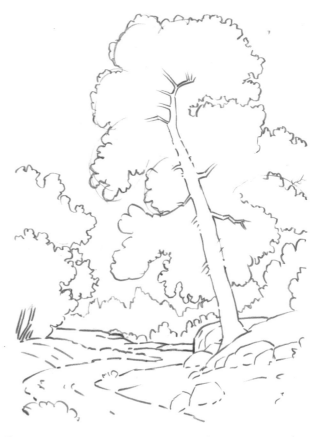

Step Two Refine the shapes of the trees and the road. Then use light vertical strokes for the trees in the background. Continue adding details as you work toward the foreground.

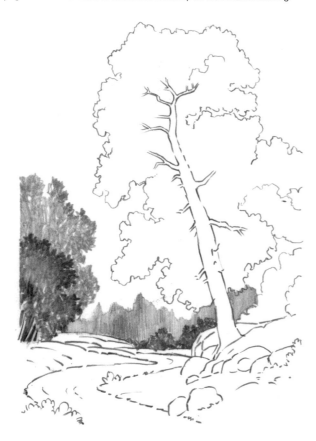

Step Three Continue adding values, and work your way to the foreground.

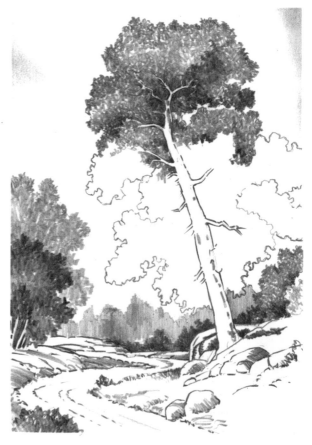

Step Four Use the side of an HB for the wide strokes of foliage and shaded areas.

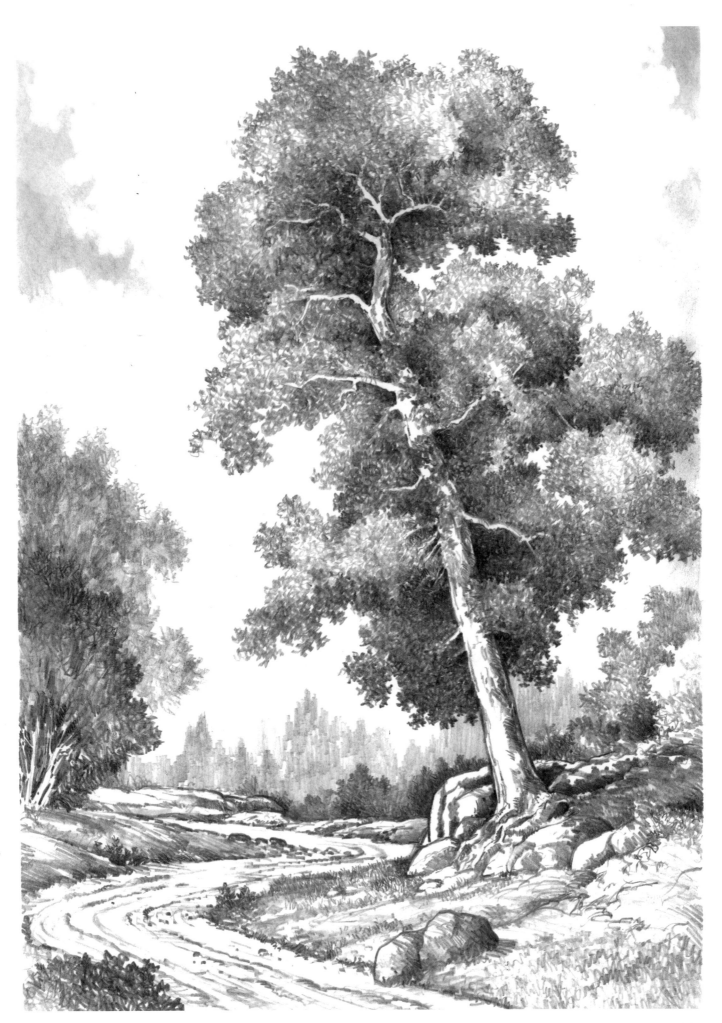

Step Five Add final dark values. Continue the foliage texture, leaving some areas lighter to create depth. Lightly shade the sky areas; then clean out the cloud forms with a kneaded eraser.

HALF DOME, YOSEMITE BY WILLIAM F. POWELL

Because Half Dome, located in Yosemite Valley, California, is fairly well known and recognizable, you should try to render the shapes and forms as close to the actual location as possible.

Sketching Loosely Block in the general shapes of the landscape elements in step 1, including the trees and surrounding rock formations.

Distinguishing Surfaces Start shading the face of Half Dome in step 2, using vertical strokes. Try to capture the major crevices so the drawing resembles the actual location. As you shade, remember to change the direction of your strokes with each new surface plane.

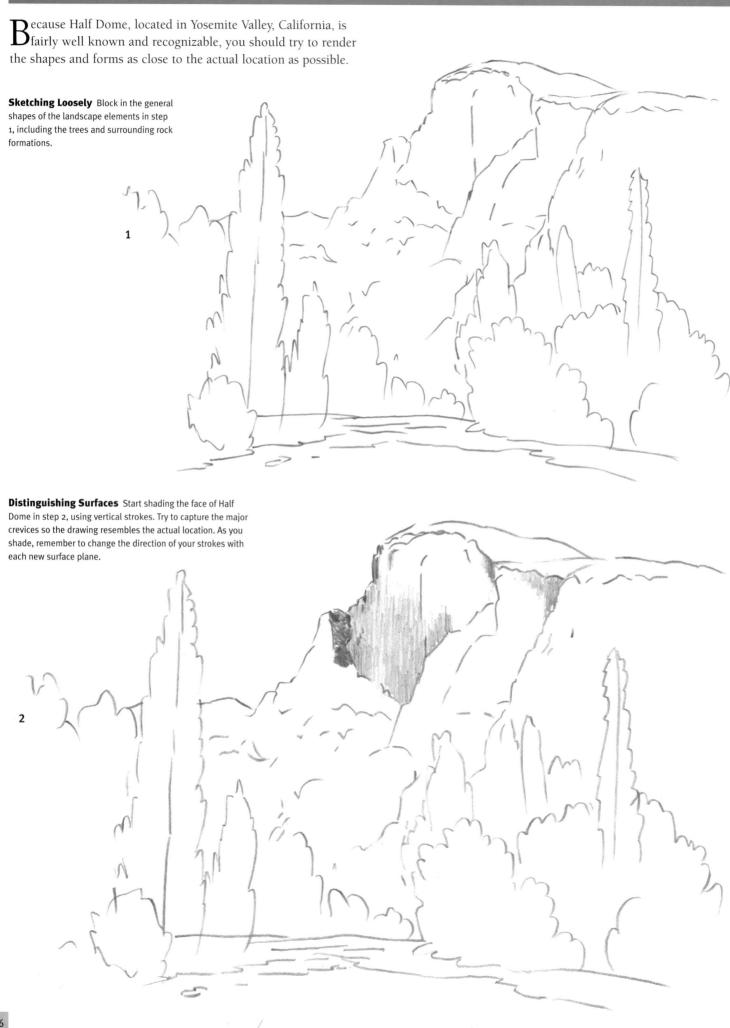

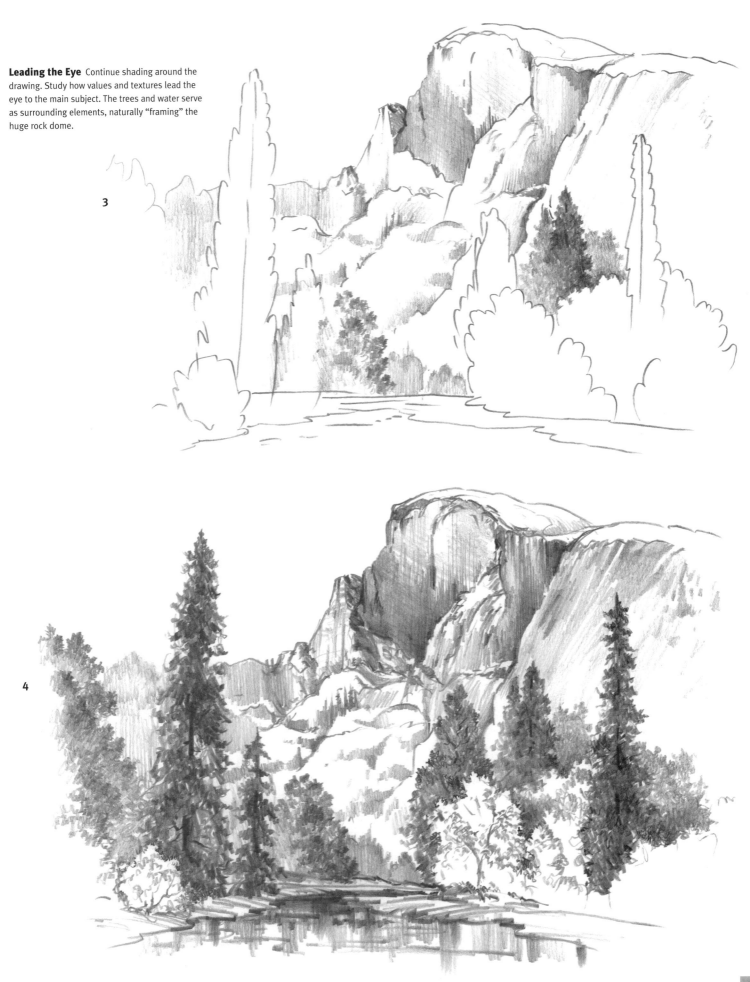

Leading the Eye Continue shading around the drawing. Study how values and textures lead the eye to the main subject. The trees and water serve as surrounding elements, naturally "framing" the huge rock dome.

3

4

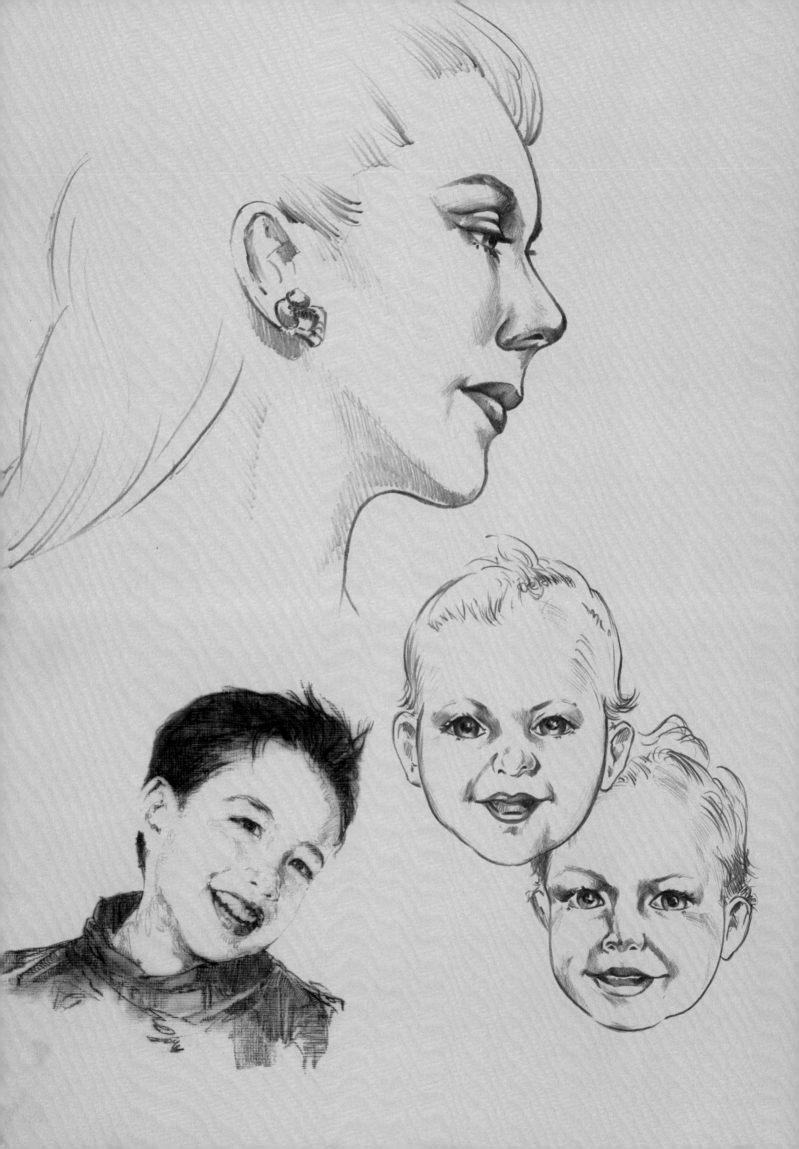

INTRODUCTION TO
PEOPLE

From the subtleties of emotion conveyed by facial expressions to
the limitless number of shapes the human form can take, people are
some of the most captivating subjects to draw. Knowing how to
capture a human likeness also gives you the confidence to explore
a wider range of subjects and compositions in your drawing adven-
tures. In the following pages, you'll learn the basic principles of
drawing figures, from finding the proper proportions to sketching
profiles and studying the movements of the human body. You'll also
learn how to apply simple shading techniques that will bring life to
all of your portraits!

BEGINNING PORTRAITURE BY MICHAEL BUTKUS

A good starting point for drawing people is the head and face. The shapes are fairly simple, and the proportions are easy to measure. And portraiture is also very rewarding. You can feel a great sense of satisfaction when you look at a portrait you've drawn and see a true likeness of your subject, especially when the model is someone near and dear to you. So why not start with children?

DRAWING A CHILD'S PORTRAIT

Once you've practiced drawing features, you're ready for a full portrait. You'll probably want to draw from a photo, though, since children rarely sit still for very long! Study the features carefully, and try to draw what you truly see, and not what you think an eye or a nose should look like. But don't be discouraged if you don't get a perfect likeness right off the bat. Just keep practicing!

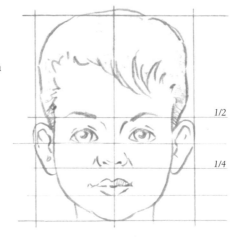

Understanding a Child's Proportions
Draw guidelines to divide the head in half horizontally; then divide the lower half into fourths. Use the guidelines to place the eyes, nose, ears, and mouth, as shown.

1/2

1/4

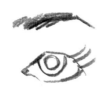

Separating the Features Before you attempt a full portrait, try drawing the features separately to get a feel for the shapes and forms. Look at faces in books and magazines, and draw as many different features as you can.

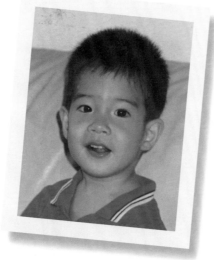

Starting with a Good Photo When working from photographs, some artists prefer candid, relaxed poses over formal, "shoulders square" portraits. You can also try to get a closeup shot of the face so you can really study the features.

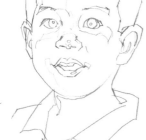

Sketching the Guidelines
First pencil an oval for the shape of the head, and lightly draw a vertical center line. Then add horizontal guidelines according to the chart at the top of the page, and sketched in the general outlines of the features. When you are happy with the overall sketch, carefully erase the guidelines.

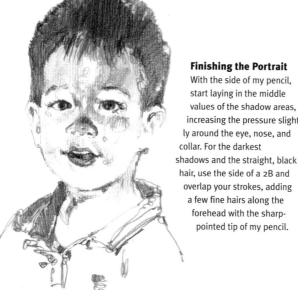

Finishing the Portrait
With the side of my pencil, start laying in the middle values of the shadow areas, increasing the pressure slightly around the eye, nose, and collar. For the darkest shadows and the straight, black hair, use the side of a 2B and overlap your strokes, adding a few fine hairs along the forehead with the sharp-pointed tip of my pencil.

COMMON PROPORTION FLAWS

Quite a few things are wrong with these drawings of this child's head. Compare them to the photo at left, and see if you can spot the errors before reading the captions.

Thin Neck
The child in the photo at left has a slender neck, but not this slender! Refer to the photo to see where his neck appears to touch his face and ear.

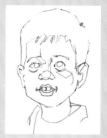

Not Enough Forehead
Children have proportionately larger foreheads than adults do. By making the forehead too small in this example, I've added years to the child's age.

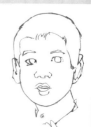

Cheeks Too Round
Children do have round faces, but don't make them look like chipmunks. And be sure to make the ears round, not pointed.

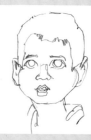

Sticks for Eyelashes
Eyelashes should not stick straight out like spokes on a wheel. And draw the teeth as one shape; don't try to draw each tooth separately.

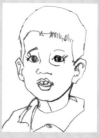

DRAWING THE ADULT HEAD

An adult's head has slightly different proportions than a child's head (see page 122 for more precise adult proportions), but the drawing process is the same: sketch in guidelines to place the features, and start with a sketch of basic shapes. And don't forget the profile view. Adults with interesting features are a lot of fun to draw from the side, where you can really see the shape of the brow, the outline of the nose, and the form of the lips.

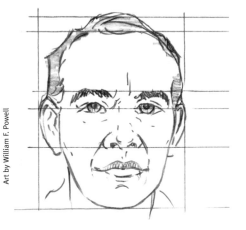

Drawing the Profile Some people have very pronounced features, so it can be fun to draw them in profile. Use the point and the side of an HB for this pose.

Focusing on Adult Proportions Look for the proportions that make your adult subject unique; notice the distance from the top of the head to the eyes, from the eyes to the the nose, and from the nose to the chin. Look at where the mouth falls between the nose and the chin and where the ears align with the eyes and the nose.

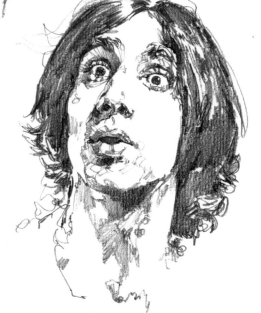

If you can't find a photo of an expression you want to draw, try looking in a mirror and drawing your own expressions. That way you can "custom make" them!

Depicting Shock When you want to show an extreme expression, focus on the lines around the eyes and mouth. Exposing the whole, round shape of the iris conveys a sense of shock, just as the exposed eyelid and open mouth do.

EXPRESSING EMOTION

Drawing a wide range of different facial expressions and emotions can be quite enjoyable, especially ones that are extreme. Because these are just studies and not formal portraits, draw loosely to add energy and a look of spontaneity, as if a camera had captured the face at just that moment. Some artists don't bother with a background, as they don't want anything to detract from the expression. But do draw the neck and shoulders so the head doesn't appear to be floating in space.

Portraying Happiness
Young children have smooth complexions, so make the smile lines fairly subtle. Use light shading with the side of your pencil to create creases around the mouth, and make the eyes slightly narrower to show how smiles pull the cheek muscles up.

Showing Surprise
Here a lot of the face has been left white to keep most of the attention on the eyes and mouth. Use the tip of the pencil for the loose expression lines and the side for the mass of dark hair.

ADULT HEAD PROPORTIONS BY WILLIAM F. POWELL

Learning proper head proportions will enable you to accurately draw the head of a person. Study the measurements on the illustration at right. Then draw a basic oval head shape, and divide it in half with a light, horizontal line. On an adult, the eyes fall on this line, usually about one "eye-width" apart. Draw another line dividing the head in half vertically to locate the position of the nose.

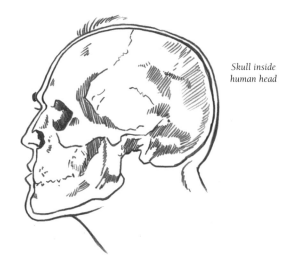

Profile view

Head length

1/3 *1/3*

Eye line

Head width

Head length

Facial mass

Looking at Profile Proportions The horizontal length of the head, including the nose, is usually equal to the vertical length. Divide the cranial mass into thirds to help place the ear.

Placing Facial Features The diagram below illustrates how to determine correct placement for the rest of the facial features. Study it closely before beginning to draw, and make some practice sketches. The bottom of the nose lies halfway between the brow line and the bottom of the chin. The bottom lip rests halfway between the nose and the chin. The length of the ears extends from brow line to the bottom of the nose.

Skull inside human head

Recognizing Bone Structure The drawing above illustrates how the skull "fills up" the head. Familiarizing yourself with bone structure is especially helpful at the shading stage. You'll know why the face bulges and curves in certain areas because you'll be aware of the bones that lie underneath the skin.

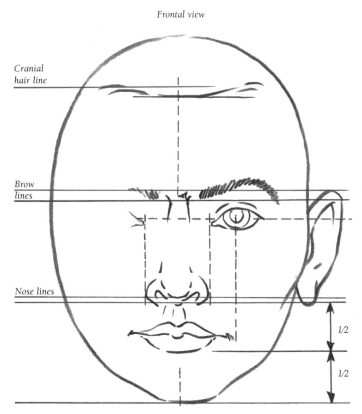

Frontal view

Cranial hair line

Brow lines

Nose lines

1/2

1/2

The bottom lip rests halfway between the nose and the chin.

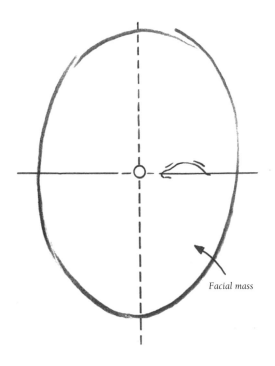

Three-quarter view of skull

HEAD POSITIONS BY WILLIAM F. POWELL

The boxes shown here correlate with the head positions directly below them. Drawing boxes like these first will help you correctly position the head. The boxes also allow the major frontal and profile planes, or level surfaces, of the face to be discernable. Once you become comfortable with this process, practice drawing the heads shown on this page.

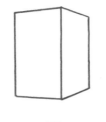
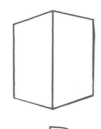
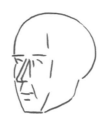

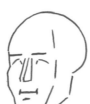
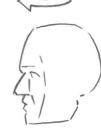

1

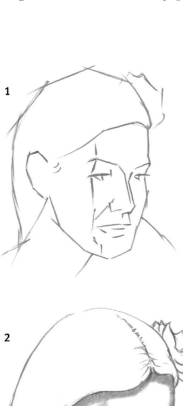

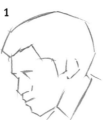
1

1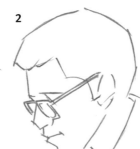

2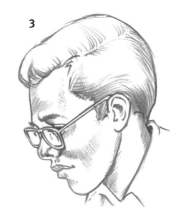

3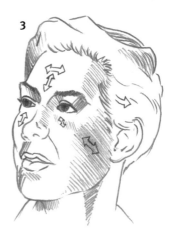

2

1

2

3

Your shading strokes should follow the arrow directions to bring out the contours of the face.

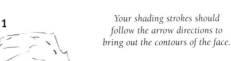
1

2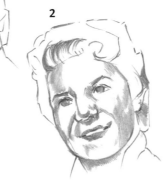

3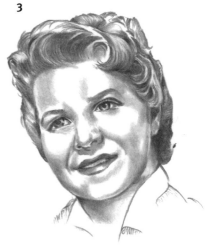

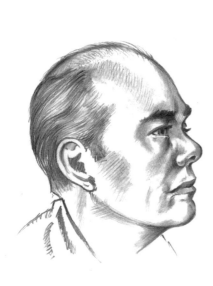

Keep all guidelines very light so they won't show in your actual drawing.

EYES BY WILLIAM F. POWELL

The eyes are the most important feature for achieving a true likeness. They also reveal the mood or emotion of the person you are drawing. Study and practice the diagrams showing how to block in frontal and profile views of eyes. Notice that with the profile, you don't begin with the same shape as with the frontal view.

1

Even if the rest of the features are correct, if the eyes aren't drawn correctly your drawing won't look like your subject.

1

1

2

Outside eye contours (front)

1

2

1

2

Outside eye contours (profile)

2

3

A person's eyes are rarely symmetrical. Look for the subtle differences in each eye to achieve a real likeness.

1

2

3

Pay particular attention to the highlights in the eye. They bring life and realism to the drawing.

Shading the Eyes Shade delicately around the eyes, but make your strokes dark enough to show the eyes' depth and indentation into the face. Very sharp pencils are best for filling in the creases and corners around the eye. These tiny areas (which don't get much light) should be very dark, gradually getting lighter as you shade away from the eye to bring out the contours of the face.

1

4

2

3

A three-quarter angle view can generate a totally different mood, especially if the eyes aren't completely open.

Eyebrows also play an important part of facial expression. They can be bushy or thin, arched or straight. Study your subject's eyebrows carefully.

NOSES AND EARS BY WILLIAM F. POWELL

Noses can be easily developed from simple straight lines. The first step is to block in the overall shape, as illustrated by the sketches below. Smooth out the corners into subtle curves in accordance with the shape of the nose. (A three-quarter view can also be drawn with this method.) Then, once you have a good preliminary drawing, begin shading to create form.

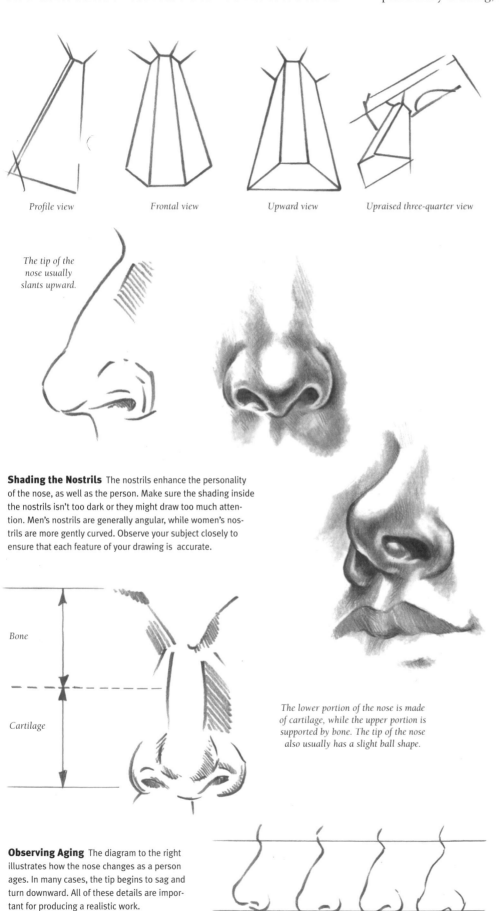

Profile view *Frontal view* *Upward view* *Upraised three-quarter view*

The tip of the nose usually slants upward.

Shading the Nostrils The nostrils enhance the personality of the nose, as well as the person. Make sure the shading inside the nostrils isn't too dark or they might draw too much attention. Men's nostrils are generally angular, while women's nostrils are more gently curved. Observe your subject closely to ensure that each feature of your drawing is accurate.

Bone

Cartilage

The lower portion of the nose is made of cartilage, while the upper portion is supported by bone. The tip of the nose also usually has a slight ball shape.

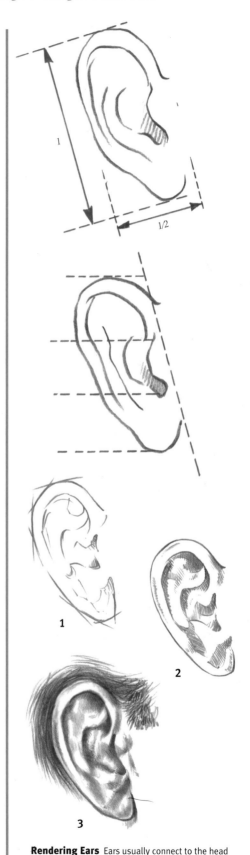

1

2

3

Observing Aging The diagram to the right illustrates how the nose changes as a person ages. In many cases, the tip begins to sag and turn downward. All of these details are important for producing a realistic work.

Process of an aging nose

Rendering Ears Ears usually connect to the head at a slight angle. To draw an ear, first sketch the general shape, and divide it into thirds, as shown above. Sketch the "ridges" of the ear with light lines, studying where they fall in relation to the division lines. These ridges indicate where to bring out the grooves in the ear; you should shade heavier inside them.

WOMAN IN PROFILE BY WALTER T. FOSTER

Once you have practiced drawing the facial features separately and have memorized the proportions, you can combine your skills to draw the entire head. Start with a simple rendering that has minimal shading, such as the profile shown here.

Establishing Proportions As shown in step 1, use an HB pencil to block in the proportion guidelines. Then carefully sketch the basic shapes of the features, as shown in steps 2 and 3. To make your lines smooth and fresh, keep your hand loose, and try to draw with your whole arm rather than just your wrist. Check your proportions before continuing.

Finish the drawing by refining the shapes, suggesting the hair, and adding minimal shading to the lips and nose with a 2B or 4B pencil.

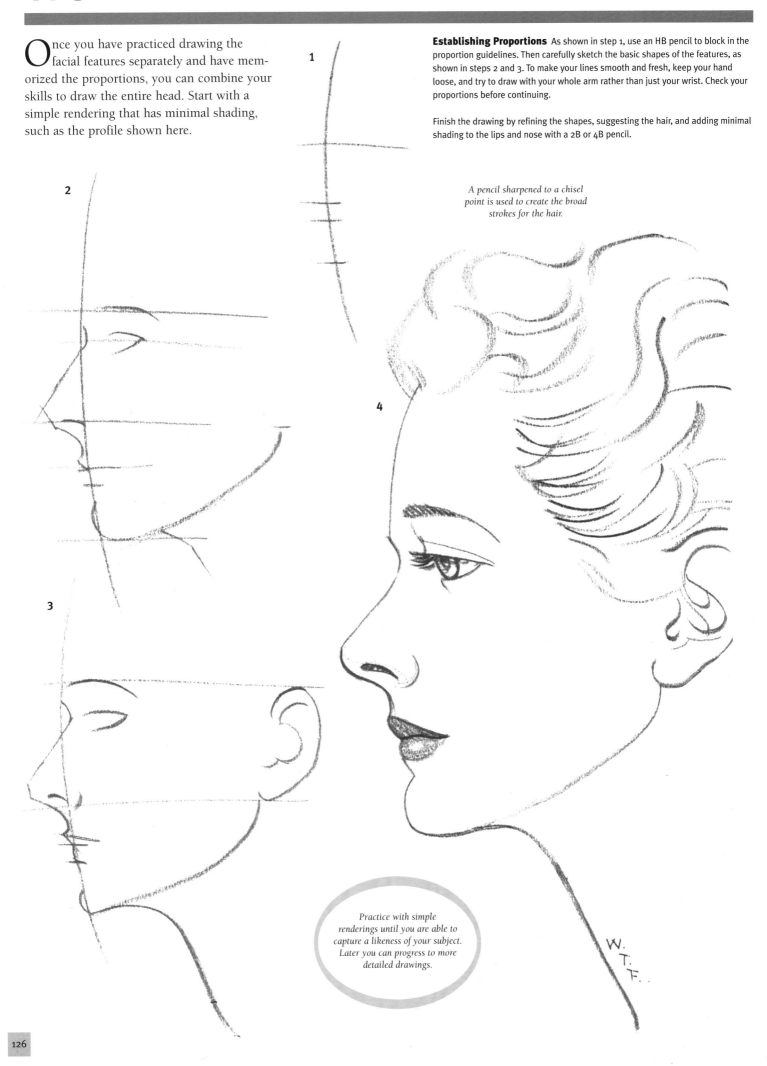

A pencil sharpened to a chisel point is used to create the broad strokes for the hair.

Practice with simple renderings until you are able to capture a likeness of your subject. Later you can progress to more detailed drawings.

W. T. F.

WOMAN FRONT VIEW BY WILLIAM F. POWELL

When you are ready to progress to more detailed drawings, try working from a photo. A black-and-white photo will allow you to see all the variations in value, which will be helpful when shading your subject.

Drawing from a Snapshot In this photo, you can see the subject's delicate features, smooth skin, and sparkling eyes. But you should also to try to capture the features that are unique to her: the slightly crooked mouth, smile lines, and wide-set eyes. Note also that you can barely see her nostrils. It's details like these that will make the drawing look like the subject and no one else.

Step Four Continue building up the shading with the charcoal pencil and willow stick. For gradual blends and soft gradations of value, rub the area gently with your finger or a blending stump. (Don't use a brush or cloth to remove the excess charcoal dust; it will smear the drawing.)

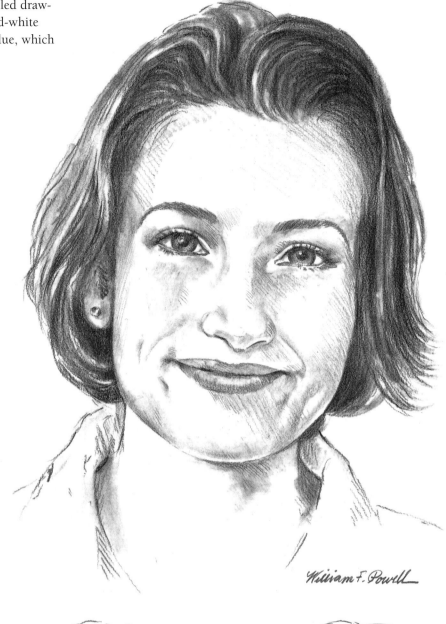

William F. Powell

Step One Start with a sharp HB charcoal pencil and very lightly sketch the general shapes of the head, hair, and shirt collar. (Charcoal is used for this drawing because it allows for very subtle value changes.) Then lightly place the facial features.

Step Two Begin refining the features, adding the pupil and iris in each eye, plus dimples and smile lines. At this stage, study the photo carefully so you can duplicate the angles and lines that make the features unique to your subject. Then begin adding a few shadows.

Step Three As you develop the forms with shading, use the side of an HB charcoal pencil and follow the direction of the facial planes. Then shape a kneaded eraser to a point to lift out the eye highlights, and use a soft willow charcoal stick for the dark masses of hair.

YOUNG MAN IN PROFILE BY WALTER T. FOSTER

These profiles include a new element: clothing. When drawing clothing, the goal is to make it appear natural. It should not look as if it has been pasted onto the subject as an afterthought. Therefore you should always include the clothing in the block-in stage.

1

2

Sketch your guidelines right through the hat; they can be erased later.

Blocking in Guidelines In step 1, sketch the basic proportions for the features, adding the hat in step 2. Remember that the hat fits around the head; it doesn't sit on top of it. In addition, the top of the hat will be slightly higher than the top of the head, and the top of the ear will be covered by the rim of the hat.

Focusing on Male Features Compare this subject's masculine features with the women subjects' feminine features on the previous pages. Notice that this subject has a stronger jaw, sharper nose and forehead, and thinner lips.

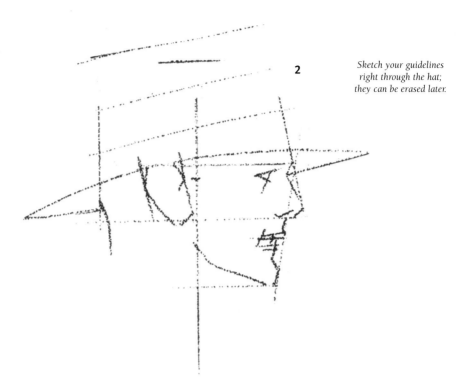

3

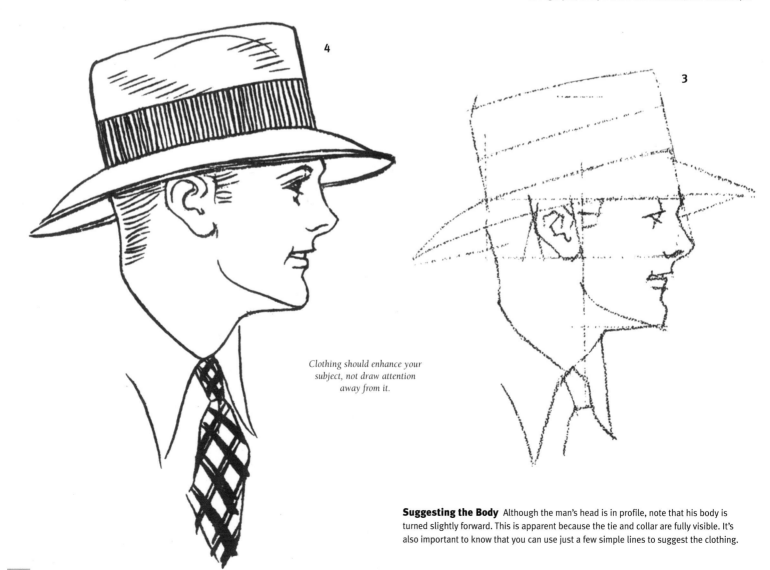

4

Clothing should enhance your subject, not draw attention away from it.

Suggesting the Body Although the man's head is in profile, note that his body is turned slightly forward. This is apparent because the tie and collar are fully visible. It's also important to know that you can use just a few simple lines to suggest the clothing.

OLDER MAN IN PROFILE BY WALTER T. FOSTER

This man is slightly older than the subject on the opposite page; the wrinkles along his face are an obvious indication. Also notice that he is turned completely at profile, so the view of the tie, shirt, and jacket are different.

Starting Simply As usual, draw the block-in lines in step 1. Build the features on these lines. In step 2, draw the rest of the head and begin to refine the features. Keep checking your proportions before continuing. In step 3, add the outline of the collar, tie, and jacket.

Expression is an important part of drawing the human head. For practice, make faces in a mirror, and try drawing what you see.

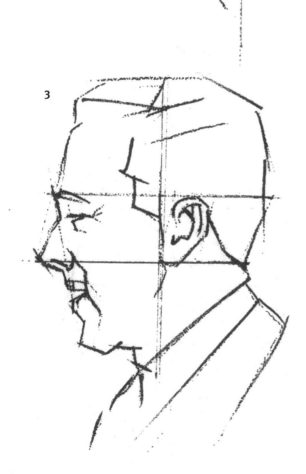

To create the slicked-back effect of the hair, draw all the strokes in the same direction, as shown.

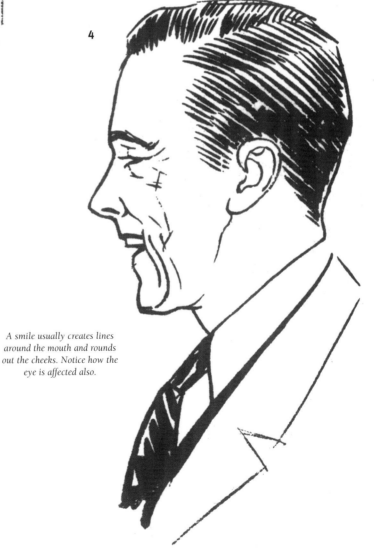

A smile usually creates lines around the mouth and rounds out the cheeks. Notice how the eye is affected also.

Adding the Final Touches For the final details, such as the hair and shading on the tie, you can use a charcoal or a brush and black India ink. (Before using brush and ink on your drawing, you might want to practice making different types of strokes on a piece of scrap paper.) Finally add a few "smile lines" around the mouth.

GIRL IN PROFILE BY WALTER T. FOSTER

The youth of children is brought out with a delicate approach. Simple renderings like these require minimal shading to create the appearance of smooth skin.

Placing the Features In step 1, begin with a very simple block-in method, using a curved line and horizontal strokes to determine placement of the eyebrow, eye, nose, mouth, and chin. In step 2, sketch in the features, along with the outline of the hair. Study your model to make sure that your proportions are correct.

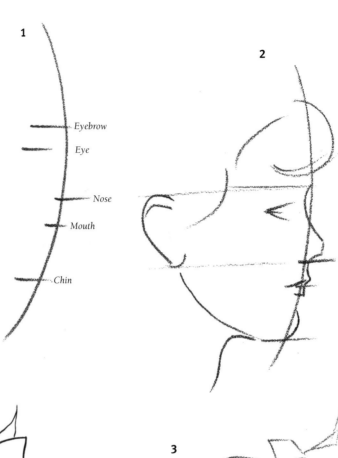

1

— Eyebrow

— Eye

— Nose

— Mouth

— Chin

2

Remember that children generally have smooth, round features.

The hair ribbon should appear to wrap around the head; it shouldn't look as if it is sitting on top of it. Try to make it blend into the hair.

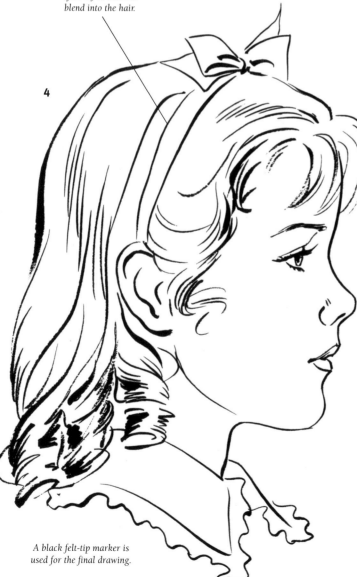

4

A black felt-tip marker is used for the final drawing.

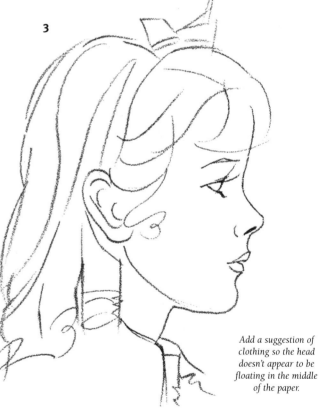

3

Add a suggestion of clothing so the head doesn't appear to be floating in the middle of the paper.

Refining Details In step 3, refine the features and suggest the waves and curls with loose strokes. In the final rendering, develop the features, making your strokes bold and definite. Note that you don't have to draw every strand of hair; just a few lines are enough to indicate the hair style.

BOY IN PROFILE BY WILLIAM F. POWELL

This drawing of a young boy uses a slightly different block-in method than was used in the previous exercise. The outline of the entire head shape is sketched first, along with the proportion guidelines. Of course, you can use whichever method you prefer.

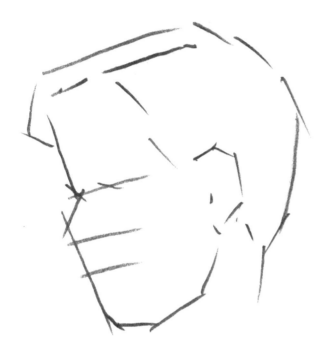

Step One Lightly sketch the overall head shape with short, quick strokes. This may be tricky because the head is not at a complete profile—but you can do it! Observe your subject closely; notice that a portion of the right cheek is visible, along with the eyelashes of the right eye.

With just a few minor changes, you can change the expression on your subject's face. Try raising the eyebrows, widening the eyes, and opening the mouth. What happens?

Step Two Begin to darken and smooth your block-in lines into more refined shapes. As you work, keep checking your proportions.

Use a 2B pencil with a blunt tip to create darker strokes in this area, bringing out the part in the hair.

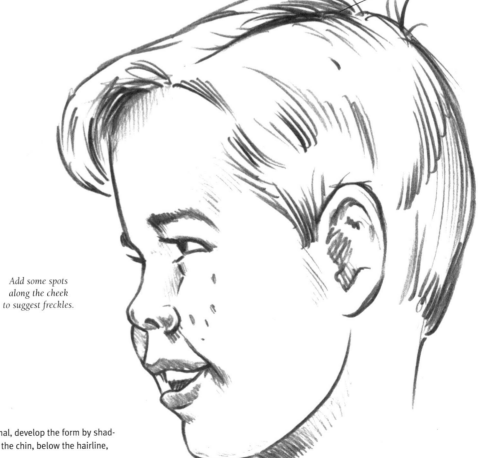

Add some spots along the cheek to suggest freckles.

Step Three As you reach the final, develop the form by shading within the smile lines, under the chin, below the hairline, and inside the part of the hair.

THE BODY BY WILLIAM F. POWELL

The human body is challenging to render; therefore it's important to start with a quick drawing of the basic skeletal structure. The human skeleton can be compared to the wood frame of a house; it supports and affects the figure's entire form.

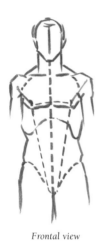

Frontal view

Torso forms into triangle shape

Drawing the Torso The frontal view illustrates the planes of the body, which are created from the skeleton's form. In men's bodies especially, the torso forms a triangle shape between the shoulder blades and the waist. In women's torsos, the triangle shape is generally less pronounced, and their bodies can even resemble an inverted triangle. In other words, the widest part of the body may be at the hips. (Refer to the diagram on page 134.)

Basic skeletal structure

Skeletal structure inside body

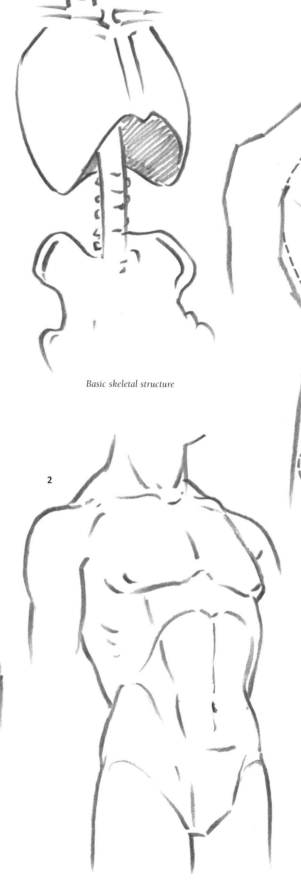

2

1

The muscles also affect the body's form. You might want to study human muscular structure to gain further insight into shading the contours of the body.

HANDS AND FEET BY WILLIAM F. POWELL

Hands and feet are very expressive parts of the body and are also an artistic challenge. To familiarize yourself with hand proportions, begin by drawing three curved lines equidistant from each other. The tips of the fingers fall at the first line, the second knuckle at the middle line, and the first knuckle at the last one. The third knuckle falls halfway between the finger tips and the second knuckle. The palm, coincidentally, is approximately the same length as the middle finger.

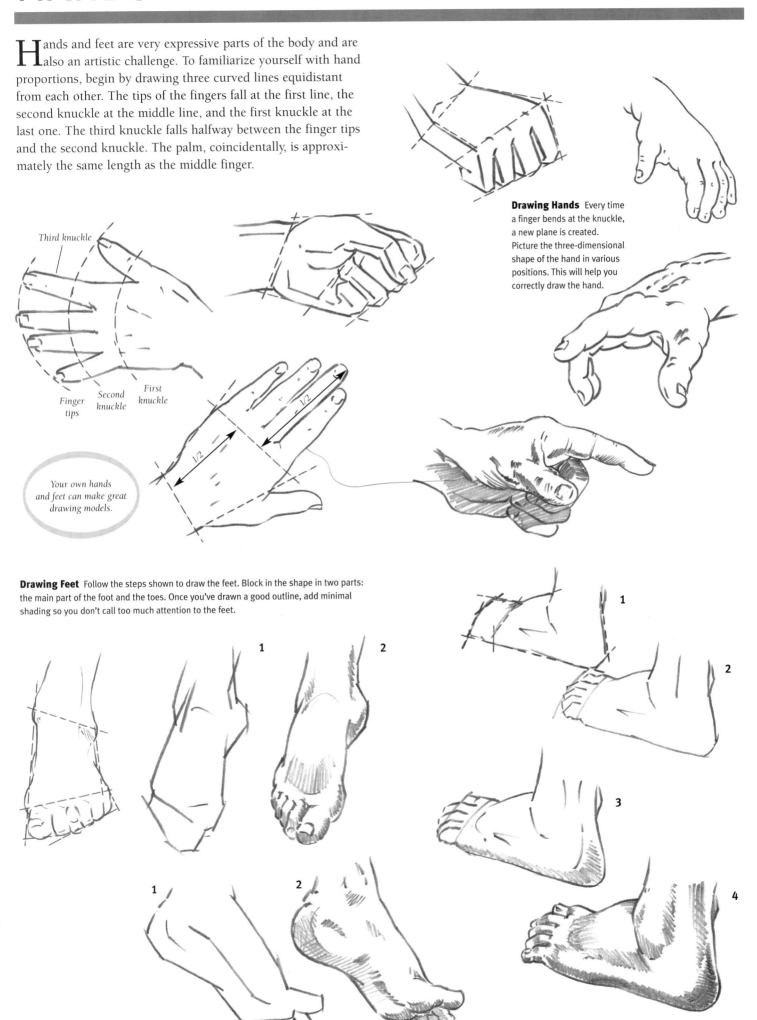

Drawing Hands Every time a finger bends at the knuckle, a new plane is created. Picture the three-dimensional shape of the hand in various positions. This will help you correctly draw the hand.

Third knuckle

Finger tips

Second knuckle

First knuckle

1/2

1/2

1/2

Your own hands and feet can make great drawing models.

Drawing Feet Follow the steps shown to draw the feet. Block in the shape in two parts: the main part of the foot and the toes. Once you've drawn a good outline, add minimal shading so you don't call too much attention to the feet.

1

2

1

2

3

4

1

2

133

FIGURES IN ACTION BY MICHAEL BUTKUS

To draw the human figure from head to toe, it helps to know something about the framework on which it's built. Many art classes have students draw people as skeletons—which is good practice in visualizing how all the parts fit together. You don't have to try that exercise; the simple drawings on page 132 will suffice. But do start with simple stick figure sketches of the skull, shoulders, rib cage, and add the arms and legs. Then once you have the proportions right, you can flesh out the forms.

CAPTURING ACTION

Remember that a gesture drawing is a quick, rough sketch that illustrates a moment of an action. (See page 15.) The idea is just to capture the gesture—it isn't about trying to get a likeness. Give yourself 10 minutes to draw the entire figure engaged in some sport or full-body activity, working either from life or from a photo. Set a timer and stop when the alarm goes off. Working against the clock teaches you to focus on the essentials and get them down on paper quickly.

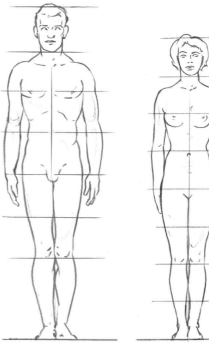

Sketching the Adult Form The average adult is 7-1/2 heads tall, but artists often draw adults 8 heads tall to add stature. The adult male has wide shoulders and narrower hips, whereas the adult female has narrower shoulders and wide hips. Notice that the midpoint is at the hips, not the waist, and that the fingers reach to mid-thigh. Refer to this chart to help you draw the correct proportions.

The human figure can be broken down into several basic shapes. To help you see the human body in three-dimensional form, practice building a figure with cylinders, boxes and spheres

Developing Gesture Drawings
Start with a simple stick figure to catch the motion; then add circles and ovals and flesh out the forms.

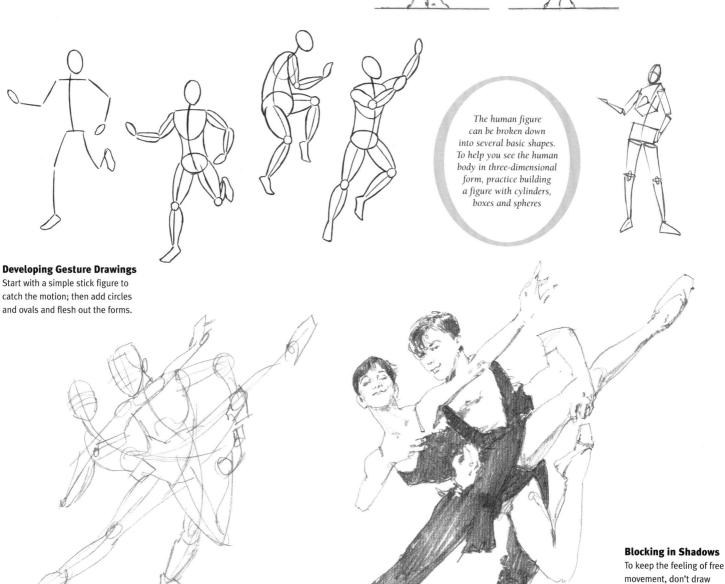

Suggesting Movement First sketch in diagonal center lines for the arms and legs, adding ovals and circles for the heads and joints. Then rough in the general outlines.

Blocking in Shadows
To keep the feeling of free movement, don't draw perfectly refined lines and shadows. Instead, focus on making delicate outlines for the dancers, and quickly lay in broad, dark strokes for their clothing.

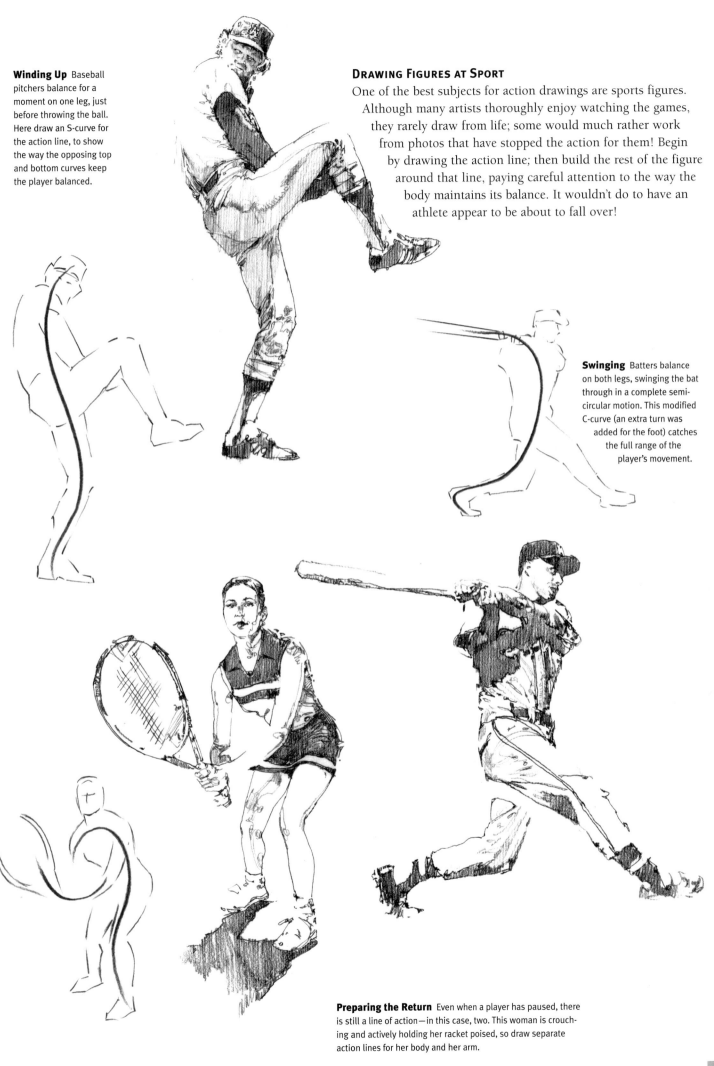

Winding Up Baseball pitchers balance for a moment on one leg, just before throwing the ball. Here draw an S-curve for the action line, to show the way the opposing top and bottom curves keep the player balanced.

DRAWING FIGURES AT SPORT

One of the best subjects for action drawings are sports figures. Although many artists thoroughly enjoy watching the games, they rarely draw from life; some would much rather work from photos that have stopped the action for them! Begin by drawing the action line; then build the rest of the figure around that line, paying careful attention to the way the body maintains its balance. It wouldn't do to have an athlete appear to be about to fall over!

Swinging Batters balance on both legs, swinging the bat through in a complete semi-circular motion. This modified C-curve (an extra turn was added for the foot) catches the full range of the player's movement.

Preparing the Return Even when a player has paused, there is still a line of action—in this case, two. This woman is crouching and actively holding her racket poised, so draw separate action lines for her body and her arm.

FIGURES IN ACTION (CONT.) BY WILLIAM F. POWELL

Before drawing this ballerina, lightly sketch the center line of balance, as well as the action line representing the shape of her spine. Start out with straight lines to lay out her body parts in correct proportion, eventually smoothing out the lines in accordance with her body contours.

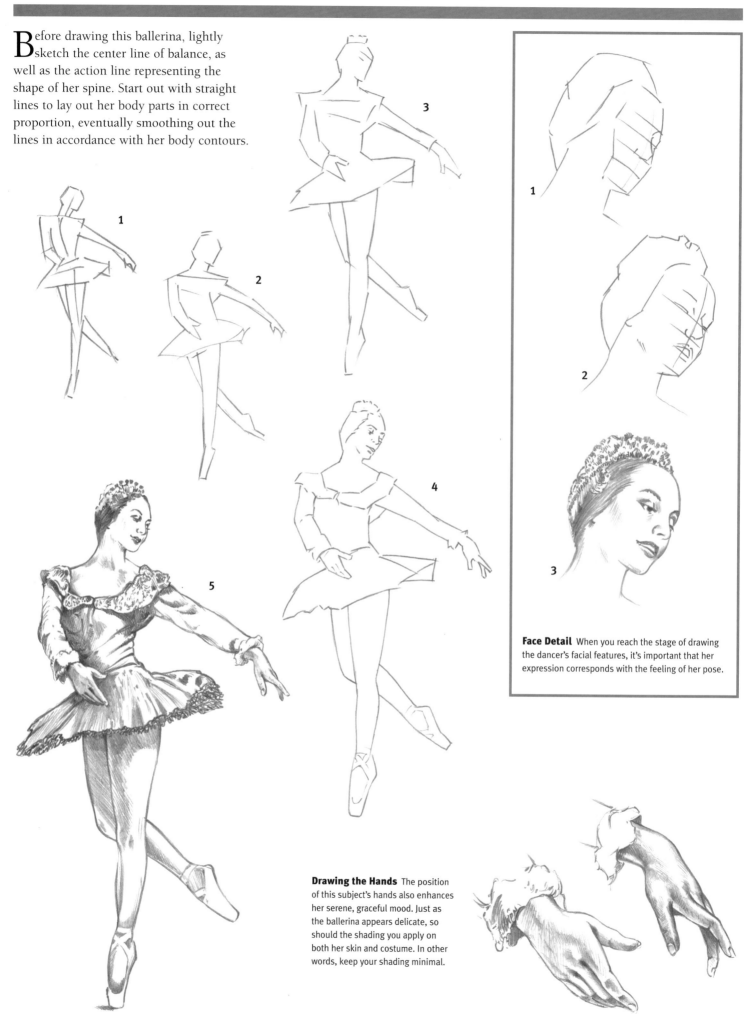

Face Detail When you reach the stage of drawing the dancer's facial features, it's important that her expression corresponds with the feeling of her pose.

Drawing the Hands The position of this subject's hands also enhances her serene, graceful mood. Just as the ballerina appears delicate, so should the shading you apply on both her skin and costume. In other words, keep your shading minimal.

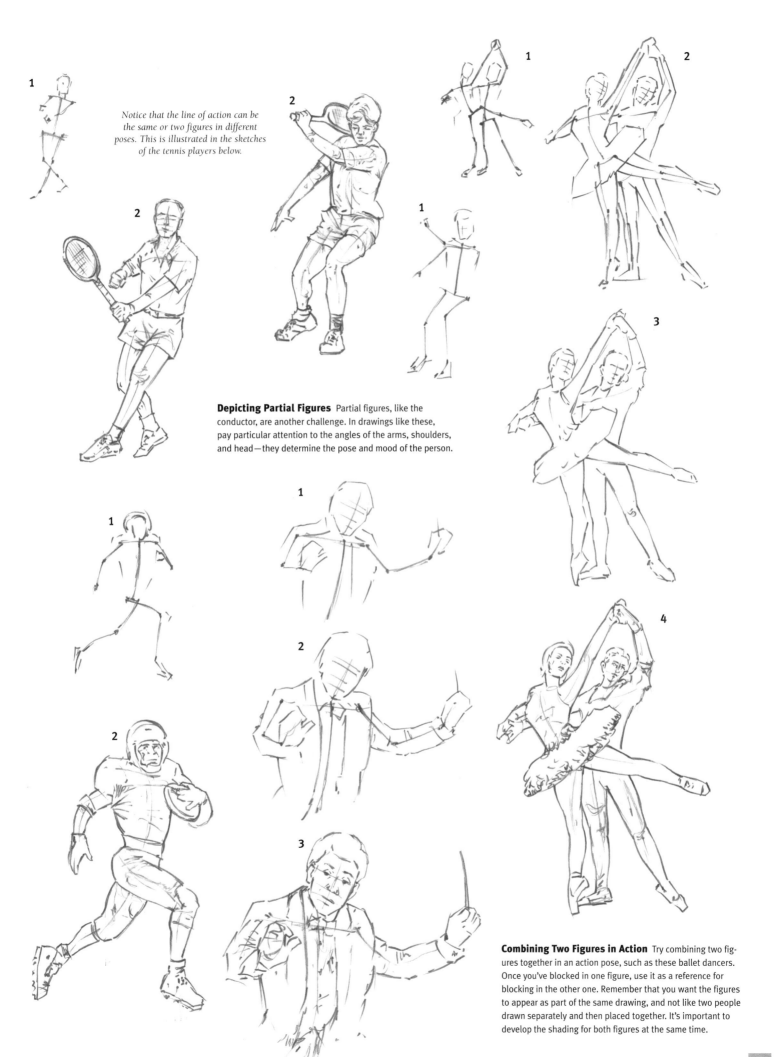

Notice that the line of action can be the same or two figures in different poses. This is illustrated in the sketches of the tennis players below.

Depicting Partial Figures Partial figures, like the conductor, are another challenge. In drawings like these, pay particular attention to the angles of the arms, shoulders, and head—they determine the pose and mood of the person.

Combining Two Figures in Action Try combining two figures together in an action pose, such as these ballet dancers. Once you've blocked in one figure, use it as a reference for blocking in the other one. Remember that you want the figures to appear as part of the same drawing, and not like two people drawn separately and then placed together. It's important to develop the shading for both figures at the same time.

PORTRAYING CHILDREN BY MICHAEL BUTKUS

Children are a joy to watch, and they make charming drawing subjects. If you don't have children of your own to observe, take a sketchpad to the beach or a neighborhood park, and make quick thumbnail sketches of kids at play. Sometimes it actually helps if you don't know your subject personally, because that way you see from a fresh and objective point of view.

MAKING QUICK SKETCHES

Children are more free and flexible in their expressions, gestures, poses, and movements than their inhibited elders are. To make sure you don't overwork your drawings of children, do speed sketches: Watch your subject closely for several minutes; then close your eyes and form a picture of what you just saw. Next open your eyes and draw quickly from memory. This helps you keep your drawings uncomplicated—just as children are. Try it; it's a lot of fun!

Exploring a Toddler's Proportions
Toddlers are approximately 4 heads tall, which makes their heads appear disproportionately large.

Establishing a Child's Proportions
By about age 10, most children are closer to adult proportions, standing about 7 heads tall.

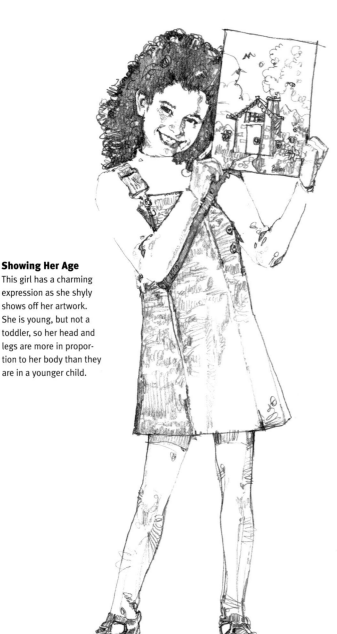

Showing Her Age
This girl has a charming expression as she shyly shows off her artwork. She is young, but not a toddler, so her head and legs are more in proportion to her body than they are in a younger child.

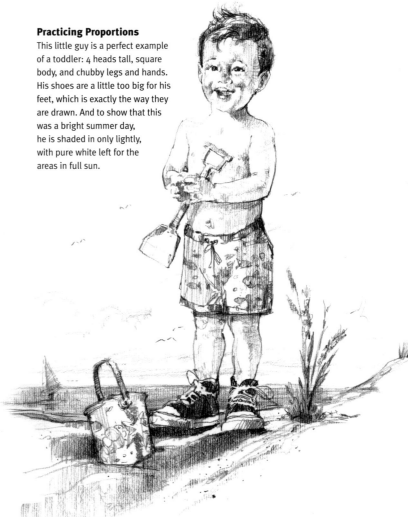

Practicing Proportions
This little guy is a perfect example of a toddler: 4 heads tall, square body, and chubby legs and hands. His shoes are a little too big for his feet, which is exactly the way they are drawn. And to show that this was a bright summer day, he is shaded in only lightly, with pure white left for the areas in full sun.

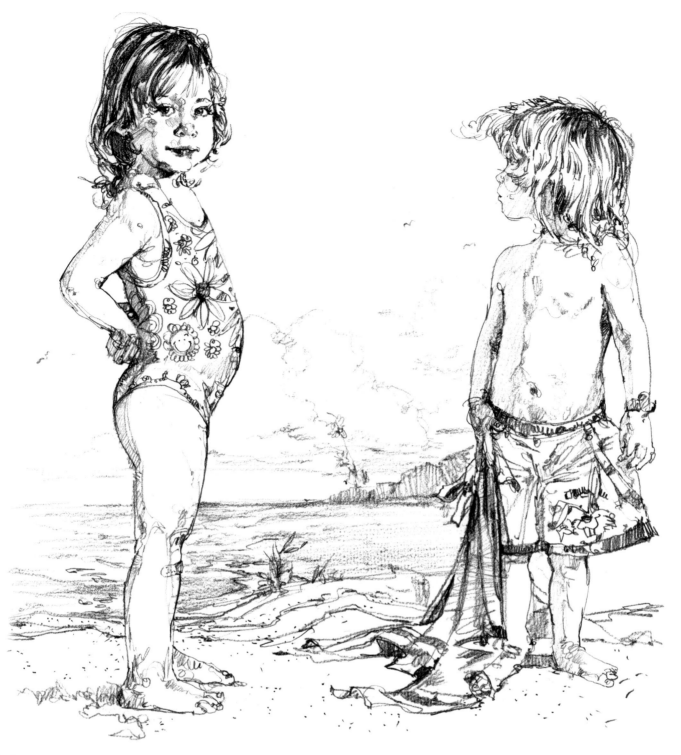

Staging To make sure they were the center of attention, these two youngsters were placed right up front, so they dwarf the background scenery.

DRAWING THE DIFFERENCES

Of course, there's more to drawing children than making sure they are the right number of heads tall. Their facial proportions are different from an adult's (see pages 120 and 121), and they have pudgier hands and feet with relatively short fingers and toes. They often have slightly protruding stomachs, and their forms in general are soft and round. Keep your pencil lines soft and light when drawing children, and your strokes loose and fresh.

Studying Hands and Feet
Study these drawings of children's hands and feet; then compare them to your own. Children's fingers are short and plump, with an almost triangular shape. Their feet are soft and fleshy, with a predominantly square shape.

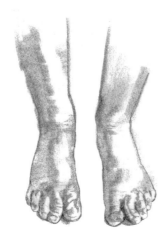

COMPOSING FIGURES BY WILLIAM F. POWELL

Creating a good composition is important in any drawing; therefore, let your subject(s) guide you. It's not necessary to place the main subject directly in the center of your composition. For example, the eyes of the girls below are looking in different directions, which determines where the girls are positioned.

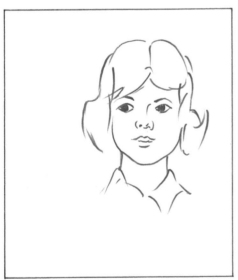

Zooming In Intentionally drawing your subject larger than the image area, as in the example below, is also a unique composition. While part of the image may be cut off, this kind of close-up creates a dramatic mood.

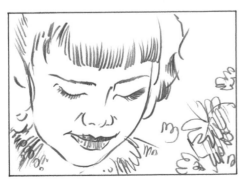

Combining Multiple Subjects You can create a flow or connection between multiple subjects in a composition by creatively using circles and ellipses, as shown to the right.

Practicing Curvatures Curved lines are good composition elements—they can evoke harmony and balance in your work. Try drawing some curved lines around the paper. The empty areas guide you in placing figures around your drawing.

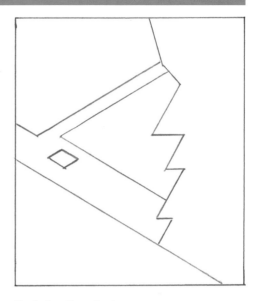

Producing Sharp Angles Sharp angles can produce dramatic compositions. Draw a few straight lines in various angles, and make them intersect at certain points. Zig-zagging lines also form sharp corners that give the composition an energetic feeling.

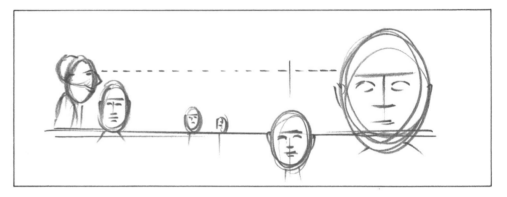

The compositions above and below illustrate how arm position, eyesight direction, and line intersection can guide the eye to a particular point of interest. Using these examples, try to design some of your own original compositions.

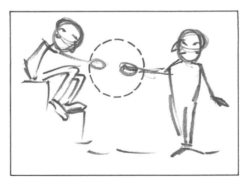

PEOPLE IN PERSPECTIVE BY WILLIAM F. POWELL

Knowing the principles of perspective allows you to draw more than one person in a scene realistically. As when you're drawing a building (see page 97), first establish the horizon line and the vanishing points. Any figures drawn along these lines will be in proper perspective. Study the diagrams at right and below to help you.

Vanishing point (VP) Horizon line

VP Horizon line

VP Horizon line

Altering Size and Depth Try drawing a frontal view of many heads as if they were in a theater. Start by establishing your vanishing point at eye level. Draw one large head representing the person closest to you, and use it as a reference for determining the sizes of the other figures in the drawing.

VP

VP Horizon line

Drawing Full Figures The technique illustrated above can be applied when drawing entire figures, shown in the diagram at right. Although all of these examples include just one vanishing point, a composition can even have two or three vanishing points. (See pages 8–9.)

INDEX

A

Action. *See Animals* (movement of);
　Figures (in action); *Lines* (and action);
　Movement, conveying
Action line, 15, 16, 135, 136, 137
Animals
　and background, 58, 69, 71, 74, 75, 81
　and basic shapes, 16, 53, 57, 58, 68–69,
　　74, 80, 81, 83, 86, 87, 88, 89, 90, 92
　birds, 84, 86, 89
　bones of, 81
　cats, 66–75
　distinguishing characteristics of, 55, 77
　dogs, 56–65
　drawing, 53–55
　elephant, 87
　feet of, 55, 72, 90
　flamingo, 86
　folds of skin of, 62, 87
　fur and hair of, 54, 55, 56, 57, 58, 59,
　　60, 61, 62, 63, 65, 66, 67, 68, 69,
　　70, 71, 72, 73, 74, 75, 79, 80, 82,
　　85, 88
　giraffes, 54, 55, 93
　gorillas, 85
　heads of, 54, 55, 56, 57, 60, 61, 62,
　　76–79, 85, 86, 93
　hippos, 84
　horses, 55, 76–77, 78–79, 82, 83
　kangaroo, 88
　koalas, 52
　markings of, 54, 91, 93
　movement of, 55, 85
　muscles of, 55, 60, 78, 79, 80, 81, 82, 88
　panda, 92
　pony, 80–81
　proportions of, 54, 59, 71, 81, 82, 85
　reptiles, 90, 91
　sheep, 55
　snake, 91
　tortoise, 90
　toucan, 89
　at the zoo, 84–85
Automobiles, 17

B

Blending
　and animals, 72, 77, 80
　and charcoal pencils, 7
　and landscapes, 99
　and still lifes, 29, 40, 44, 45, 49

Butkus, Michael, 10–11, 18–19, 54–55,
　188, 120–121, 134–135, 138–139

C

Cats. *See Animals* (cats)
Center of balance, 136
Center of interest, 46, 96, 107, 139, 140
Charcoal drawings, 7, 8
　and painting, 8
　papers, 6
　pencils, 7
Circles, 16, 17
　and animals, 54, 68, 69, 76, 83, 85,
　　89, 90
　and figures, 134, 140
　and still lifes, 22, 36
Clouds. *See Landscapes* (and clouds)
Color, creating illusion of, 61
Composition
　and animals, 73
　and figures, 140
　good, 46, 140
　and landscapes, 96
　and still lifes, 26, 46–47
Cones, 9, 10, 16, 17, 23
Contour drawing, 14, 87
Contrast
　and animals, 72, 73, 77, 81, 84
　and landscapes, 101, 107, 114
Crayon
　Conté, 7
　　and shading, 68, 69
Cubes, 9, 10, 16, 17
Cylinders, 9, 10, 16, 17, 83, 134

D

Depth, creating, 9, 16, 46, 72, 81, 95, 96,
　97, 101, 112, 115, 124
Dimension, building, 18–19, 78
Dogs. *See Animals* (dogs)
Drawing board, 7
Drawing through, 16, 17

E

Ellipses, 9, 16, 17, 140
Erasers, 6
　and animals, 57, 63, 65, 66, 67, 68,
　　85, 86
　and figures, 126
　and landscapes, 101, 115
　and still lifes, 23, 30, 40, 41, 45, 48, 51

F

Fences, 13
Figures in action, 15, 119, 134–137
　and background, 121, 139
　and basic shapes, 121, 122, 123, 134
　beginning portraiture, 120–121
　the body, 132, 134, 136, 137, 138, 139
　bones, 122, 125, 132, 134
　children, 14, 118, 120, 121, 130, 131,
　　138–139
　clothing, 128, 129, 130, 136
　and composition, 140
　and contour drawing, 14
　facial features and expressions, 118,
　　119, 120, 121, 122, 124–125, 126,
　　127, 128–129, 130–131, 136, 138
　and gesture drawing, 15
　hair, 120, 121, 126, 127, 129, 130, 131
　hands and feet, 14, 133, 136, 139
　heads, 118, 120–121, 122–123, 126,
　　127, 128, 129, 130-131, 136, 137,
　　138, 141
　men, 128, 129, 132, 134
　muscles of, 121, 132
　in perspective, 141
　profiles, 119, 121, 123, 124, 125,
　　126, 128–131
　proportions of, 119, 120, 121, 122, 126,
　　127, 128, 129, 130, 131, 133, 134,
　　136, 138, 139
　skin and complexions of, 121, 129,
　　130, 136
　women, 118, 126, 127, 132, 134
Fixative, 7
Flowers. *See Still lifes* (flowers)
Foliage. *See Landscapes* (and trees and
　foliage)
Foreshortening, 9, 84
Form
　defined, 16
　developing, 18–19, 21, 57, 70, 76, 78,
　　81, 82, 83, 93, 125, 131, 134
　　See also specific techniques
Format, and composition, 46
Forms
　basic, 9, 10, 16
　creating and building, 16
　seeing, 17
　See also Shapes; specific forms
Foster, Walter T., 57, 78, 126, 128–133
Fruit. *See Still lifes* (fruit and vegetables)

G

Gesture drawing, 14, 15, 134
Glass. *See Still lifes* (glassware, pottery, and other containers)
Glaze, 45

H

Highlights and animals, 57, 63, 65, 66, 67, 68, 81, 83, 85, 87, 89, 92
and figures, 124
and shadows, 19
and still lifes, 23, 24, 30, 40, 41, 45, 50, 51
and values, 18, 19
Hills. *See Landscapes* (and mountains and hills)
Horses. *See Animals* (horses)

I

India ink, 79, 126, 129

K

Knives, 6, 7

L

Landscapes
background of, 96, 98, 100, 101, 106, 107, 109, 111, 112, 114
and basic shapes, 102
and clouds, 12, 95, 98–99, 115
and composition, 96
and deserts, 110–111
foreground of, 96, 97, 109, 111, 112, 114
middle ground of, 96, 112
and mountains and hills, 95, 97, 108–109
panoramic view in, 96
and perspective, 95, 97, 106, 112
and points of view, 95, 107
and roads, 96, 97, 106, 114–115
and rocks, 95, 100–101, 112–113, 116–117
and structures, 97, 106–107
and trees and foliage, 12, 13, 94, 95, 96, 97, 100, 101, 102–105, 106, 109, 112, 113, 114–115, 116, 117
and water, 94, 95, 112–113, 117
Light
and animals, 71, 73, 88
candlelight, 28
and landscapes, 100, 110, 111
and shading, 71, 73, 88, 100, 110, 111, 112, 138

and shadows, 9, 18, 19, 30
and still lifes, 30
Lighting, 6, 46
Line of direction, 46
Lines
and action, 13, 15, 16, 134, 135, 136, 137
angled, 50, 140
and animals, 54, 58, 61, 62, 63, 64, 65, 69, 70, 72, 73, 74, 75, 76, 78, 79, 80, 81, 82, 83, 84, 88, 89, 90, 91, 92, 93
in background, 73, 76
and basic shapes, 16, 17
block-in, 25, 40, 44, 51, 60, 62, 63, 67, 70, 72, 74, 79, 80, 81, 82, 84, 90, 93, 100, 101, 104, 105, 108, 111, 114, 116, 124, 125, 127, 128, 129, 130, 131, 133, 134, 137
and composition, 140
and contour drawing, 14
and figures, 120, 121, 122, 123, 124, 125, 126, 127, 128, 129, 130, 131, 133, 134, 135, 136, 137, 139, 140, 141
and foreshortening, 9, 84
jagged, 109
and landscapes, 97, 98, 100, 101, 102, 104, 105, 106, 107, 108, 109, 111, 114, 116
and pencil types, 7
and perspective, 8, 141
and scribbling, 12, 76
and still lifes, 22, 23, 25, 31, 32, 33, 34, 36, 42, 44, 45, 46, 50, 51
width of, 32, 33, 83
zigzagging, 64, 140

M

Maltseff, Michele, 79, 82–83
Matte finish, 49
Mountains. *See Landscapes* (and mountains and hills)
Movement, conveying, 13, 15, 55, 113, 119, 134–137

N

Negative space, 13, 26, 49
Night drawing, 6

O

Observation and seeing, 10, 14–15, 51, 56, 72, 79, 80, 81, 86, 100, 102, 125
Overworking a drawing, 68, 72, 138

P

Painting, 8
Papers, 6, 7, 8, 42
Pencils
flat sketching, 43, 45, 99, 104
holding, 10, 16, 105, 127
and lead softness, 7
sharpening, 7
and values, 19
People. *See Figures*
Perspective, 8–9
and figures, 141
and landscapes, 95, 97, 106, 112
one-point, 8
and still lifes, 21, 51
two-point, 8
Photographs, using, 19, 46, 86, 116, 120, 134, 135
Portraits. *See Figures*
Positive space, 13
Powell, William F., 12–17, 20, 22–52, 57, 60–65, 84–94, 96–117, 118, 122–125, 127, 136–137, 140–141
Proportions
and animals, 54, 56, 59, 73, 78, 79, 83, 84, 87
and figures, 119, 120, 121, 122, 126, 127, 128, 129, 130, 131, 133, 134, 136, 138, 139
and landscapes, 106
and still lifes, 11, 32, 51

R

Realism, 95, 97, 124, 125
Rectangles, 16, 17, 91
Reflections, 48–49
Roads. *See Landscapes* (and roads)
Rocks. *See Landscapes* (and rocks)
Roughing in, 10

S

Sandpaper block, 7
Scribbling, 10, 12, 13
Shading, 6
and animals, 53, 54, 55, 57, 58, 59, 60, 61, 62, 63, 64, 65, 66, 68, 69, 70, 71, 72, 73, 74, 77, 78, 79, 80, 81, 82, 83, 85, 86, 87, 88, 89, 90, 91, 92, 93
creating depth with, 9
and figures, 119, 121, 122, 123, 124, 125, 126, 127, 129, 130, 131, 132, 133, 136, 137, 138

hatching and cross-hatching, 32, 33, 37, 83

and landscapes, 95, 98, 99, 100, 101, 102, 103, 106, 107, 108, 109, 110, 111, 112, 113, 114, 115, 117

and light source, 71, 73, 88, 100, 111, 138

and pencil types, 7

and roughing in, 10

and still lifes, 21, 22, 23, 24, 25, 26, 27, 28, 29, 30, 31, 32, 33, 34, 35, 36, 37, 38, 39, 40, 41, 43, 44, 45, 47, 48, 49, 51

and values, 18, 19

Shadows

and animals, 54, 55, 62, 65, 72, 73, 83, 87, 89, 90, 92, 93

cast, 9, 18, 23, 25, 26, 29, 30, 31, 46, 47, 49, 72, 83, 89, 90, 92, 93

and developing form, 18

and figures, 120, 134

and hatch strokes, 32

and highlights, 19

and landscapes, 99, 106, 107, 110, 111

and roughing in, 10

and still lifes, 12, 18, 24, 25, 26, 27, 29, 30, 31, 32, 44, 45, 46, 47, 49, 50

Shapes

basic, 16–17

See also Animals (and basic shapes); *Figures* (and basic shapes); *Landscapes* (and basic shapes); *Still lifes* (and basic shapes)

combining, 16

seeing, 17

Silhouetting, 13

Sketch pads, 6, 12, 116, 138

Sketchbooks, 6, 8, 86

Sketching

and developing form, 18–19

and painting, 8

starting with, 12–13

techniques, 12–13

"thumbnail," 19, 46, 138

Spheres, 9, 10, 16, 18, 134

Squares, 16, 17, 139

Still lifes

and background, 20, 30, 35, 43, 46, 50

and basic shapes, 11, 17

books, 17

bread, 50–51

candlelight, 28

cheese, 18

and composition, 46–47

eggs, 48–49

flowers, 12, 29, 30, 31, 32–45

fruit and vegetables, 17, 18, 21, 22–23, 24–25, 46–47

glassware, pottery, and other containers, 17, 19, 28, 30, 46–47, 48–49, 50–51

pinecones and trees, 26–27

reflections and lace, 48–49

and sketching, 12

traditional, 21

Stroke and lift technique, 25, 27, 31

Strokes

and animals, 54, 55, 56, 58, 59, 61, 63, 64, 65, 66, 68, 69, 70, 71, 72, 73, 74, 75, 76, 77, 78, 80, 81, 82, 83, 84, 87, 88, 89, 90, 91, 92, 93

and figures, 120, 123, 124, 127, 129, 130, 131, 134, 139

hatch and cross-hatch, 32, 33, 37, 83

and landscapes, 99, 104, 105, 107, 113, 114, 117

and movement, 13, 55

and sketching, 12, 16

and still lifes, 22, 23, 25, 27, 28, 31, 32, 33, 43, 44, 45, 46, 47, 50

and tools, 7

and warming up, 10

Structures. *See Landscapes* (and structures)

Sunlight, 101, 111, 138

See also Light

T

Tavonatti, Mia, 56, 58–59, 66–69, 70–77, 80–81

Techniques. *See specific techniques*

Texture

and animals, 54, 55, 65, 66, 67, 70, 75, 81, 82, 86, 88, 89, 90, 92

and charcoal papers, 6

and landscapes, 99, 101, 102, 104, 105, 107, 108, 110, 112, 113, 115, 117

rough, 12, 47

and still lifes, 22, 25, 26, 27, 30, 42, 47, 50

Tools and materials, 6–7, 86

See also specific tools and materials

Tortillons, 6

Trapezoids, 83

Trees. *See Landscapes* (and trees and foliage)

Triangles, 16

and animals, 57, 58, 63, 76, 88

and figures, 132, 139

and landscapes, 102

V

Values, 5

and animals, 57, 64, 65, 71, 72, 74, 77, 80, 81

and composition, 46, 47

and creating illusion of color, 61

and developing form, 18, 19, 81

and figures, 120

and landscapes, 100, 102, 103, 107, 109, 114, 115, 117

and rough texture, 12

and still lifes, 50

Vanishing point, 141

Vantage point, 85, 91

Vellum finish, 50

W

Warming up, 10–11

Water

and landscapes, 94, 95, 112–113, 117

reflections in, 113

and still lifes, 23, 41

waterdrops, 31

waves, 13

Work station, 6